Media Representations of Visual Art & Artists
(second, revised edition)

UNIVERSITY
UP *of*
JL
LUTON PRESS

THE **ARTS COUNCIL** OF ENGLAND

Dedicated to my parents – Roy and Ruth Hayward

Picture This
Media Representations of Visual Art & Artists
(second, revised edition)

Edited by Philip Hayward

UNIVERSITY
UP of JL
LUTON PRESS

THE **ARTS COUNCIL** OF ENGLAND

British Library Cataloguing in Publication Data
A catalogue record for this page is available from the British Library

ISBN: 1 86020 518 6

Published by
University of Luton Press
Faculty of Humanities
University of Luton
75 Castle Street
Luton, Bedfordshire LU1 3AJ
England

Book designed by Design & Art, London
Printed in Great Britain by Whitstable Litho Ltd,
Whitstable, Kent, UK

Preface

It was ten years ago that Philip Hayward came to see me with an idea for a book on visual arts and the media. The Arts Council of Great Britain (as it was then) had never before published a book of critical writings, least of all, a book on the relationship of the arts to the media.

The Arts Council itself had been producing films on the arts for two decades and had built up a library of more than 250 titles. The broadcasting environment of the late 1980s was such that the Arts Council was now co-producing programmes with television companies.

It seemed to us apposite that a book that explored the relationship between the visual arts and film would be a useful addition to the growing number of books on the media, most of which focused on the media from a sociological point of view. High art was seen as the antithesis of popular media, but as the media was the most popular means by which people were exposed to the arts then it seemed appropriate to explore that relationship.

Four major series on the visual arts remain landmarks that helped generations of people to understand art. *Civilisation*, *Ways of Seeing*, *Shock of the New* and *State of the Art*; each in their different ways marked a turning point in the way that art was presented and understood. However, popular cinema has always had a love/hate relationship with visual art and artists which we were also concerned with.

The result was *Picture This*. Much has changed since the book was published and to mark its tenth anniversary we decided to publish a revised second edition; *Picture This II*. New essays have been commissioned and old ones revised. We trust that *Picture This II* will prove as popular with a new generation of readers as its illustrious predecessor.

There are now ten books in the series; *Picture This: Media representations of visual art and artists* (ed. Philip Hayward) was the first volume in the series and deals with a range of topics, including the representations of visual art in popular cinema, and how broadcast television has revolutionised our

relationship to culture and cultural practices. The second volume, *Culture, Technology and Creativity in the late Twentieth Century* (ed. Philip Hayward), addresses various aspects of how technology and culture inter-relate. Topics include digital technologies, computers and cyberspace. Volume three, *Parallel Lines: Media representations of dance* (ed. Stephanie Jordan and Dave Allen) collects together accounts of how dance and dancing have been represented on public television in Britain. The book considers the role of dance in a variety of television practices including pop-videos, popular dance programmes, and experimental and contemporary dance. Volume four, *Arts TV: A history of arts television in Britain* (ed. John A. Walker), is the first general, systematic history of the various types of genres of arts programmes – review programmes, strand series, drama documentaries, artists profiles, etc – and gives a chronological account of their evolution from 1936 to the 1990s. Volume five, *A Night in at the Opera: Media representations of opera* (ed. Jeremy Tambling), offers an arresting range of accounts of how the popular arts have represented this high art form written by specialists in music, media and popular culture. It raises issues which have bearing on the sociology of music and about its implications for television and video culture. Volumes six and seven *Diverse Practices: A critical reader on British video art* (ed. Julia Knight) and *The British avant-garde film 1926-1995* (ed. Michael O'Pray) highlight the rich practice of artists working with film and video. Volume eight, *Boxed Sets: Television representations of theatre* (ed. Jeremy Ridgman) discusses the aesthetics of television dramatic production and performance and reassesses some of the assumptions about the influence of theatre on the emergence of television drama as a specific form. The ninth book *Dramatic Notes: Foregrounding Music in the Dramatic Experience* (ed. Neil Brand) deals with the dramatic effect music has on image.

We would like to take this opportunity to thank Philip Hayward for revising and editing this book and the publishers – the University of Luton Press – who joined us in its production. We are grateful to them for the untiring and thoughtful way in which they approached the task.

Finally, the views expressed herein are those of the authors and should not be taken as a statement of Arts Council of England policy.

Will Bell
Series Editor
Arts Council of England

Contents

Acknowledgements

Thanks to Will Bell for his support for a second edition of this anthology; to Merilyn Palmer for secretarial assistance; to the staff of the Mitchell Library in Sydney and Gosford Public Library; and to Rebecca, Rosa and Amelia for their various encouragements.

Chapter 4 – John Robert's 'Postmodernism, Television and the Visual Arts' originally appeared in *Screen* vol 28 no 2 1987 and **Chapter 7** – Griselda Pollock's 'Artists Mythologies and Media Genius, Madness and Art History' in *Screen* vol 21 no 3 1980 – both are reproduced by kind permission of the Society for Education in Film and Television. **Chapter 9** – Diane Waldman's 'The Childish, the Insane and the Ugly' originally appeared in *Wide Angle* vol 5 no 2 1982 and is reproduced by kind permission of the John Hopkins University Press. **Chapter 13** – Simon Watney's 'Landscapes of Speculation' originally appeared in *Undercut* 7/8 and is reproduced by kind permission of the *Undercut* Collective.

Chapter 2 – John Wyver's 'Representing Art or Reproducing Culture ?'; **Chapter 5** – Steven Bode's 'All that's solid melts on the air'; **Chapter 8** – Julian Petley's 'The architect as *Übermensch*'; and **Chapter 10** – Marie Gillespie and Sylvia Hines' 'Critical contradictions', were originally published in the first edition of *Picture This* (1988).

Thanks to the following bodies for their permission to print photographic material as follows: Weintraub Screen Entertainments for stills from *The Rebel*, Chapter 1; The Arts Council of Great Britain, *Pottery Ladies* and *Shock of the New* stills Chapter 1; London Weekend Television, all stills Chapter 2; Illuminations for the *State of the Art* stills by Geoff Dunlop reproduced in Chapters 1, 2, 4; The National Gallery for the photographs of Van Gogh paintings Chapter 7; the BFI Production Board for stills from *The Draughtsman's Contract*, Chapter 13.

1
Introduction
Representing Representations

Philip Hayward

This anthology addresses the manner in which cinema, television and video, and, to a lesser extent, literary fiction, press reviews and published criticism, have sought to represent the visual arts and architecture and those involved in their production. Analysis of this field necessarily involves a consideration of the complex set of issues raised by the representation, interpretation and criticism of one representational medium by another. The individual studies in this volume reveal a series of critical preconceptions and discourses interacting with each other in an often unconscious process. The analysis of these reveals deep seated cultural presumptions about the 'essence', function and appeal of (visual) art itself.

My emphasis on the *unconscious* interactions within such an area of media practice should not be taken to imply that its practitioners are unaware of the existence of major debates and critical differences, nor that they necessarily assume any representational *transparency* for their work. It rather reflects the manner in which many practitioners and critics are still wont to claim some degree of privileged insight into the (assumed) 'essence' and/or essential condition of their subjects (and this is as true of many of those critics and practitioners influenced by various aspects of Marxist, feminist, semiotic, psychoanalytic and/or postmodern theory as it is to those working within more traditional paradigms). Such perceptions are premised on two assumptions. First, that there is an objective 'essence' to be grasped. Second that a subjective empathy and/or complementary analysis can somehow 'override' or at least *suppress* the specific signifying systems of the media used; and obscure and/or elide the complex ideology behind the apparently empathic recognition and/or 'complementary' critical reading.

The project of this anthology is the analysis of the critical address and methodology of a series of media representations of visual art, not simply in themselves (as somehow isolated from the subject of their representation) but in addition to their address to their (apparent) subjects. It analyses the chains of meaning, the slippages and disjunctures present, in what might be termed 'serial representations'.

EARLY CRITICAL DEBATES – THE NINETEEN FIFTIES

Much of the early writing around the representation of art and artists on film concentrated on issues of how the filmic medium could best represent the work of art and/or the artist's 'vision' with the greatest degree of representational *fidelity*, or, at the very least, complementarity. Arguments around these themes were of course orientated in various ways and focused on a number of different concerns (detailed below). An illuminating series of discussions took place in the early 1950s in the pages of the British magazine *Sight and Sound*. There were various aspects to these debates. With regard to painting, a prime consideration was the use of film technology to make the pictures transcend both their filmic and televisual representation (and often the supposed representational 'limitations' of their own medium) and somehow 'come to life'. Critics such as Francis Koval praised the work of film makers who utilised film technology to effectively extend the pictorial into the filmic (and thereby give the viewer a privileged point of entry into the painting's pictorial space). Discussing the work of Luciano Emmer in 1951, for instance, he argued that:

> those who have seen his art films such as *Il Paradiso Perduto* (from the paintings by Bosch) or *Dramma di Cristo* (from Giotto's frescoes) are impressed by the vivid expressiveness of the paintings as seen by the apparently ubiquitous eye of the camera. Elaborate camera movement and dramatic editing make the figures seem almost three dimensional, and despite the black-and-white photography the human eye and its guiding mind enjoy the illusion of colour and movement.[1]

Although this approach was developed in a more dramatic manner in later films, such as Alain Resnais' *Guernica*, it proved to be short-lived in critical acclaim. Indeed, by 1955 Lotte Eisner was writing in *Sight and Sound* that, 'the

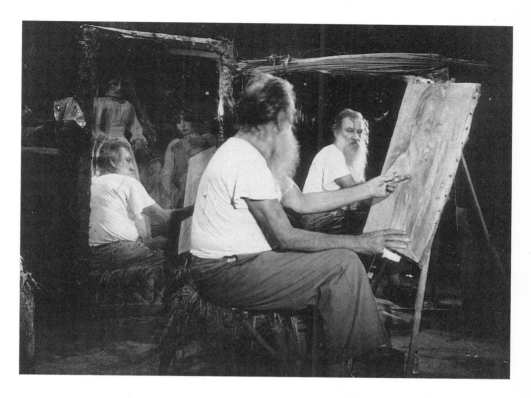

Margot Benacerraf's *The Painter Reveron* – singled out by Lotte Eisner for its penetrative vision.

possibilities of treating a picture like a scene in a studio without the element of the third dimension – has now become stale with imitation and abuse'.[2]

Another major preoccupation of early critics was the nature of the perception and appreciation of the artist by the film maker, an approach which, they often argued, necessitated an intuitive and sympathetic engagement (rather than the cultivation of a critical distance). Eisner singled out Margot Benacerraf's direction of *The Painter Reveron* for approbation in this regard, arguing that 'no film maker has so deeply *penetrated* the work of an artist in a film'[3] (my emphasis). She went on to praise the film maker for knowing 'how to see' and claimed that Benacerraf had 'an innate sense of rhythm and montage'.[4] Lauro Venturi even proposed a whole category of 'films on art' typified by 'their close adherence to the original canvas and to the *inner spirit and meaning* of both the paintings and the painter' (my emphases).[5]

Attempts to produce work premised on such empathic interpretations persist in contemporary media practice, most notably in that school of art film production where directors have attempted filmic recreations of the apparent visual environment(s) suggested by the style and *mise-en-scène* of particular painters' and photographers' work. (See, for example Derek Jarman's [self explanatory] *Carravagio* or Steven Dwoskin's Bill Brandt-inspired *Shadows from Light*.) This approach has also been apparent, albeit more obliquely, within mainstream fiction film production where cinematographers and directors have often attempted to recreate the visual and/or lighting styles of particular painters (with varying degrees of success). Examples of this tendency include John Duigan's *Sirens*, which represents the life of Norman Lindsay with images derived from his own art (see Chapter 12 for further discussion); John Byrum's attempt to recreate aspects of Edward Hopper's paintings in the visual design of *Heart Beat*; and the self-consciously referential lighting compositions used in films such as Terrence Malick's *Days of Heaven*.

Along with this attempt to isolate 'good practice', much of the critical debate about art films in Britain and North America has involved critics in a somewhat complex situation regarding the vocabulary of art and film. Much of the early critical work on film as a medium had concentrated on arguing it as (potentially) valid as an art form in it own right, with the result that, by the 1950s, the work of certain directors, such as Flaherty and Eisenstein, was regarded (in film circles at least) as 'art'. The vocabulary of the 'art film', the 'film on art' and 'film as art' was therefore somewhat confusing and pointed out a complex interlinking of hierarchical cultural values and assumptions about the representational function of media.

The significance of this terminological confusion was signposted by Lauro Venturi in an article in *The Quarterly of Film, Radio and TV* in 1953,[6] where he attempted to unpick the confusion over the terminology 'art films' and 'films on art' by setting out four categories of film which qualified for the status of art in different ways:

(a) 'Films for which works of art are made expressly'[7] – such as the animated films made by artists such as Oscar Fischinger or Norman McLaren.

(b) 'Films which deal primarily or exclusively with the narrative contents of one or more already existing works of art'[8] – such as the work of Luciano Emmer.

(c) 'Films which deal with the historical, critical or technical aspects of art and artists'[9] – skills-instructional films and artists' biographies, filmed lectures on art and critical essays on art.

(d) 'Films in which the works of art are pretexts for something else'[10] – films which use works of art as the visual material for narratives; or critical theses which do not concern themselves *primarily* with the works of art concerned or issues concerning art (nb Venturi includes Resnais' *Guernica* in this category).

Venturi's purpose in drawing up such precise guidelines was not simply academic pedantry. It rather reflected a scrupulous desire to eradicate confusion as to degrees of 'art' (a term whose own definition is of course never specified), which remains (to Venturi at least) a crucial ('high') cultural paradigm. Venturi's earnest desire to create a binding system of classification reflects the potential danger he (and others) saw in the profusion of various styles of film making. As he stated: '[o]nce a definition of contents is reached, the recent avalanche of art films and films on art can be channelled and analysed with some hope of classification'.[11]

While the opening section of Venturi's article acknowledged the validity of considering certain films as 'art' in their own right (ie as 'film art');[12] his attempts at classification perpetuated a hierarchical differentiation of fine art and film practice. This, and similar debates, signify the manner in which the first generation of film critics succeeded in asserting certain films as art in their own right while maintaining the established status of traditional art forms with reference to a shifted (although tightly guarded) classificatory distinction (ie 'film art' as opposed to 'fine art'). It should however be noted that the occasional work of French critics which appeared in English during this period was markedly different in orientation. Writers such as Jean Queval expressly denied the need for rigid delineations of type, arguing that '[at] present, there is little to be gained from introducing rigid categories into a genre which is still searching for principles'.[13] Similarly, reflecting the development of more sophisticated schools of film criticism in France, Rene Micha even singled out films for praise which *prioritised* their media specificity in representing their subject (rather than attempting to *efface* it). He specifically commended a practice which would 'sacrifice none of the cinema's own powers, and thus prefers on occasion to let the painting suffer'.[14] Such foreign emphases did not however secure widespread acceptance in anglophone critical culture during the 1950s.

The last three decades have seen significant shifts in the emphases of both arts documentary production and the critical writing addressed to it. Since the early 1960s, film and television producers have largely abandoned attempts to enhance pre-constituted artworks with the aid of media technology. Instead, producers have moved towards giving a more contextual representation of the artist, their personal situation and the significance of their work. In terms of criticism, writers have largely abandoned such early pre-occupations as the desire to rigidly categorise the nature of representational styles of media practice and, influenced by Walter Benjamin's seminal essay 'The Work of Art in the Age of Mechanical Reproduction',[15] (or perhaps more precisely, by its influence on John Berger's own highly influential *Ways of Seeing* book and TV series);[16] have turned to acknowledging the inherent problems, limitations and

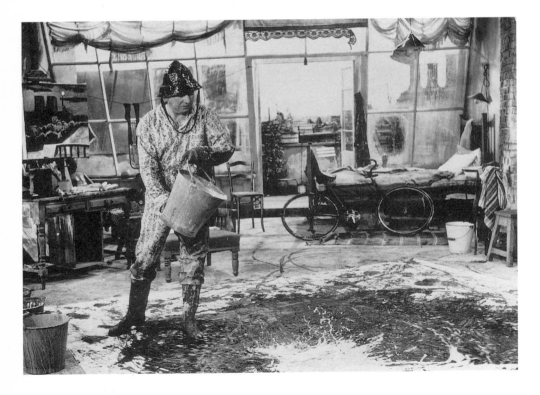

The actual moment of creation – as represented by Robert Day in *The Rebel*

transformations affected by the process of re-presentation from one medium to another. But if criticism has shifted away from a pre-occupation with the mystery of creativity, much media practice has still retained the fascination with the actual moment of creative expression.

During the 1960s and 1970s a number of media producers (and critics) concentrated on identifying a uniquely privileged area of operation for the film maker – their presence at (and recording of) the moment of creation of the artwork. Such approaches had also attracted critical praise during the 1950s, when a number of critical pieces used remarkably intense prose descriptions to describe the supposed 'mystery' and 'wonder' of artistic creativity. Eisner, for instance, commented that in Benacerraf's *The Painter Reveron* the audience is 'shown the immediacy of the moment of creation, taken alive: an astounding presence is revealed, stripped naked in all its complexity'.[17] Similarly, although writing with a more traditionally English (and male) reserve, Patrick Hayman commented that in John Read's film *Lowry*, the 'magic of this mysterious occupation [ie painting] comes across in a splendidly satisfying way, as the painting itself grows and changes under the joyful brush of the artist'.[18]

This extreme 'fetishisation' of the *actual moment* of creation has resulted in the production of a number of film texts which, in attempting to record this moment in as direct a manner as possible, have merely served to highlight the shortcomings of the approach. This is particularly true of a number of films addressing themselves to Abstract Expressionist painting. In Hans Namuth and Paul Falkenberg's *Jackson Pollock* for example, the film makers endeavoured to catch Pollock in the 'act of creation'. They attempted to produce a precise record of his technique by having the artist simulate his painting style on a sheet of horizontal glass below which was mounted a film camera. The exercise proved so trying to Pollock however that he rapidly abandoned the simulation declaring himself 'out of touch' with his work. Jan Vrijsman's *The Reality of Karel Appel* is, if anything, even more removed from any representation of actual painterly technique and observed creativity. It features the artist flicking paint at a glass screen (substituting for a canvas) in a frenzy of apparent creativity (accompanied by a Dizzy Gillespie soundtrack). Both films principally emphasise the inevitability of attempts to simulate the process and technique of painting (etc.) being necessarily only a representation of that simulation. Both go beyond the mere insertion of a camera behind the shoulder of the working artist (where at least some semblance of the creative process can be

recorded) and produce a false instance where the artist ends up either not being able to simulate their work (as is the case with Pollock) or by effectively adapting the work into a performance for camera (in the case of Appel); both instances being at substantial removes from the apparent projects of the films.

While little recent film and television work has attempted to represent visual artists in the actual moment of creation,[19] other approaches have still attempted to capture aspects of the live experience of artistic execution. Perhaps the most blatant (and in many ways bizarre) of these have come in the form of the BBC's mini-series *Painting With Light*.[20] This comprised six programmes which took six contemporary artists and had them compose a series of video images (so called 'video paintings') with the aid of the electronic Quantel Paintbox (with which they had little or no previous experience) and a technician – the process of image production appearing directly on the screen. Aside from the (understandably) highly preliminary nature of the visual work so produced, the exercise says a lot about the low self-esteem of the medium that complete novices at a complex form of new media technology were invited to experiment with it with the results being broadcast on national TV. Could one for instance imagine a reverse situation where a group of cinematographers were helped to create their first ever oil paintings, the results of which were then packaged and promoted as exemplary practice in a major touring exhibition? Probably not. The significant difference is of course relative cultural status. In Europe at least, television (and particularly in the British context the BBC) still possesses a marked inferiority complex with regard to traditional 'fine art' media (and even cinema), the result of which is its constant quest for status-by-association – hence the use of celebrity artists for the *Painting With Light* series.

The use of established (fine) artists to bring cache to the medium is of course something of an international phenomenon. At the major European symposium 'The Art of Television' (held in September 1987 at Amsterdam's Stedlijk Museum) for instance, Christine van Assche (video curator at the Pompidou Centre) chose as a prime example of French TV's (supposedly) innovative approach to art, a brief animated collage made by the 80-year-old Surrealist painter Matta.[21] This was every bit as preliminary as any of the BBC's *Painting With Light* series and had seemingly no address to the specificity of television as anything other than a medium for basic stop-motion work.

The irony of involving traditional fine artists such as painters with the medium of television is that in changing the context of their work (from the easel to

the screen), the specific qualities of their traditional practice which are coveted by the media (their precise composition and the *aura* of the original) are of course dispensed with. At the very moment of their transmission and reception (not to mention playback after time-shift recording) images, such as those original Quantel Paintbox compositions generated by the artists in *Painting With Light*, are subject to myriad individual transformations (which go far beyond those transformational effects noted by Benjamin with regard to *mechanical* processes of reproduction).[22] Aside from their initial video tape recording, encoding and transmission, the result of their being translated into visual images on different models of TV set (with different screen sizes and individual technical peculiarities) and on different individual sets themselves (with their range of personally determined colour, brightness and contrast settings and/or specific faults), not to mention the possibility of their being watched in black and white; is to render any of the artists' decisions about precise colour composition, intensity, luminescence, etc, largely irrelevant. Any *aura* the original video image may have had is immediately dissipated in the instant of its first recording and, in Derrida's phrase, the 'original' image is inevitably 'split in itself'[23] at the moment of its subsequent electronic reproduction.

The rationale behind these attempts to capture the moment and process of creation on the screen derives from the notion of the artist as an exceptional individual, the cult of the isolated (and often 'tortured') genius. This approach to the artist through (usually) *his* work is of course not only a feature of documentary material, it is also present in a welter of popular fictional work on the topic. As Griselda Pollock details in Chapter 7, popular Hollywood cinema has found the stereotype of the 'tortured artist' a highly attractive subject for representation. There is after all, much in the myth of the inspired individual artist striving to transcend everyday reality and produce a ('high') cultural artefact which recalls the intensity of saintly conviction or the nobility underlying classic tragedy.

The 'tortured artist' myth also offers a number of other attractions – and cross-identifications – for film makers. Its representation serves to valorise the *auteur* figure and often represents the *auteur* as forging great works of art under (near-intolerable) social pressures and cultural and economic philistinism. It is surely no accident that Michael Cimino initially approached United Artists to remake King Vidor's *The Fountainhead* (which, as Julian Petley points out in Chapter 8, is virtually a celebration of individual totalitarianism)

before settling on the idea of a film about the Minnesota feuds (*Heaven's Gate*). Similarly, it is less than surprising that Derek Jarman should toil so fervently to raise funds to make his impressionistic, eponymous biography of Caravagio, nor that the figure and occupation of the draughtsman in Peter Greenaway's *The Draughtsman's Contract* should so closely parallel that of the film maker (see Chapter 13 for further discussion).

The theme of individual artistic conviction so intense as to be personally and socially damaging (the underlying motif of both *The Fountainhead* and films such as Alexander Korda's *Rembrandt*) is closely allied to another enduring cultural stereotype, that of the mad artist. In Chapter 7 Griselda Pollock analyses the biographical myth of Van Gogh as the epitome of this representation in Modern Art. As Diane Waldman indicates in Chapter 9

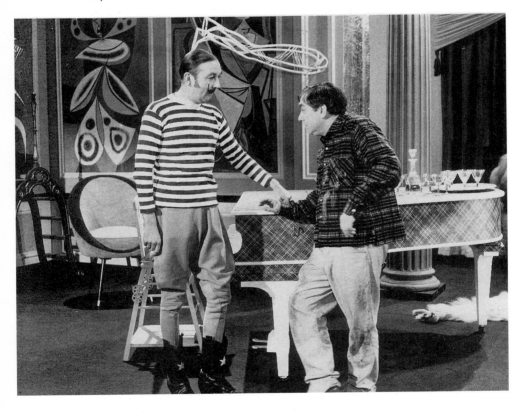

Modernism as a confidence trick foisted on the art established by a coalition of pretentious foreigners and devious entrepreneurs – Robert Day's *The Rebel*

however, the myth is also one which can be mobilised to *critique* artistic production rather than simply mystify it. As Waldman outlines, a significant trend in popular culture during the 1940s characterised Modernism as a style which principally served to indicate the psychological disorder of its producers, both in itself and in the aberrancy of their rejection of the more conventional pictorial forms privileged by the pre-Modernist tradition. (It should be noted that this argument also has its contemporary art historical incarnation in Peter Fuller's reading of the psychological crises which afflicted those artists – such as Jackson Pollock, Mark Rothko and David Smith – who were at the forefront of the first generation of Abstract Expressionists).[24]

The approach outlined by Waldman also has its equivalent in British popular culture, where Modernism is similarly distrusted, but on slightly different grounds – on that of its being essentially a 'con' (a confidence trick) foisted on the art establishment by a coalition of pretentious foreigners and devious entrepreneurs. In many ways Robert Day's film *The Rebel* exemplifies this particularly enduring perception. *The Rebel* relates the story of a singularly untalented (British) no-hoper (played with relish by Tony Hancock) who exiles himself to France, negotiates Parisian cafe society and is eventually acclaimed in error. Despite its contemporary setting, the film does not represent a specific response to developments in British contemporary art practice. Indeed its scenario is arguably more appropriate to the Parisian art world of the early Twentieth Century than to the late 1950s. This representation of Modernism as a 'con' has however retained a sense of permanence in British culture, which has not been party to the recuperative and ideologically motivated critical repositioning around Modernism, and specifically Abstraction, which took place in America in the late 1950s.[25] This continuing perception results in a re-occurring theme in media News coverage of (Modern) art, periodic tabloid scandals about events such as Carl Andre's pile of bricks being purchased and exhibited in the Tate,[26] life size submarines being constructed out of car tyres on the South Bank;[27] or preserved cows being exhibited as 'art'.

But however understandable such attitudes may be as a corrective to the perceived affectation and excesses of bourgeois culture, they have now become so institutionalised in popular discourses that they operate as indiscriminate cliches. News coverage of the London opening of 'Judy Chicago's Dinner Party' in 1985 provided graphic examples of this. As Marie Gillespie and Sylvia Hines outline in Chapter 10, so strong have the force of these cliches become that

The Pottery Ladies (above) and
Käthe Kollowitz (top right) – two films
attempting to re-evaluate the history
of women in arts and crafts.

even the indisputably skilled artefacts on display were discussed and parodied within the standard dismissive terms of reference. An item on the ITN Channel Four 7pm News (broadcast on 1 January 1985) exemplified this tendency by privileging (and thereby implicitly colluding with) the opinion of a passing 'man on the street' (who had of course not actually *seen* the exhibition) that it looked like 'a con job' to him.

On one level, media reports such as the ITN News item detailed above simply reflect and exacerbate the continuing difficulties faced by women trying to establish themselves as artists within traditional fine art practice. However, they also evidence a more central aspect of the art establishment's struggle for hegemonic control, the need to police the boundaries of fine art practice. This is necessary in order to repress, exclude or marginalise types of work which aspire to its privileged status (the cultural legitimation which allows for exhibition, discussion and/or approbation) despite being produced from significantly different traditions of cultural practice. The

conceptual differentiation between 'art' and 'craft' is a key aspect of this enterprise (and these oppositional paradigms undoubtedly contributed to the art establishment's generally cool reaction to 'Judy Chicago's Dinner Party' – relying as it does primarily on ceramics and fabric work). This differentiation does of course have another key strategic function, concerning issues of gender, class and ethnicity; the supposedly less important 'crafts' traditions usually being those practiced by women, the working classes and/or members of less industrially developed cultures.

It is perhaps one of the more significant aspects of critical work and media practice in countries such as Britain and the United States over the last decade, that many of these formerly marginalised crafts practices have now been opened up for re-evaluation. Although much of this work often retains a fine art paradigm which rests somewhat uneasily with the non-fine art focus of its work; studies such as Rozsika Parker's *The Subversive Stitch*[29] and documentary series such as Jenny Wilkes' *The Pottery Ladies* have begun a significant critical reconsideration of their subjects. Hand in hand with this has of course been the critical reassertion of women as producers within the established fine art medium; a tendency signalled in Britain by the publication of Griselda Pollock and Rozsika Parker's *Old Mistresses*[30] and furthered by curatorial policies which have seen a gradual increase in the exhibition of female artists' work; the production of a growing number of documentaries highlighting the achievements of Twentieth Century female artists (eg *Kathe Kollwitz, Slade Women, Lives of Artists Not Wives of Artists, Frida Kahlo and Tina Modotti*, etc); and the continuing work of directors such as Gina Newson who (in programmes such as *Imaginary Women*) have attempted to address some of the more complex issues around art, society and female creativity.[31]

Art produced within non-Western and/or pre-industrial societies has also been subject to a similar historical marginalisation to that of women's work. Cultural artefacts from these societies have traditionally been approached from one of two perspectives, as either anthropological and/or archaeological artefacts, or else (within the history of Modernism), as 'primitive' forms of art possessing stylistic aspects capable of being developed in a supposedly more sophisticated manner by Western fine artists[32].

The almost complete absence of black artists within the Western fine art tradition to date (an absence no doubt compounded by the continuing *invisibility* of those who have had a significant presence), has, somewhat

Claes Oldenburg's *Clothes Peg* and *Lightening Field* – the swansong of modernism?

inevitably, resulted in the absence of their representation in the Western media. (In this context, the final episode of the 1987 TV series *State of the Art –* entitled 'Identity, Culture and Power', was, aside from anything else, significant for simply *representing* the opinions and work of a range of black artists.) Whereas black musicians or black cultural events such as London's Carnival have been frequently covered in the broadcast media, black artists have been rarely featured within (British and European) television (let alone the cinema) other than in specifically black-orientated programme slots such as *Ebony or Asian Eye.*

If black artists have been overwhelmingly excluded from the Western fine art tradition as producers, there is still the possibility of partially reclaiming the ideological grounds for their exclusion through examining the represented presence of black people in the artefacts of Western culture itself. Alongside their depiction as standard elements in Western genre painting (as for example, the three kings in depictions of the Nativity legend); their supposedly peripheral presence in the canvases and prints of particular periods such as the Eighteenth and Nineteenth Century offers, as David Dabydeen's television documentary *Art of Darkness*[33] clearly demonstrates, an area of significant

analysis for an understanding of the construction of 'blackness' as a Western cultural 'Other'.

Some of the most original representations of non-Western arts practices have, unsurprisingly, developed at the geographical (and generic) fringes of the media map, in the work of the Papua New Guinean video maker Titus Tilly[34] for instance, or the music videos produced for Australian Aboriginal band Yothu Yindi.[35] The video for Yothu Yindi's debut single 'Mainstream'[36] is particularly significant in this regard. The song and video are a powerful statement of the band's 'bothways' philosophy, that of both engaging with contemporary Western culture and preserving traditional customs and identity. Along with their other (audio-visual) work, the politics of their tribal group (the Yolngu) and the broad Aboriginal Land Rights movement; the video attempts to re-claim and resignify icons and images of Australia. To this end the video pursues a particular textual strategy. In a series of rapid montage sequences, the blackened silhouette of the island-continent of Australia is filled with the rich, vibrant patterns of Aboriginal dot paintings. This serves to reclaim the map of Australia and its identity by subverting the tradition of Western maps and atlases which once coloured a quarter of the world red in order to represent the extent of British imperial dominion. There is a second political aspect to the images used in the video, that of their ownership. While the band contacted the communities and artists who produced the works for permission to use them in the video, they deliberately chose not to seek permission from the Western art collectors who had purchased them, regarding traditional Aboriginal 'ownership' of the images as paramount.

VALUE

As the discussion of Yothu Yindi's 'Mainstream' video identifies, the issue of ownership is an important aspect of the cultural politics of art. However, while it may be a crucial one for many marginalised groups, there is a very different sense of its operation within the traditional mainstream of Western culture. One of the most succinct summaries of the relationship between the value of art – understood both aesthetically and economically – and its cultural context of legitimacy and legitimation was offered in a sketch by the British comic Tommy Cooper. Appearing on stage with a violin in one hand and a framed oil painting in the other, he used to relate the following anecdote:

I was cleaning out the attic last week and I found this old violin and this old oil painting. So I took them to an expert and he said to me 'What you've got there is a Stradivarius and a Rembrandt. Unfortunately [pause] Stradivarius was a terrible painter and Rembrandt made rotten violins'.[37]

This sketch tells us much about the popular perception of art. The names of (high) cultural 'celebrities' are invoked as guarantors of value – understood here in a primarily economic sense – and then comically undercut. Cooper's skit plays upon the audience's awareness that they have no terms or grounds for identifying either the 'legitimacy' of an artwork or its value. Both of these are seen to reside – and, what's more, reside relatively unproblematically – in the hands of experts, whose word is law. Indeed, their comments are so definitive that Cooper finishes his routine by destroying the violin and painting and discarding them as worthless. It is a sketch that illustrates many of the points John Berger laboured in his *Ways of Seeing* series (discussed by Philip Bell in Chapter 3) but, significantly, lacks any sense of critique. There is no sense in which Cooper is attempting even a modest *verfremdungseffekt*, attempting to identify the absurdity in order to get his audience to question the relationship of art and value. Rather, Cooper's sketch suggests the indifference of the 'mass' audience identified by Baudrillard.[38] They get the joke and understand the absurdity involved but they don't care, they are indifferent enough to go along with the game.

In one sense, Cooper's joke may be understood to be at the expense of initiatives such as Sir Kenneth Clark's *Civilisation* series and book (both 1969) and the general BBC/public service broadcasting project of informing and enlightening the masses. However the joke is double edged. Its scepticism about the aesthetic aspect of art – or rather the possibility of knowledge about this being available to 'average citizens' – serves as an uncomfortable reminder for more earnest analysts[39] that popular television audiences respond more readily to the lampooning of art than to radical political critiques. More particularly, it suggests that the first response does not necessarily create fertile ground for the second. In many ways, one of the closest comparators to Cooper's approach in the 1990s has been that of the K Foundation,[40] pranksters from a more self-consciously avant-garde tradition. Their contribution to the history of popular comic deflation of the art establishment has been to invert the outcome of the annual Turner Prize by awarding a greater sum of money to

the artist they deem to be worst than that awarded to the official winner – a joke which both Cooper and Tony Hancock's protagonist in *The Rebel* would have wholeheartedly approved of.

In 1995 the K Foundation took the gesture one stage further and burnt a large sum of money in front of an invited group of journalists as an (intended) critique of the relation between art and value. Their stunt earned them an *Omnibus* documentary on BBC2, which duly inscribed them within the official space of TV art. For all the spectacularity of TV images of burning cash, the issue of money and the art market was brought home with a greater sense of ethical urgency in a programme on art fraud in the BBC-2 series *Despatches* in 1996. In a programme entitled 'Sotheby's Under Question', Peter Watson presented an expose of smuggling rings bringing Apulian vases from Italian burial sites to the London auction house Sotheby's. Felicity Nicholson, head of Sotheby's Antiquities department, summarised the company's philosophy with the declaration that: 'our business is to sell antiques... I am not there to make a judgement as to where they may have come from'. This aspect of the art and antiquities market was, of course, one which Sir Kenneth Clark chose to overlook entirely in his 1969 series *Civilisation*.

REPRESENTATION AND POSTMODERNISM

During the 1980s a number of critics identified a series of distinct stylistic developments in Western culture. Several diagnosed these as indicative of a major shift occasioned by the latest stage in the development of international capitalism. In anglophone culture at least, these developments were generally characterised as 'Postmodern'. The scope of this chapter does not permit any sustained exposition of the general principals of Postmodernism nor an analysis of its full range of implications for contemporary media practice[41]. It therefore confines itself to aspects of critical debates around Postmodernism most specifically relevant to media representations of visual art.

The moment of Postmodernism in Western culture is now often seen as one which has either waned (in terms of its affectivity) or which was never as momentous, let alone all-embracing, as its enthusiastic advocates once made out. However, Postmodernism remains an intriguing characterisation (if not global phenomenon) which is apposite for several of the analyses presented in

this anthology. Consideration of its operation can, for example, illuminate aspects of cultural production in evidence *prior* to the identification of its existence. One such aspect is the manner in which styles of media, and specifically film, have fed back into the realm of fine art, design and architectural practice. There are of course myriad subtleties and resonances to the eternal re-reflection and play of influences between the (visual) styles of film, television and video and the various styles of visual representation which occupy the same contemporary moment. Although there have been many arguments asserting the influential nature of certain styles of filmic images on individual painters[42], this relationship is perhaps nowhere so marked as in Morris Lapidus' Miami Beach hotel architecture. As Beverly Heisner has detailed,[43] the work of set designers such as Carl Jules Weyl (Busby Berkeley's collaborator at Warner Brothers) and the RKO designers Van Nest Polglase[44] and Carroll Clark proved formative influences on Lapidus' design for the public spaces in such ornate hotels as Miami's Fontainebleau and Eden Roc.

Lapidus' work on these buildings drew upon predominantly *illusory* filmic spaces to create actual architectural spaces that embodied aspects of the dynamic qualities of those (fictional) filmic spaces created through set design, camera work, lighting and editing (not to mention the additionally affective aspects of choreography and music) in the classic Hollywood musicals of the 1930s. There is much in this approach which prefigures the more general approach to the design of public spaces represented by architects working within the aesthetics of the Postmodern movement in architecture (which was the first discipline to use the term as a designation of an actual school of practice). As Lapidus once remarked:

> Busby Berkeley, more than anyone else had caught that kind of elegance
> and glamour that everyone yearned for. He created a dream world... If
> they had a group of dancers, they somehow were in spaces that were not
> the kind of spaces that people were accustomed to. They were curving,
> sweeping, undulating spaces... I decided to use these movie techniques.[45]

This characterisation prefigures the sort of concerns and striving for effect that Fredric Jameson noted in a more advanced form in the architecture of John Portman's Bonaventura Hotel in Los Angeles.[46] Discussing the hotel, Jameson has asserted that the new architectural spaces on offer are as different from the spaces of traditional modernist architecture 'as the velocities of space craft are to those of the automobile';[47] producing new and often disorientating

places which are significantly different from those people are accustomed to and which their inhabitants *necessarily* experience in a different way.

Several chapters in the volume address and/or critique aspects of cultural production which can be characterised as Postmodern. As Wyver, Roberts and Bode variously signal, in Chapters 2, 4 and 5 respectively, during the 1980s several of the stylistic modes associated with Postmodernism – and particularly that of *bricolage*[48] – appeared to offer media producers alternative ways of both constructing representation and formulating critical discourse. The style of documentary bricolage which developed in the mid-late 1980s sought to construct a form of text and textual address which interrogated its subject in a variety of ways, using different modes of address and/or forms of material. It did not attempt to produce unified (or even necessarily *coherent*) theses, but rather emphasised the diversity, tensions and contradictions of its referential text(s) and its own form and analyses. James Collins has characterised this as 'juxtaposition as interrogation', a form which he identifies as involving 'a careful, purposeful consideration of representational alternatives – rather than... simple pastiche or the "plundering" of history of art as though it were an attic filled with the artefacts of one's ancestor'.[49] As has argued, 'discursive juxtapositions do not [necessarily] result in the "emptying out" of all styles', but can 'form the basis of a productive engagement with antecedent and contemporary modes of organising experience'.[50]

Of the small number of media texts which have begun to explore this area in a productive fashion, it is perhaps the *State of the Art* series (discussed in Chapter 4) and Triple Vision's *Prisoners* which most convincingly illustrated the potential of the approach. *Prisoners* demonstrates how styles of analytical media *bricolage* can employ the incorporation, fragmentation and contextualisation of a key referent (in this case Ridley Scott's pastiche Orwellian 1984 Apple Mac computer commercial) and produce a text and textual strategy which transcends its formal precedents[51] and, as Bode discusses in Chapter 5, moves towards a deconstructive reading (in the Derridean sense). In Chapter 11, Lone Bertelsen also identifies Mark Stokes' documentary on Cindy Sherman, *Nobody's Here But Me*, as a succesful analytical text. Her discussion involves considerations of Postmodern style in photographic art and the contemporary politics of representation. In particular, she raises a number of questions about the abandonment of critical position and critique in Postmodern photography. Writing in the mid-1990s, she

identifies a profound critical 'edge' to Sherman's work. She characterises this as an engagement with the (deep-seated) aspects of phallocentric discourse identified by the theorists such as Luce Irigaray. She argues that Sherman (and Stokes' film) produce critical discourse, with particular regard to the representation of the female – and female body – *through* Postmodern style. In this regard, at least, Bertelsen sees aspects of Postmodernism as alive (and kicking).

As Roberts and Bode also argue however, there is a risk of various Postmodern representational practices undermining their referential address by virtue of their de-centred structure (and/or discourse); and a corollary danger of their textual surfaces coming to signify primarily as *themselves* rather than as representation. In addition to the above there was of course the problem of producing *any* form of representation within a cultural order which seemed increasingly marked by the production of styles and images which incorporated and/or pastiched their immediate antecedents as a matter of course (seeking no critical reading or recontextualisation other than simple effect on its own terms). As Bode's chapter outlines, the blank parody of pastiche often fails to provide even a skeletal discourse about its overt subject of representation, breaking down into a superficial play of surfaces and movements drained of any significance aside from that of style in itself (Joan Jonas' music video for Paul Simon's *Rene and Georgette [Magritte]* being a case in point). In a culture marked by this approach, there is obviously also a problem of readings. If audiences are principally attuned to the fascination of the free slide of signifiers, then simply borrowing this approach and transferring it to documentary runs the problem of being read against the grain (or rather on the surface).

In attempting to develop representational styles which require viewers to construct meaning out of a complex set of differently articulated discourses there is however the danger of all voice retreating from material, rendering it an aimless jumble of impressions and sources whose interactions merely produce an apparent 'meaning effect' at a superficial level. As John Roberts points out in Chapter 4:

> the use of a systematic inter-textual aesthetic as the basis for documentary work therefore has both advantages and disadvantages. On the one hand, it clearly offers an advance in the complexity and texture of argument over the profile of the lecture, but given the tendency of

anti-narrative structures to weaken causality, it can also reduce ideas to a heterogeneous soup.

Despite the claims of some critics and practitioners during the 1980s, Postmodern representational styles cannot in any sense be seen to have marked an advanced stage in any sort of evolutionary progress of representational forms and discourses towards ideally comprehensive or incisive modes of address or analysis. Rather, they can be seen as one aspect of a complex set of shifting textual strategies determined by, and reacting to, changes in broader cultural patterns.

END-OF-THE-CENTURY REPRESENTATION

The specific example of the influence of Hollywood set design on the architectural practice of Morris Lapidus, discussed in the previous section, gives us at least a partial indication of the degree of influence exerted by Hollywood Cinema during its heyday in the 1930s. The shift in power and influence towards television and home-video cassette play over the last four decades has not simply substituted one media form for another. In contemporary Western society, television operates on a different basis and different level of intensity. Whereas the cinema was (at its peak) a venue for leisure (a latterday 'pleasure dome') which privileged individual films as individual texts (and in the case of premieres and certain new releases textual *events*), the nature of the contemporary media order is such that we now have a culture increasingly *saturated* by a proliferating variety of media – the various forms of television (now including cable and satellite), video, home computers, CD-Roms, the Internet etc.

This development of the media, combined with the tendency in advanced monopoly capitalism for all visual art to be increasingly commodified as market product, has resulted in a complementary shift in the relation between the media (and particularly) television and art itself. The respectful distance which typified much media Arts programming during the 1950s-1970s is increasingly disappearing in favour of a more clearly exploitative approach which does not so much seek to *represent* art (or the artist) but rather *transform* it into television. Heretical as it might seem, we can draw parallels between television's coverage of sport and its approach to the arts. Television coverage

of sport has produced significant changes in aspects of sports, their rules, public perceptions and the attendance, expectations and behavioural patterns of its followers. Similarly, television, press and magazine coverage of the arts has increasingly tended to commodify artists and artworks; to produce models of practice for artists to confirm to; and to patronise those artists (from various fields) astute enough to conform to these tenets. Much contemporary work seems specifically *made to be represented.*

As John Walker discusses in Chapter 6, there has been a loss of direction, and even crisis, in British arts TV in the mid-1990s. This is not simply a local phenomenon. Perhaps befitting a culture which as been seduced – and arguably left abandoned – by the hot discourse of radical Postmodern theory, there is a plurality, a seemingly free overlap of various styles of media arts representation, most of which seem dis-engaged from any current thrust of artistic and/or political practice. In this regard it is significant to note that at the height of various stylistic engagements with Postmodernity in the late 1980s, American film-maker Philip Haas and British artist David Hockney made a film which deliberately identified with the early tradition of arts documentary production (described in Section I above) in order to ruminate on the present. The film was entitled *A Day on the Grand Canal with the Emperor of China, or, Surface is Illusion but so is depth.* The film examines three artworks through Hockney's narration. Two of these are Chinese scrolls, 'The Kangxi Emperor's Southern Inspection Tour', by Wang Hui and assistants (c1698) and 'The Qialong Emperor's Southern Inspection Tour', by Xu Yang (1770). The third is Canaletto's 'Plaza San Marco, Looking South and West' (1763). Aside from brief appearances by Hockney, images from these works comprise the sole visual material of the film.

In its earnest simplicity, the documentary initially appears to be a self-conscious homage to the early days of art film making. There are no computer graphics or special effects. The camera either presents us with Hockney, flatly and frontally, as he narrates (or, in one wonderfully back-to-basics sequence, [literally] 'chalks and talks') or else moves across the scrolls and canvases pausing lengthily on details. The film is a classic example of the category of arts film which Venturi described as marked by the 'close adherence to the original canvas and to the inner spirit and meaning of both the paintings and painter'.[52]

As Andrea Stratton characterised it, the film 'works beautifully without any fuss'.[53] The camera looks closely at the paintings, we follow as Hockney leads us

through them. Indeed, the film's narration introduces this as its preferred reading, claiming that: '[we] are going to make a *journey* down two Chinese scrolls and a Western painting with this scroll of film' (my emphasis). There seems no place for discourse in all this. We are told that we are simply moving through a series of picture-scapes. This is of course somewhat disingenuous. The discourse is that of Hockney's 'common-sense' art criticism and of the camera's careful surveillance of the works Hockney guides us through. Indeed, Hockney rapidly slips into philosophy – and even the mythic – by claiming that each of the film's art works and 'journeys':

> ...has a different attitude towards time and space and narrative. They seem to add up to even another journey that I think we are still making and we don't know where it will end and that may be the real subject of this film.

A Day on the Grand Canal... deliberately positions itself outside the stylistic, analytic and/or creative approaches Bode and Roberts discuss in their chapters. But while it specifies its address as historical, and therefore prior to the historical moment of Postmodernity, many of its concerns are shared by more self-consciously contemporary films. In its discussion of different concepts of time and space, its discussion of the difference (and/or 'superiority') of Oriental art and culture, and its intimation of a crisis in Western modes of representation; it resembles Chris Marker's epic meditation *Sunless*. By virtue of its folding of four decades of arts film production into a simple but ingenious film essay, *A Day on the Grand Canal...* , made in 1988, summarises the histories sketched in this Introduction, and the chapters that follow, and introduces us to the pluralist 1990s.

Hockney and Maas's film was completed shortly after the publication of the first edition of *Picture This*. In the nine years between writing the Introduction to the first version of this volume and the production of this second edition, several new media phenomena have emerged. Along with CD-Rom and the still-emerging form of virtual reality, the most significant of these has been the Internet. At time of writing – January 1998 – there has been a veritable explosion of articles, magazines, books, theses, TV and radio programmes etc addressed to the nature, operation and potential of the Internet. Indeed the discourse is blossoming so thick and fast that it offers a fertile ground for analysis in its own right. Similarly, albeit in more modest proportions, there has been a profusion of artists' sites on the Internet. There are now virtual galleries,

artists' home-pages and a range of other locations being constructed. These are relatively cheap to establish and do not require the specific sanction, commission or funding necessary for film production or broadcast. As with a variety of other uses of the Internet, the old gatekeepers are becoming redundant as the walls come down.

This anthology, even in its revised second edition, has not attempted to survey this rapidly evolving terrain of possibilities. There are many facets to the interaction – and/or reconfiguration – of visual arts practices on the Internet, or through CD-Roms, virtual reality systems etc. These merit careful, detailed study in their own right rather than any tokenistic tacking-on to a critical project such as this (and are indeed are beginning to receive such attention in the pages of new media journals such as *Convergence - The Journal of Research into New Media Technologies*). Whatever the different contexts, signifying practices and/or levels of interactivity involved however, they are likely to be informed by the same melange of cultural values and preoccupations which the various contributions to this volume have identified as at work in the (traditional) media's representation of visual arts. In this way, this anthology offers analyses that can be taken up by subsequent studies of the new media, since while technology can – and demonstrably does – develop rapidly, concepts of art and creative expression show a surprising resilience and resistance to change.

NOTES

1 Francis Koval, 'Interview with Emmer', *Sight and Sound*, vol 19 no 9, January 1951, p 354.
2 Lotte Eisner, 'The Painter Reveron', *Sight and Sound*, vol 25, no 2, Autumn 1955, p 105.
3 *ibid*, p 106.
4 *ibid*.
5 Lauro Venturi, 'Films on Art: An attempt at Classification', *Quarterly of Film, Radio and TV* Summer 1953, p 389.
6 *ibid*.
7 *ibid*, p 386.
8 *ibid*, p 387.
9 *ibid*, p 389.
10 *ibid*, p 390.
11 *ibid*, p 386.
12 *ibid*, p 385.
13 Jean Queval, 'Film and Fine Arts', *Sight and Sound*, February 1950, p 35.

14 Rene Micha, cited in Gavin Lambert's (untitled) review of *Films on Art: A Specialised Study, an International Catalogue* (Paris, UNESCO, 1949), *Sight and Sound*, March 1950, p 41.

15 Walter Benjamin, 'The Work of Art in the Age of Mechanical Reproduction' in his *Illuminations*, London, Jonathan Cape, 1970.

16 John Berger et al, *Ways of Seeing*, Harmonsworth, Penguin, 1972 and *Ways of Seeing*, a series made by BBC Television in collaboration with Mike Dibb.

17 Eisner, *op. cit.*

18 Patrick Hayman, 'Art films by John Read', *Sight and Sound*, vol 26 no 4, Spring 1957, pp. 217-218.

19 With the significant exception of the *State of the Art* series which filmed the sculptor Anthony Gormley in the act of producing.

20 A series of six programmes broadcast on BBC2 during May–June 1987, featuring Jennifer Bartlett, Richard Hamilton, Howard Hodgkin, David Hockney, Sidney Nolan and Larry Rivers – see Henry Fenwick and David Hockney (interview), 'Paint Box of Tricks' in *Radio Times*, May 2-8, 1987, pp. 82-84.

21 *Untitled*, Matta, France, 1986 (originally broadcast on Canal Plus).

22 Walter Benjamin, op. cit.

23 Jacques Derrida, op. cit.

24 See Peter Fuller, 'Jackson Pollock' in *New Society*, April 26th 1979 (also included in Peter Fuller *Beyond the Crisis in Art*, London, Writers and Readers, 1980).

25 See for instance, Eva Cockcroft, 'Abstract Expressionism, Weapon of the Cold War', *Artforum*, June 1974; and Serge Guilbaut, *How New York Stole the Idea of Modern Art*, Chicago, University of Chicago Press, 1983.

26 On the occasion of the Tate Gallery purchasing Carl Andre's brick sculpture 'Equivalent VIII' in 1976.

27 David Mark's 'Polaris', constructed out of 3,300 car tyres, being exhibited on the South Bank in 1983.

28 Damien Hirst exhibited a work entitled 'Some Comfort Gained', comprising two dead cows preserved in formaldehyde, at the White Cube Gallery in London in 1995.

29 Rozsika Parker, *The Subversive Stitch*, London, Women's Press, 1984.

30 Griselda Pollock and Rozsika Parker, *Old Mistresses*, London, Routledge and Kegan Paul, 1981.

31 See Sylvia Paskin's interview with Newson, 'Art and Images of Women', in Philip Hayward (ed) *Picture This* (first edition), London: John Libbey, 1988, pp 161-166.

32 A tendency especially prominent in early Western European Modernist painting, where a succession of 'primitive' styles such as Japanese Art, Breton peasant art, African masks and Islamic design, etc., influenced the painting styles of artists such as Van Gogh, Gauguin, Picasso, Matisse, etc.

33 *Viewpoint '87 – Art of Darkness*, written and presented by David Dabydeeen, directed by David Moloney, Central Television, 1987.

34 See Philip Hayward, 'A New Tradition', *Perfect Beat* vol 2 no 2 January, 1995.

35 See Philip Hayward, 'Safe, Exotic and Somewhere Else' and Lisa Nicol 'Custom, Culture and Collaboration' (both) in *Perfect Beat* vol 1 no 2, January 1993 for further discussion.

36 See Steven Muecke, 'Yolngu Culture in the Age of MTV' *Independent Media*, no 92, October 1990.

37 Transcription taken from the sketch compilation and tribute programme *Tommy Cooper*, broadcast on Thames TV in 1987.

38 See Jean Baudrillard, *In the Shadow of the Silent Majorities*, New York, Semiotext(e), 1983.

39 Such as John Berger, in the 1972 TV series *Ways of Seeing* (discussed in Chapter Two) or Geoff Dunlop, Sandy Nairne and John Wyver, in the 1987 series *State of the Art* (discussed in Chapter Three).

40 The duo of James Cauty and William Drummond, who formerly established themselves as musicians with a series of idiosyncratic and commercially successful combos including the JAMMs (Justified Ancients of Mu Mu), The KLF (the Kopyright [and/or Kylie] Liberation Front) and The Timelords.

41 For further discussion of the general concept of Postmodernism see Fredric Jameson 'Postmodernism, or the Cultural Logic of Late Capitalism' in *New Left Review*, no 146, July-August 1984; for further discussion of the relation between Postmodernism and media practice see *Screen*, vol 28 no 2, Spring 1987 (Postmodernism issue).

42 See for instance Erika Doss, 'Edward Hopper, Nighthawks and Film Noir', *Postscript*, vol 2 no 2 Winter 1983.

43 Beverly Heisner, 'Movie Scenery and Popular Architecture: Morris Lapidus' Miami Beach Hotels', *Postscript*, vol 1 no 1, Fall 1981.

44 Who originally trained as an architect himself, working on designs for the presidential palace in Cuba during World War One before joining Famous Players-Lasky in 1919.

45 Morris Lapidus, as cited in Beverly Heisner, *op cit*

46 Fredric Jameson, *op cit* pp. 80-84.

47 *ibid*, p. 84.

48 A textual style which, in Jameson's phrase 'proceeds by differentiation rather than by unification' – Fredric Jameson, 'Postmodernism or the Cultural Logic of Late Capitalism', *op cit* p 75.

49 James Collins, *Uncommon Cultures: Popular Culture and Postmodernism*, New York, Routledge, 1989 p 140.

50 *ibid*.

51 Such as Joseph Cornell's *Rose Hobart* (USA, 1937), which reworks sequences from George Melrose's *East of Borneo* (USA), 1931) to produce a form of collage whose effect is similar to that practice Andre Breton termed 'synthetic criticism' (Also see J. Hobermans', 'Joseph Cornell', *American Film*, vol 5 no 4, January-February, 1980.

52 Venturi *op cit* p 389.

53 In her on-screen introduction to the film for its screening on the Australian channel SBS TV's *Masterpiece* series in April 1996.

2
Representing Art or Reproducing Culture?
Tradition and Innovation in British television's
coverage of the Arts from the 1950s-1980s

John Wyver

In the early years of British television, the medium's relationship with 'the arts'
was almost exclusively defined by the relay. An overwhelming majority of
programmes were (and to a lesser extent still are) live or recorded
transmissions of events from a television studio or from an outside broadcast
location. The intent is to 'bring the world into the viewer's home'. Consider for
example, the early months of 1949 when the BBC was providing a single
television service for an hour in the afternoons and then from just 8.30pm to
10.15pm. Searching the schedule for signs of 'the arts' it is evident that
Monday evenings frequently offered a prestigious ballet, and a number of
concerts and recitals were dotted around the schedule. There were occasional
screenings of purchased documentaries about painters, and even less frequent
lectures from a television studio about such subjects as 'The Eye of the Artist'.
There were also three major dramas each week, many of them light comedies
but with the classics strongly represented. Excluding the purchased films, all of
these programmes, whatever their other characteristics, were essentially live
transmissions. Such relays (of drama, music, dance, and discussion), are then
the foundation stones of television's relationship with the arts (and of its
relationship with most other areas of its concern).

The technology today is far more sophisticated, and the use of recordings and
editing mean that the approach and coverage can be a good deal more subtle
and responsive, but programmes which are essentially relays remain central
today. Triumphant examples have included a version of Trevor Nunn's intimate
and claustrophobic production of *Macbeth*, Patrice Chereau's production of *The
Ring from Bayreuth* and, just as spectacular and involving, the 1985 Live Aid
broadcast.

Complementing the medium's relays are the three distinctive forms of television *about* the arts, the forms which television has developed to understand and communicate the experience of culture. These forms, which can most conveniently be characterized as the profile, the biography and the lecture, are the central strands to the tradition as it presents itself to contemporary programme makers. Each has been enormously valuable for the discussion and appreciation of the arts, but each has been restricting. For the three forms share certain fundamental features which can offer only a narrow and limited range of understandings of culture. And combined with the dominant assumptions about culture within British thought, they have, for all the delights and insights offered, created a tradition which is in significant ways an impoverished one.

The history of the arts profile on British television begins in 1951, when in the first British film documentary made especially for the still nascent medium, John Read directed a study of Henry Moore. Painters and sculptors had appeared on screen before this and Read himself had directed a live broadcast built around photographs of the Elgin Marbles. But the Moore programme was the first full length arts film and may be regarded as the originator of the genre. As might be expected from the son of the eminent critic Herbert Read, this important director's area of interest was, and remains to this day, the visual arts; and through the 1950s he developed and refined the profile with films about the major British artists of the time: Graham Sutherland, Stanley Spencer, John Piper and L S Lowry. The fundamental importance of this work is that it initiated British television's creative interpretation of the arts.

In 1958 the BBC acknowledged Read's achievement by re-screening all of his films to date. That same year the Corporation started the fortnightly magazine series *Monitor*, edited and presented by the late Huw Wheldon. Within the selection of items in each edition there was frequently a profile, either by Read or by film-makers like Peter Newington who were indebted to Read's work; and numerous programmes today, across Britain's television networks, retain the impress of these early films. The characteristics of this form are now commonplace: a concentration on one figure, who is interviewed and shown in the act of creation. There is a stress on autobiography and a reliance on introspection; as is suggested by the title of Read's early series *The Artist Speaks*, the interpretation of the work is mainly that offered by the creator. Such films endeavour to approximate on the small screen a sense of the

emotional impact of the work – they are concerned above all to communicate the *feeling* of the work, whether this is a poem, a picture, a musical composition or a novel, and in this, the best of them are surprisingly successful.

This concern to reproduce, or at least to approximate, what is thought to be the aesthetic force of a work has been carried over into the closely related forms which have developed from the classical profile of an individual. The most profitable of these has been the process film, where a new drama, opera or dance is followed from rehearsal to reception. Attention is invariably focused on the production's theatrical impact, and is rarely devoted to, say, finding a historical perspective on the work or understanding the financing and investment decisions made by the producers. Obviously the profile form was not an invention of television; it was an important element in journalism and more considered criticism, and of course, in radio. And as is suggested by the title 'Talks Department', where Read made all his early films, radio was a crucial influence on the early years of television in Britain. Aspects of the younger medium were carefully modelled on radio, but it had the wonderful additional capacity of showing an artist at work, and from the beginning Read and others were as quick to exploit this as their initially cumbersome equipment would allow.

John Read recognizes the influences of the British documentary tradition of John Grierson (under whom as a junior assistant he began his career) and Robert Flaherty (who just before his death in 1951 had begun work on a film about Picasso's 'Guernica') on his film making. This tradition stressed, in Grierson's words 'the creative treatment of actuality'[1] and directors like Paul Rotha and Ralph Bond, as well as Flaherty himself, were very much occupied with the poetry of film language. From Grierson too, Read drew a recognition of the importance of narrative; the documentarists of the 1930s having honed the technique of narrative accounts of social processes in films like *Drifters*, *Night Mail* and *Aero Engine*.

Narrative was also a fundamental element in a further group of influential films about painting: a series of Italian documentaries begun in 1940 by Luciano Emmer and Robert Vlad. In Read's words each one was 'a piece of dramatic story telling... from the paintings of Giotto, Carpaccio, Jan Eyck and Bosch... the visuals were largely details from a number of different paintings by the same artist, rearranged to suit the conventions of narrative'.[2] These films were the forebears of certain crucial elements in British television's framework

for the arts: a focus on the individual (with a complementary stress on autobiography and introspection); a desire to suggest and interpret the emotion and poetry of a work and its creation (with a consequent preference for feeling over analysis) and a reliance on linear narrative.

Monitor, the first regular magazine series about the arts, embraced the profile form with enthusiasm and broadened the range of subjects on whom it was imposed; the writer Shelagh Delaney, impresario Rudolph Bing, actress Katina Paxinou and the composers Gian Carlo Menotti, Peter Maxwell Davies and Dudley Moore, as well as many others. Huw Wheldon's enthusiastic and engaging manner, his brilliance as an editor and his support for the best young film-makers around (Ken Russell, John Schlesinger) quickly established the series within the BBC schedule. At first a fifty minute programme could include Peter Brook considering *musique concrète* with an extract of his production of *The Tempest*, a short film by Schlesinger about a circus, an interview with Kingsley Amis, Joseph Cooper at the piano, a view of Epstein's sculpture and a report on *Cat on a Hot Tin Roof* (which was in fact the rather indigestible menu for programme one); but soon the series settled down to presenting studio links and two films (and occasionally only a single work) each fortnight. *Monitor's* subsequent influence can hardly be overestimated. It stimulated and served the growing interest in culture amongst the British middle classes and it coincided with the blossoming of the distinctive post-war voices within the arts in Britain. John Osborne, Arnold Wesker, Harold Pinter and others were enriching the theatre, Lindsay Anderson, Karel Reisz and Tony Richardson were transforming the cinema and British Pop was set to emerge from art school. *Monitor* responded to these initiatives, mediating the new, and the unfamiliar elements of the old, for an increasingly curious and engaged audience. Inevitably then, *Monitor* set the mould for the arts magazine series, which was soon to be copied by Independent Television (ITV), and which has been more or less successfully emulated ever since.

As a national network of regional companies financed by advertising, ITV had appeared as a second television channel in 1955. Slow initial growth was followed within two years by an unprecedented boom in audiences and revenue, since the companies were presenting almost exclusively home-grown entertainment and comedy alongside bought-in thrillers and westerns from the United States. The culmination of growing criticism came in 1962 when ITV was rapped over the knuckles by the Government's Pilkington Committee and

was instructed to act more responsibly towards the audience. Tempo was one response to such feeling and started as a rival to *Monitor* in 1961. Edited at first by Kenneth Tynan, *Tempo* produced a number of distinguished programmes, but despite running until 1968, failed to establish a solid identity or reputation. Since then ITV has developed the form with *Aquarius* (1972-77) and with the highly successful *The South Bank Show*, edited and presented since it began by Melvyn Bragg.

As well as artist's profiles, and a certain amount of straightforward studio based arts journalism, *Monitor* made its own significant contribution to the two other forms of arts programming: the lecture and the dramatized biography. As with the profile, the illustrated lecture remains a resilient form. Like the profile, it too had obvious precedents in radio, but again television was a great improvement in that it could show the work being discussed. (We should however note the intriguing transitional form known as Radiovision,

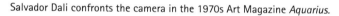

Salvador Dali confronts the camera in the 1970s Art Magazine *Aquarius*.

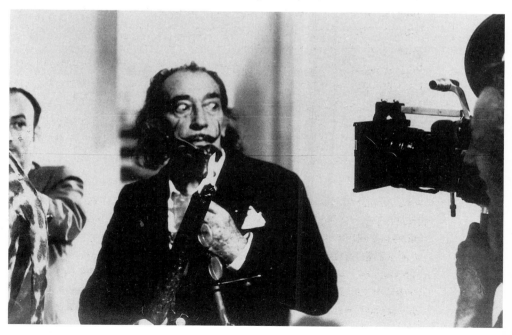

where the listener purchased slides of paintings to be discussed on the radio at a later date and viewed or projected these during the broadcast). At first the television lecture was based in the studio to which paintings, reproductions, or in the popular variant known as 'master-classes', music students would be brought for consideration.

Monitor nurtured the lecture form and introduced intellectuals from a less restricted range of disciplines and beliefs, but television lectures reached an apogee with *Civilisation* in 1968. Since then, the 'personal view' documentary blockbuster has become one of the staples of prestige television and has been a major force in arts television. Its distinctive features – a presenter (usually a man) popping up in situ around the world, a chronological over-view of the area of knowledge, a glossy spin-off book for the coffee-table – are now as familiar as those of its best known personalities. Since Clark gave us *Civilisation*, Bronowski has offered *The Ascent of Man*, Ronald Harwood has covered the theatre in *All the World's a Stage*, Dame Margot Fonteyn has looked at *The Magic of Dance*, Robert Hughes has given us an up-date on the visual arts *(Shock of the New)* and John Roberts tracked *The Triumph of the West*.

To a considerable degree, *Civilisation* and most of its siblings share the critical approaches of the film profile: a focus on individuals, a stress on feeling (hence the dramatic lighting and expressive camera movement, supplemented by music) and a narrative account (the story of Western Civilisation from the Dark Ages to the light of Impressionism); but they also depend on a fourth critical element, a positivist conception of knowledge. For Clark and most of his followers, the acquisition of knowledge is dependent on direct experience of a place or canvas or a fresco. From this intuition derives the familiar filmic device of showing the narrator in the Pazzi Chapel, on the stage of La Scala, or by the banks of the Avon. Such involvement, it is implied, gives him, and by extension you the viewer, direct access to a 'truth' about the Renaissance, or Verdi, or Elizabethan Theatre. And so the words of the narrator or lecturer, and (usually) his thesis are validated in the most convincing way possible. Such a style has numerous antecedents, but clearly draws on eighteenth century notions of enlightenment through undertaking 'the Grand Tour' and, later, on the Victorian middle-class version of this in both organised tourism and 'magic lantern' slide shows. At the same time, the employment of empiricism is directly in line with the traditions of education in Britain from the same period onwards.

The intellectual approach was invariably from the populist ends of academic disciplines. In the visual arts, this meant Kenneth Clark. And with him and his peers came attitudes which blended a stress on the over-riding importance of 'High Art' and its seriousness with broad strokes of elitism. As Lord Clark disingenuously writes of his appearances on ITV in the 1950s and early 1960s:

> I stubbornly continued to do programmes on general topics, and some of them were quite amusing. I remember one called 'What is good taste?' in which I had constructed a bad-taste room and a good-taste room. The bad-taste room contained almost everything that was then to be found in the average home, a flight of china birds and a carpet from the Co-op.[3]

'Gradually,' he continues, 'it became clear to me that what people wanted was to know about individual artists'.[4] And so the lecture form similarly narrowed its subject matter to reinforce the picture of the visual arts presented by film profiles.

As the use of films became more widespread, the lecture form became more mobile. From May 1966 on BBC2 there was a series of short films called *Canvas*, which featured a critic or artist reflecting on a painting of her or his choice, shot in the gallery or church where the work was hung. Over a decade later *One Hundred Great Paintings* was working with precisely the same idea, and – although quite different in many other respects – as far as form went, so were the Open University 'Modern Art and Modernism' course TV programmes. The thesis of such programmes may be offered as a 'personal view', but it is invariably within the mainstream of thought. Kenneth Clark was invited to make *Civilisation*, not John Berger, who had to be content with a far less lavish riposte three years later in *Ways of Seeing*. Further, knowledge for Kenneth Clark is not only dependent on experience, but is 'natural', a matter simply of visiting enough places. As the press release for *Civilisation* boasted, 'Eleven countries and 117 locations visited. Works in 118 museums and 18 libraries shown'. If you too had gone to all these places, such a claim implies, then you too would have come to precisely the same conclusions as Lord Clark. Knowledge in this system, then, is not problematic. There is little room for complexity and contradiction, and knowledge is certainly not seen as a construction, produced within and according to the tenets of particular political or social or ideological frameworks. Robert Hughes in *Shock of the New* nodded towards an awareness of this understanding, and the Open University's 'Modern Art and Modernism' course programmes embrace it fully, but only Berger has managed to build it into the basis of a mass-audience series.

As might be expected, the basic attitudes of television in its relationship with the arts are those shared by much of the mainstream of our culture. At heart they are the legacies of nineteenth century Romanticism. The catalogue which follows is tinged with caricature, but only to the extent necessary to reveal as contentious, ideas which are otherwise taken as 'natural' or obvious. Art, for television, is what artists make – a comment not as tautologous as it may first appear. For art on television is above all about people; individuals who are special, skilful, gifted, perhaps inspired. Most of them work on their own, creating, in whatever medium, for the pleasure, edification and enlightenment

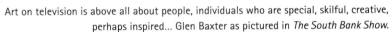

Art on television is above all about people, individuals who are special, skilful, creative, perhaps inspired... Glen Baxter as pictured in *The South Bank Show.*

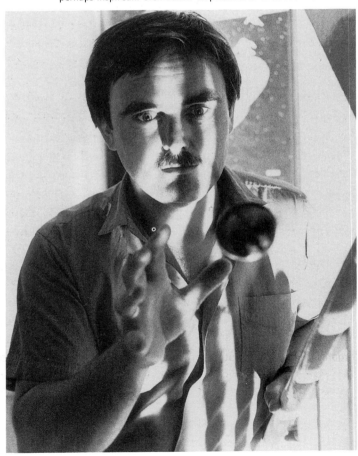

of us all – as long, that is, as we share a particular sense of ideas and values, which is invariably assumed and rarely made explicit.

Artists usually have a 'vision' or 'something to say' (at least if they are any good) and individually use their chosen medium to express that. These messages (at least from the best of them) are about ultimate or eternal truths, insights into the human condition. Politics and economics, history, or the specific national or social circumstances of the present, may be important for an artist, but (within traditional fine art practice) he or she is attempting to transcend them, reaching beyond them into something more important.

Who are these people, these artists? Mostly they inhabit the mainstream of our culture, or rather, the particular culture dominated by the Euro-American tradition and given form in Britain by the Sunday reviews, Radio 3, the Arts Council, the Royal Opera and Royal Ballet, major galleries like the Tate and the Hayward and theatre companies such as the RSC (Royal Shakespeare Company) and the National. If they are not generally accepted as part of the cultural pantheon of the past, then they are important because they are treated seriously by the Sunday reviews, Radio 3 and the Arts Council. Broadly they conform to certain patterns, work within identifiable traditions. But beyond the choice of all of them is a notion, an elitist hierarchical notion, of excellence. They are already recognised and television rarely takes a risk in the art and artists with which it deals.

Those favoured are mostly the denizens of an 'official' mainstream culture (one of the less distinguished would-be inheritors of the *Monitor* mantle was actually called *Mainstream*). It is a culture which believes before all else in the morally educative value of art. Television is certain that art is 'Good for You'; a deep seated notion carried over from the Reithian principles on which radio, and later television, were founded. Prior to the establishment in 1927 of the British Broadcasting Corporation, John Reith had been general manager of the British Broadcasting Company, a cartel of radio manufacturers. Secure as the first Director General of the new corporation, Reith underpinned his new organisation with a notion of public service which has remained the most potent force in British broadcasting to this day. That this idea was central from the beginning can be seen in the words of the Royal Charter which noted:

> ...the widespread interest ...which is shown to be taken by Our Peoples in
> the broadcasting services and of the great value of such services as a
> means of disseminating information, education and entertainment.5

There is no doubt that for Reith, informing and educating the public were more urgent tasks than entertaining them, and the BBC interpreted these ideals in a paternalistic framework, strong traces of which remain to this day. Culture, moreover, was to be one of the prime forces in the informing and educating of the people.

An equally significant contribution to the understanding of the arts and culture within British life as a whole, and particularly within British broadcasting, was made by the Cambridge academic F R Leavis. Leavis' influence on education has been wide and deep, and rather more contradictory than is often allowed. For this argument it is important to note his sense that serious literature's highest aspiration is to explore life with a moral seriousness and thus to enrich it. The consequent moral education of the reader is his or her only hope of resisting the technological society which is constantly threatening to swamp civilisation. The continuing force of these ideas are clear in this recent credo by John Read (from an interview in the magazine *Antique Collector*):

> the basic reasons for (making art programmes) is simply that you've
> got to stand up for the imaginative world, the imaginative element in
> the human personality, because I think that's constantly threatened. It's
> a very materialistic society; it's an increasingly technological society,
> or economic society; and there are other values – people do have
> imagination and sensibilities, and I think that does need constant
> exposition.6

It is a Leavisite credo with which almost no one in British arts television would disagree.

It must be recognized that these principles, the programme makers who have worked with them, and the programme forms which they have developed, have jointly created a strong and enduring tradition which has been one of television's most significant contributions to enriching the lives of people in Britain over the past thirty years. It should also be recognized (although it rather more rarely is) that this tradition has been restrictive and exclusive. By and large, any cultural element on the cutting edge of what was once called the avant garde has been consistently ignored. So has cultural experience from

outside the Euro-American tradition, despite Britain's slow and painful, yet fundamental development into a multi-racial and multi-cultural society. So too has much cultural experience not immediately recognized as 'art', in craft-based practices, in community work, and in popular culture. At the same time the medium has been stubbornly unwilling to relax traditional criteria of evaluation and to allow art to create its own world, its own rules, and its own appropriate basis for judgement. And the predominant frameworks have frequently prevented elucidation of historical, social and political context, and have lead television to ignore other approaches which can be constructive in

Ken Russell, the innovator of the artist's biography.

understanding and appreciating cultural experience. So that, for example, television has rarely examined ways in which art is presented, distributed, exhibited and criticised.

Perhaps surprisingly this has not always been the case with some of the most distinguished work in the third dominant television form: the dramatised biography. The key work in this history is a film not about a visual artist, but a musician: Ken Russell's *Elgar*, first shown in 1962. Actors were used to portray a creative individual for the first time in an 'arts documentary', but such were the constraints on the form at that time, they were not permitted to speak. The success of the film – which put forward a traditionally Romantic evocation of an artist – was such that Russell was able to develop the form rapidly, and he subsequently made two television films about visual artists: *Always on a Sunday* (the story of Henri Rousseau, co-scripted by Melvyn Bragg, and first screened in 1965) and *Dante's Inferno* (about Rossetti, first screened in 1967). The Rousseau film is a delightful portrait of a 'misunderstood' and neglected artist, but is straightforward and rather one dimensional. *Dante's Inferno* is however far more ambitious and complex, offering ambiguous and occasionally contradictory reactions to the painter. Many of the meanings and ideas on offer are carried in the images and in the juxtapositions. Nonetheless the final effect is a portrait of the artist as a guilt-ridden and tormented genius. Which remains the dominant representation in television drama documentaries, right through to the portrait of Mark Rothko in the BBC's reconstruction of the court-case which followed his suicide (*The Rothko Conspiracy*, first screened in 1983).

In this respect, television was foreshadowed by the commercial cinema (and numerous nineteenth century biographies). Visual artists from Rembrandt (played by Charles Laughton in Korda's eponymous 1936 film) through to Van Gogh (played by Kirk Douglas in *Lust for Life*, 1956) and Michelangelo (played by Charlton Heston in *The Agony and the Ecstasy*, 1965), were presented in this way. Television has offered few challenges to this image, and has retained the focus on an individual and on a strong narrative. Yet some of the medium's most interesting engagements with the visual arts have been in this form. Lesley Megahey's films, for example about Gauguin (1976) and the minor Dutch painter Schalken (1979), both use the technique of reconstructing scenes from canvas on film, but place these sequences within richly suggestive approaches to the artists. In Megahey's film on Gauguin (which avoids any representation of the artist himself), this involves showing the building of the

South Sea island sets on the sound stage where the film was shot, so suggesting a parallel between the painter's mythical construction of the lives of noble savages and television's equally mythical construction of the life of the artist. By contrast, *Schalken the Painter* adopts a very different approach. Scripted as a Gothic horror story, with every frame conjuring up seventeenth century Dutch genre paintings, the conjunction of these two sets of conventions proves not only entertaining but also questions the underlying ideas which we use to approach paintings of this type.

This trilogy of the profile, the lecture and dramatised biography retains its dominance today, as do the organising principals which each element utilises: narrative, individuals, feeling rather than analysis, and a positivist concept of knowledge. These principals are complemented by a set of assumptions about the value and worth of 'the arts', assumptions which also issue from specific history.

The writing of this chapter to this point has attempted to retain elements of a neutrally descriptive tone. The intent has not been to be negative or dismissive. For although the representations of the visual arts on television have been highly restricted, many valuable, informative and enlightening programmes have been made. But the traditions have been so strong that they have virtually excluded, or totally marginalised both significant areas of the visual arts and important approaches to them. Such approaches come from 'alternative' critical positions (alternative to television's mainstream that is) and – when they have been realised – have often drawn on different traditions of documentary.

One such alternative tradition could be identified as springing from the work of Humphrey Jennings. Although Jennings (who died in 1951) was close to the group of Grierson-inspired sponsored film-makers of the Thirties and Forties, his work has always been seen as distinct. In films like *Listen to Britain* and *Diary for Timothy*, he developed a highly personal, poetic style, largely free from commentary and dependent on the juxtaposition of images and, crucially, sounds[7]. His mosaic-like films are not narratives, but painstakingly edited sequences of precisely framed shots. In television, and in the area of the visual arts, this style has been explored by director Geoffrey Haydon, whose (eponymous) films include studies of Roy Lichtenstein and Ed Ruscha (both in the BBC's 1979 series *Seven Artists*) and an *Arena* programme on the ruralist David Inshaw. Although centred on single painters, none of these is a conventional profile, and each is more an immaculately crafted meditation

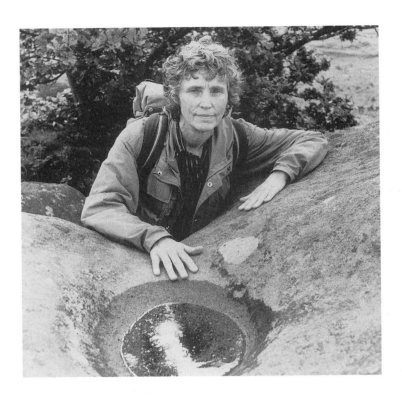

Fay Godwin and Roald Dahl as represented on *The South Bank Show* – denizens of an official culture?

with pictures and sounds from locations as varied as a Californian townscape (Ruscha) or the English countryside (Inshaw).

A quite different alternative tradition of film-making was initiated with the analytical investigations *Housing Problems* and *Children at School* in the Thirties. These studies employed location filming, interviews, reconstructions and graphics to highlight the social inadequacies of the time. Their influence is now seen in numerous current affairs programmes, but their methods are only occasionally employed in programmes about the visual arts. Holding fast to its preference for feeling over analysis, television rarely looks at the institutions of the art world, at the ways painting and sculpture are written about, bought and sold, commissioned and exhibited. There are exceptions: a 1966 documentary *The Art Market* and two excellent films for *Omnibus* in 1977 directed by Julia Cave, titled *For Love or Money*; but few other directors have attempted to scrutinise the circulation of art works with the analytical methods of journalism. And it is also curious to note that two other programmes on related subjects, *The Rothko Conspiracy* and Peter Watson's similarly named, elaborately disguised, entry into art crime, *The Caravaggio Conspiracy* (1984) drew heavily on conventions from other genres, the courtroom drama and the detective film.

A third documentary alternative is less cohesive but can be seen to have grown out of a radical investigation of the fundamentals of film and the cinema during the Seventies. This truly independent work is difficult to characterise briefly but could be held to embrace films as different as *Nightcleaners* and *Riddles of the Sphinx* and the structural explorations of Peter Gidal and Malcolm LeGrice, (none of which could be regarded in any way as 'conventional' documentary). Such work was introduced to television in Channel Four's *Eleventh Hour* slot and has informed the making of several of the Arts Council's films about the visual arts, including Peter Wollen and Laura Mulvey's *Frida Kahlo and Tina Modotti*, James Scott's *Chance, History, Art* and Stephen Dwoskin's *Shadows from Light* about photographer Bill Brandt (which Channel Four screened in a prime time slot).

Alternatives to television's dominant presentation of the visual arts have also been achieved by programme makers working within common forms, but inflecting them with (for television) unexpected critical approaches. Mike Dibb's profile of the painter Robert Natkin made with the collaboration of art critic Peter Fuller (*Somewhere Over the Rainbow*, 1981) remains one of the best examples. Shifting frames of reference (psychoanalysis, fantasy, the painter's

relationship with the market) are employed to present a stimulating study of Natkin quite different from what could almost certainly have resulted had he been the subject of a profile on *The South Bank Show*. In a similar way Gina Newson's film with Marina Warner, *The Making of Joan of Arc* (1983), took television's traditional lecture format, but cut across its conventions by attending closely to the relationship between changing representations of the 'Maid of Orleans' and the cultures which had thrown each of them up.

One further influential alternative was not nurtured (like many of the above) by Channel Four, but rather by the BBC's *Arena* strand, formerly edited by Alan Yentob. Since 1978, *Arena* has made a number of exuberant cultural celebrations modelled on Nigel Finch's *My Way*. This parcelled together in a knowing, funny mix, twenty or so film and video versions of the song. The clashes of styles and apparent formlessness created a pattern which *Arena* has developed in *The Private Life of the Ford Cortina*, *It's All True*, *Chelsea Hotel*, *Ligmalion* and others. These are all highly structured, even if presented as naïve, collages centred around a theme or object, and they often employ music and quirky humour to create enjoyable and popular programmes.

The importance of these programmes lies in the way in which they break with television's usual forms of dealing with the arts and with the medium's dominant form of vision. Considered with an awareness of the tradition sketched above, they can be seen to dispense (by and large) with narrative; they are not centred on individuals nor are they dependent on a positivist conception of knowledge – subjectivity and shifting frames of reference are fundamental to their form. Though their analytical content is minimal, they are also significant for challenging the notion of the relay, the concept of television as a 'window on the world'.

As Stephen Heath and Gillian Skirrow emphasized in their influential analysis of a 1977 *World in Action* programme (originally published in the journal *Screen*),[8] the concept of the relay is a key one for television not just as an approach to production (ie the 'actual' live coverage of an event) but also as a 'term of its exploited imaginary, the generalized fantasy' which 'is then taken for the ground reality of television and its programmes'.[9] This 'generalized fantasy' is then part of an ideology (of television) which is self-nourishing and presents itself as unproblematic, even 'natural'; as Heath and Skirrow stress: 'The empirical rule of the dominance of the picture is a rationalization of the ideology of the document, the window on the world'.[10]

Though the above-mentioned *Arena* programmes make no challenge to the relay model within each individual brief segment, their mixing of forms and strategies (including fictional models) is undoubtedly a resistance to the media's dominant form of vision. Martin Jay has suggested that one (perhaps *the*) feature of postmodernism is its challenge to the primacy of vision, and while the value of the label is debatable, it is the parallels with his arguments which prompt consideration of these *Arena* programmes as examples of postmodern television. Moreover, they share certain features of what is regarded as characteristic of postmodernism in the visual arts as a whole, including the appropriation of imagery, the borrowing of the surfaces of historical styles and the breakdown of distinctions between 'High Art' and mass culture.

If it is useful to think of the *Arena* programmes under discussion as postmodern, they should be recognized as exemplars of symptomatic postmodernism. That is, while they do offer some challenge to the medium's dominant mode of television, they also share certain features of the television culture as a whole. They could not be seen as examples of what we might call oppositional postmodernism, or in Hal Foster's phrase 'a postmodernism of resistance'.[11] To understand how a 'postmodernism of resistance' might be created within television, consider first the argument of Raymond Williams.

In his book *Towards 2000*,[12] Williams argues that key modernist innovations were originated as responses to the complex effects resulting from the dominant institutions of political and corporate economic power destroying traditional communities and replacing them with newly created concentrations of power (both real and symbolic) in a few metropolitan centres. Williams also notes the paradox that the same processes which controlled and centralised the new means of universal distribution – the cinema and later broadcasting – were at the same time being discovered and developed. Thus Williams says:

> the very conditions which had provoked a genuine modernist art became the conditions which steadily homogenized even its startling images, and diluted its deep forms, until they could be made available as a universally distributed 'popular' culture.[13]

The most significant aspect of Williams' argument is however (for the purposes of this essay), his crucial avoidance of both technological determination and cultural pessimism; put simply, he rejects the idea that advances in cable and satellite television will necessarily bring wall-to-wall *Dallas*, and that this is

State of the Art – an attempt to reformulate television's approach to the Arts.

necessarily a 'Bad Thing'. The real enemies Williams asserts, 'not only of culture but in the widest areas of social, economic and political life, belong to the dominant capitalist order in its paranational phase.[14]

How then to offer a resistance to these forces, and in particular to their current cultural manifestations? One idea which influenced the thinking of the writer Sandy Nairne, the producer/director Geoff Dunlop and myself as we were preparing our series of documentaries *State of the Art* was a resistance to the dominant model of television, which, following Benjamin, might be called 'dialectical images', or after Berger, 'a dialogue of images'. Like a previous Channel Four series *About Time* (made by Mike Dibb, Chris Rawlence and John Berger), which used juxtapositions of images and arguments against each other to open up debate (rather than affect a precise predetermined closure), *State of the Art* was widely regarded as postmodernist. Leaving aside the questions about the usefulness of this designation, it is not my intention here to respond to the largely negative reaction which the programmes received on their first transmission, since the series is described well in John Robert's essay in this volume.[15] The tradition to which it responded is laid out above, it may be left to the individual viewer to decide its relative success or failure.

NOTES

1 Although this definition is frequently noted, a specific reference in
 Grierson's own writings has eluded me. *In Grierson on Documentary*,
 edited by Forsyth Hardy, London, Collins, 1946; Hardy, who was a
 close colleague of Grierson, writes in his introduction (p. 11):
 (Documentary) 'derived from *documentaire*, a term applied by the
 French to their travel films, Grierson used it to describe Robert
 Flaherty's *Moana*, an account of the South Sea islanders. Later he
 defined it as 'the creative treatment of actuality'.
2 Read in an untitled, unpublished paper delivered at the Institute of
 Contemporary Arts, London on 11 June 1983.
3 Kenneth Clark, The Other Half, London, John Murray, 1977,
 pp 207-208.
4 *ibid*, p 208.
5 *Fourth Charter of the British Broadcasting Corporation*, July 1952,
 London, HMSO Cmd. 8605.
6 John Read (interview) in *Antique Collector*, November 1982.
7 With regard to the extent of Jennings' 'personal authorship' we
 should however note the arguments advanced by Dai Vaughan for
 recognition of the crucial role played by his long time editor Stewart

McAllister (see *Dai Vaughan, Portrait of an Invisible Man*, London, British Film Institute, 1983).

8 Stephen Heath and Gillian Skirrow, 'Television – A World in Action', *Screen*, vol 18 no 2, Summer 1977.

9 *ibid*, p 56.

10 *ibid*.

11 Hal Foster, 'Postmodernism: A Preface'. In Foster (ed) *The Anti-Aesthetic: Essays on Postmodern Culture*, Port Townsend, Bay Area Press, 1983, p xii.

12 Raymond Williams, *Towards 2000*, Harmonsworth, Penguin 1985.

13 *ibid*, p 143.

14 *ibid*.

15 John Roberts, 'Postmodernism, Television and the Visual Arts', pp 60-75 (this volume).

3
The Generation of Images
Ways of Seeing

Philip Bell

In Summer 1994, BBC 2 re-screened the four part series *Ways of Seeing* some twenty two years after its initial broadcast. The series was produced by Mike Dibb and written by John Berger, who also features as the on-screen presenter. Since the initial broadcast, the series has been widely circulated on 16mm film and videotape in Britain, Australia and the USA and used extensively in colleges and universities. An eponymous book based on the series, written by Berger and Dibb in collaboration with Sven Blomberg, Chris Fox and Richard Hollis, was also published in 1972 by BBC/Penguin and has been similarly influential. This chapter analyses the nature of the series, its relation to its immediate predecessor – Sir Kenneth Clark's thirteen-part *Civilisation*, its initial reception and its subsequent use in Art and Media education.

I CIVILISATION AND ITS CONTENTS

> Every subject must be simplified if it is to be presented in under an hour.
> Only a few outstanding buildings or works of art can be used as evidence,
> and what is said about them must usually be said without qualification.
> Generalisations are inevitable and, in order not to be boring, must be
> slightly risky.[1]

The condescending pedagogy, the few great men, the risky generalisation – these revealing cues to the genre of televised art as a catalogue of 'civilisation's' greatest achievements, introduced *Civilisation*, Sir Kenneth Clark's book-of-the-series. Clark's thirteen hour long tour through Europe's architectural and museum-hoarded 'treasures', first broadcast in 1969,

instituted a new TV genre. Over the next decade it was followed by an irregular procession of slightly eccentric academics speaking earnestly to camera about the 'ascent of man' or the wonders of anthropological diversity. Such illustrated lecture series were distinguished by their ambitious scope – the world, the universe, the history of Europe – and by their equally grand scale – several hours of expensive production. They foregrounded terse exposition by experts pictured in front of archaeological milestones or aesthetic masterpieces, each presenter telling 'us', in reverential tones, that this was/is our culture, our heritage, our history, that this represents our finest achievements. In the introduction to his book, Clark informed us, without a hint of irony, that he did not know what civilisation was, but that he could recognise it when he saw it. With Ruskin's help, he told us why he could claim to be looking at *it* (sic) 'now'. Almost without drawing breath, Clark reminded his audience that civilisation meant more than 'art' because '[g]reat works of art can be produced by barbarous societies'[2], employing a discourse which removed aesthetics from sociology, and elevating the praiseworthy examples of the civilised above the mundane crafts. Clark compared Apollo (of the Belvedere) to an 'African' (*sic*) mask, asserting that the European sculpture 'embodies a higher state of civilisation'[3] than the mask. The former shines forth from a world of 'light and confidence', the latter represents the spirits of 'fear and darkness'.[4]

The responses to *Civilisation* were predictably varied, according to the ideological contexts of the numerous critics and reviewers whose role is to publicise and extend the audience for such programmes. Unsurprisingly, if only because 1968 had seen a climax of European (especially French) debates around the political functions of 'art', non-establishment commentators reacted with mirth and/or anger towards the Eurocentric hyperbole and universalistic (yet explicitly èlitist) 'humanism' of Clark's exposition.

The complacent èlitism of Clark's programmes was judged by some to be an anachronism at best, but the rhetorical appeals to great Western traditions seemed to include, or at least to invite acquiescence from, diverse audiences, whose assumed ignorance of the great tradition the programmes promised to dispel. Clark's programmes were pitched at the spectator who recognised many of his examples of art or architecture but who lacked a coherent structure by which to name or to judge their significance. He offered an orderly teleology of continuous if diverse progress towards 'civilisation' which was constructed as an attribute of history and of any audience members sophisticated enough to

accept that the term applied to them by watching the programmes and accepting their flattery. Notwithstanding his constant appeals to a universalistic 'we', Clark allowed that never before had so many 'been as well fed, as well-bred, as bright-minded, as curious and as critical as the young are today'. So things would not fall apart and the barbarians were not at the gate. But '[t]he trouble is that there is no centre'[5]. Clark argued that Marxism has failed, leaving 'us with no alternative to heroic materialism, and that isn't enough'.[6]

It would be easy to list the many vague abstractions on which Clark built his case. But of more importance is the underlying, unargued assumption that Western societies have travelled through two thousand years along a single road towards increased enlightenment and that the arts are indicative of, if not the embodiment of, this ineffable but unquestionable progress. Art embellishes, memorialises, celebrates; it expresses the 'greatest' human aspirations and values. Art is the grammatical and ideological subject of this discourse, the agent of its own significance. Art transcends its historical and social context yet can be identified by its period's style as evidence of the tradition by which we can all consider ourselves civilised.

Ways of Seeing did not overtly critique *Civilisation*. Instead, it used television differently. It defines 'art' and culture without recourse to the unitary discourse of heroic humanism; it questions its own judgements and lacks certainty; it visits few museums; it moves from the social context of art in (Benjamin's) 'age of mechanical reproduction' to the people whom artworks address; and it refuses to assume that the arts are discontinuous with other practices by which meaning is circulated (advertising, for example). *Ways of Seeing* did not approach *Civilisation* as an orthodoxy to be critiqued by analysis and argument. Rather it sought to make an alternative type of television and to demonstrate that by interrogating the arts in their social and economic contexts, the irrelevance of èlite humanism would become patent to all who accepted Berger's invitation to consider **how** (not just **what**) images meant in the age of McLuhan, Marcuse, and Barthes. For, without seeking to reduce the discourses of *Ways of Seeing* to New Left platitudes, it is important not to ignore the context within which Berger spoke – his was not the first; it was not a revolutionary voice.

Although it had never penetrated the orthodoxy of anglophone television, the analysis of art as a commodity, the semiotic deconstruction of photographic

realism, sociological critiques of advertising as creating 'false needs', and destructive demonstrations of museum art's mystified value, pre-dated Berger's and Dibb's programmes. Berger would also have been aware of the popularised probings of Marshall McLuhan and debates around the 'globalising' potential of electronic culture. Indeed, McLuhan had observed (cf Clark) that 'art was anything you could get away with'. His more thoughtful observation that the content of a new medium was the older media, might also have proven fruitful to anyone seeking to reply to Clark's lengthy televised argument. For it was the vernacular voice and physical reach of the '**mass**' medium of television that combined to accelerate the changing ways by which art could be understood *outside* the gallery, the museum and the textbook.

Clark's programmes were, even for their time, quaintly ignorant of the social context of television, even if they were sophisticated visual catalogues of the West's treasures. Berger's reply (which does not explicitly mention Clark's series) was not to produce an alternative catalogue (of radical, revolutionary or non-èlite artworks, for example), but to speak differently about images by using the most popular visual medium of the day. Instead of claiming the objectivity of the connoisseur/expert, Berger addressed his armchair audience in the second person, asking them to think critically about his claims and inviting non-experts to discuss images in front of the camera. These programmes involved a different **use** of television and implied different assumptions about who was watching, and why.

Clark's illustrated tour through the civilising achievements of history took for granted the uniqueness, the genius and the inspiration embodied in the buildings and artworks he surveyed. By standing in front of these as he delivered his judgements, Clark overlooked what television made most obvious – that the works once had a particular social and physical context, but this could not be recreated on television. Clark ignored the significant question of how audiences interpret these works through the medium of television itself. The 'reproduction' of the works through the video camera, editing, framing, verbal contextualisation – is not reflected on by the programme. The medium itself is ignored. Ruskin or Arnold, not Benjamin, seem to provide the vocabulary for the discourse of *Civilisation*. The classical canon remains the object of unproblematical contemplation not the difficult, controversial phenomena which require *work* to read and judge, work which would relativise and question the assumption of a unitary aesthetic meta-discourse. Berger, by

contrast, asked questions about the examples he considered. The expository structure and verbal commentary of *Ways of Seeing* are distinctly different from the mono-logic of the omniscient narration of *Civilisation*.

II BENJAMIN AND THE BOX

If, as Walter Benjamin had asserted, 'the technique of reproduction detaches the reproduced object from the domain of tradition',[7] then *Civilisation* can be seen as an attempt to construct just such a tradition to include works which had already become commodities, brand names and post-cards. Clark's tourist-guide discourse denied the loss of uniqueness and 'aura' by visiting the great achievements of Western culture in their original locations, leading the electronic spectator through a virtual museum in which a particular tradition was repeatedly asserted. Benjamin had seen in this tradition 'a number of outmoded concepts, such as creativity and genius, eternal value and mystery'[8] which the rise of photographic reproduction and de- or re-contextualisation had rendered obsolete: 'for the first time in world history mechanical reproduction emancipates the work of art from its parasitical dependence on ritual'.[9]

Benjamin's essay is the intellectual inspiration for the Berger–Dibbs series. The radical import of their eccentric point-of-view is to see, from various places where images are read and used, that the 'artistic' function of the image on the gallery wall is only *incidental* to its political and social function and significance. But television programmes are not rigorous academic arguments, and Berger and Dibbs embed this thesis and the analytic categories on which it rests in a series of demonstrations of the value of artworks as used by various classes of viewers. Instead of reiterating Benjamin's analyses of the changing material value of the post-auratic artwork, Berger walks up to a framed image of Venus and Mars. He raises a scalpel and cuts out the face of Venus to make a photograph-like image of a 'pretty girl'. Of course, the image has been mechanically reproduced; it is not 'the original'. So the viewer's relief that Berger's iconoclasm is merely a pedagogical ploy is accompanied by the realisation that his/her religious view of the art work as an invaluable icon is anachronistic in the world of televisual imagery. Similarly, Berger recontextualises (verbally and visually) other works to 'demystify' them (in the jargon of the times).

Each of the four *Ways of Seeing* programmes dealt with the uses to which art could be put, its social contexts of production and reception. Using the rhetoric of video, honed in television commercials and in expository formats generally, they suggested ways by which contemporary viewers could derive meanings from images (including those labelled 'art') without being reduced to mere admirers of the quality of the images seen, or to dupes of the mystificatory mantras of arts commentators. Second, they attempted to unsettle the audiences'/viewers' ideological assumptions concerning art itself by linking 'high' traditions to publicity and news photographs, and exposing the classical female nude genre to questions of sexuality and power. The four half-hour programmes were titled 'Reproductions', 'Possessions', 'Nude or Naked' and 'The Language of Advertising'.

Collectively, they seek to demonstrate how assumptions of 'false religiosity' and mystification inform the dominant discourses by which *representational* art is represented in the popular media (and in the academic authority which they revere). *Ways of Seeing* does this through a series of devices which include: actions (such as cutting an apparently expensive original into pieces); examples analysed contextually/historically; comparisons drawn between 'high' and popular art; presentations of how a picture can be read in various ways depending on context; reflections on the sequential reproduction and quotation of images; and, significantly, by drawing attention to the mediating role of Berger's own discourse and to the selectivity of the televisual reproduction of images. Images are treated as texts to be read or *used*. They are seen as potentially socially meaningful. Although Berger's position as presenter is privileged, he asks questions that are not simply rhetorical; he allows his own enthusiasms to be glimpsed; he interviews children and women about their interpretation of particular pictures and classes of images.

III REPRODUCTIONS

Taking his cue from Benjamin, Berger asserts that, due to the development of photo-reproduction, we now see paintings 'as nobody saw them before'. The cash value (the absurd prices paid) for paintings, he asserts, is a substitute for the loss occasioned by the camera making them reproducible. Yet such mechanical reproduction has multiplied the contexts in which an image can be seen and, therefore, its 'possible meanings'. To carry this idea to his audience,

Berger simply alters the context by varying the music accompanying an image, by contrapuntal juxtaposition of moving 'news' images with a Goya, for instance, or by showing how a verbal 'anchor' (to use Barthes' term) can fix one preferred reading of a potentially polysemous image. He tries to demonstrate how academic formalism obscures and mystifies a Hals painting, by repressing its direct, accessible social meaning. Pictures can be thought of as 'words' rather than holy relics; they can be selected and used in discourse, their meanings are not fixed. He warns his audience, direct-to-camera, to 'consider' what he has said, but to 'be sceptical of it'.

POSSESSIONS

Possessions illustrates the theses that 'before they are anything else, (pictures) are themselves objects which can be bought and owned', and that oil painting (its subject matter, its value) incorporates particular historical attitudes to property and exchange. The illusionism of oil painting, its sensuous realism advertises and celebrates the wealth and power of its owners or provides exemplary depictions of virtuous mobility reflecting the owners' social position. Bourgeois portraiture, landscapes celebrating ownership, are claimed to be the genres which chronicle and re-affirm the value of paintings as possessions and of their owners as a class. Berger allows that some works (eg a self-portrait by Rembrandt) 'turn the tradition against itself' and may represent the 'struggle' of existence, conceding the relevance of some aesthetic criteria, at least. *Possessions* is, perhaps, the most reductive and tendentious of the four programmes. It proposes general vulgar Marxist demystifications but also seeks to exempt what Berger sees as significant paintings (incorporating, say, struggle, or rebellion) from the art-as-bourgeois-trophy tradition which it selectively illustrates.

NUDE OR NAKED

Nude or Naked takes issue with the classical tradition of the Western (female) nude. In contemporary culture, Berger asserts, women watch themselves being watched, objectifying their own bodies as sites to be looked at. As in advertising, classical nudes voyeurised and infantilised women, blaming them

for their 'vanity' which was a rationalisation for male power. The European nude tradition, Berger argues, was merely a beauty pageant or soft-pornographic trophy cabinet possessed and displayed by men for their own and other men's pleasure: 'aesthetics, when applied to women, are not as disinterested as the word 'beauty' might suggest'. For to be a nude in art is to be shown as naked and yet 'not to be recognised as oneself'. Ingres and girlie magazines are juxtaposed to make the point that nudes are posed for the viewer's pleasure. 'Prime Ministers discussed under paintings like these', Berger observes.

It may be a measure of the programmes' timeliness that these 'feminist' arguments were advanced at the very beginning of the wave of sexual politics that, in Britain and Australia, followed the publication of Germain Greer's *The Female Eunuch* (1970). Berger finishes the *Nude or Naked* programme by presenting a studio discussion among five women about the issues raised. They confirm and expand on the theme of the objectification of women's bodies in art generally and in contemporary advertising, fashion and the media. The demystification of high European art is achieved, rather bluntly, even crudely, but Berger allows that Eastern erotic arts and some exceptionally intimate paintings in the European tradition do escape the charge laid at the door of the bulk of the Western genre.

THE LANGUAGE OF ADVERTISING

This programme is a sustained critique of capitalism's visual construction of social envy of which glamour is the object. Berger seeks to link advertising's photographic production of sensuous commodities to Western Art's tradition of the still life and the nude. He juxtaposes modern advertising and paintings from various periods to show how the reproducible iconic sign makes visual meaning into a commodity, images into currency, and art into a language speaking to consumerism and envy. Behind these images but necessary for their commercial currency, lies the labour of the people who lack the glamour of advertising models. Berger shows the actual production (the work) involved: women work on a production line in a cosmetics factory. In a relatively long sequence, using shots of much longer duration than are usually found in advertising, accompanied by the incessant noise of the factory, the women's repetitive labour is shown. This seldom depicted (in art or advertising) world of

work is the programme's way of de-glamorising the advertising image, just as the nude and the art image had been recontextualised in other episodes by nakedness and reproduced copies respectively.

As these brief summaries suggest, the four programmes arise out of New Left writings of the 1950s and 1960s which re-read Marx (especially the Young Marx), and, in anglophone contexts, relied on translations of writers such as Benjamin and Adorno who emphasised the commodification of mass culture, especially of the image and popular music in industrialised capitalism.

The principal televisual device which Berger and Dibbs employ is not easily described and was not directly translated into the print and graphics of the eponymous publication. This 'device', very simply, involves de- and re-contextualisation of familiar images. Such defamiliarisation suggests the 'making strange' of modernism, and, indeed, it is employed to prise the image free from its congealed connotations. This is not merely a ploy to show that reproduction has denied images their aura (although it sometimes does this); it is a way of drawing attention to the principle that images always mean as texts-in-contexts, and that 'reading images' involves ways of seeing which are dependent on these contexts. But this not a formalist exercise. The contexts which the programmes manipulate and permit are the contexts in which the respective images are likely to be seen by contemporary audiences, and include the panning of the television camera, the sounds of different genres of music, the shocking contiguity of news programmes or a page of *The Observer*. This single trope, of course, contradicts what most expository and illustrative uses of images involve in television. It makes the audience/spectator compare their immediate or unreflexive reading of a particular image with the reading which the new or changing context provokes. Thus the series demands the viewer to engage in an active conversation with Berger.

Even in those cases where Berger seeks to generalise about the ideological significance of a genre (such as the nude) juxtapositions and other recontextualisations are used. Aesthetics, formalism and abstract images are excluded from the discourse in favour of sociological critique citing images representing human participants and/or the posed body. Berger's examples are seldom drawn from 20th Century art, although an extract from Dziga Vertov's *Man with a Movie Camera* introduced *Reproductions*, and is used to illustrate the relativity of the spectator's position in an age of photography. Of course, 1970s advertising images are shown, but to see Berger as 'Modernist' in so far

as this suggests a valorisation of abstractionism, expressionism or formalism is to misrepresent the images on which the series focuses (*cf* Bruck and Docker's charge that Berger is 'Modernist' and anti-'realist').[10]

III. WHY BERGER?

Ways of Seeing provoked an extensive response over many years. Peter Fuller claimed that the TV series, taken with the book of the same title, have had 'a greater influence than any other art critical project of the (decade to 1980)'.[11] Indeed, Geoff Dyer has argued that:

> throughout the 1970s it was the key text in Art colleges in Britain and the USA; for many students it represented a turning point in their thinking about art.[12]

It is not possible to evaluate these claims empirically, except to note that detailed critiques were published during the fifteen years after *Ways of Seeing's* broadcast, and that, in Australia for example, (where the series was never broadcast), it was used by virtually every tertiary arts and media institution for many years. Notwithstanding the literature which came to identify and define postmodernism in the two decades after *Ways of Seeing*, Berger's pop-Marxist and rather idiosyncratic arguments continued as lecture-substitutes for students who were not even born when it was first broadcast. This clearly reflects the dearth of televisually-literate material on the arts, as well as the absence of any audio-visual ideology-critiques of advertising and gender images throughout the 1970s which might have replaced the institutionalised reliance on *Ways of Seeing*. (Many academics almost came to know the programmes by heart.) Teachers continued to use it despite guilty embarrassment as the issue of artworks in an age of mechanical reproduction was subsumed by theories of the simulacra, postmodern pastiche and the 'active audience'. However, these developments, like serious contention with Berger's particular versions of anti-élitist modernism, have not found a place in the popular broadcast media, which remain as unreflexive about their own cultural and political significance as they do about the 'high' arts.

Berger agrees with the consensus that both the TV series and the book suffer from 'immense theoretical weaknesses',[13] yet the TV format of illustrating unorthodox ways of seeing the most ubiquitous and orthodox of images is

surprisingly original (or at least un-imitated) a quarter of a century after its first screening. The 'weaknesses' of which *Ways of Seeing* has been accused include: idealism (mystificatory anti-materialism); philosophical incoherence; residual romanticism (eg Berger's views of Van Gogh and Hals); un-theorised assumptions about the nature of power as it relates to art; unsubstantiated historical generalisations; and a puritanical rationalism.[14]

While most of the sustained critiques of *Ways of Seeing* were published in the decade following its original broadcast – see for instance, *Art Language* (1978, Vol 4 no 3) and Peter Fuller's *Seeing Berger* (1980), for detailed critiques from contrasting perspectives – the debate has continued. As recently as 1989, Bruck and Docker, writing in the Australian journal, *Continuum*, attacked *Ways of Seeing* for its modernism, seeing it as anti-'Pleasure' and 'risible' from the perspective of postmodern populism.[15] Such academic analyses can be seen as intertextual extensions of Berger's (written) texts only, for they have not engaged directly with the *form*, the address or the televisual context of the broadcast version of Berger's and Dibb's positions. Indeed, *Ways of Seeing* remains provocative in the 1990s despite the theoretical weaknesses of its contentious verbal argument. It can still be viewed (if one ignores Berger's role as the earnest teacher) as the single most important attempt to circulate in the public media, questions which were suppressed in decades of idealist humanist anglophone arts and culture discourse. It moved the image out of its gilt frame, off the wall of the gallery and isolated it as a text in need of a context.

Berger's *Ways of Seeing* was an 'intervention' (as we would have said in 1972) which popularised Benjamin and the New Left for a whole generation of students. It had no terms for anticipating the post-modern, but it provided an easy excuse for rejecting the grand narratives of great traditions and civilising progress. That students have continued to be shown *Ways of Seeing* throughout the postmodern aftermath of the traditions that it interrogates is an irony that Benjamin might have anticipated. 'Modernism's fellow-traveller' (as the *Art Language* Collective labelled Berger) was never able to escape the traditions that he criticises. His attempt to 'empower' his audience to trust their judgements against the weight of the great tradition misread the times. Berger could only exempt some images from his critique, to allow a few artists 'authenticity'. Meanwhile, the very images of publicity and escape which he lamented had marched to the high ground. Berger's demonstration of Marxist-humanist conscience looks increasingly lame against Benjamin's hoped for

emancipation of the image from its parasitical dependence on ritual. For advertising and publicity images have become a hegemonic form of 'capitalist realism' (to borrow Michael Schudson's term),[16] and the wished for 'transformation' of the modern media has only consolidated the commodification and exchange of images, 'auratic' or not. Art has not been 'politicised', but the political continues to become more subtly aestheticised.

Applying Benjamin's observation to Berger, when the context of *Ways of Seeing* changes, the significance of the programmes also must change. Looked at in the 1990s,[17] they might be seen as nostalgic examples of leftist humanism which rely on, and perpetuate, some of the assumptions which they originally seemed to critique. They now proclaim the value of the individual conscience holding out against the tide of simulacra. Berger's was the first, and – seemingly – the last such voice on television.

NOTES

1 Kenneth Clark, *Civilisation*, London: BBC/John Murray, 1969, p.xv.
2 *ibid*, p 1.
3 *ibid*, p 2.
4 *ibid*.
5 *ibid*, p 347.
6 *ibid*.
7 Walter Benjamin, 'The work of art in the age of mechanical reproduction', in J. Curran et al (eds) *Mass Communication and Society*, London, Edward Arnold, 1977, p 387.
8 *ibid*, p 385.
9 *ibid*, p 390.
10 Jan Bruck and John Docker, 'Berger Revisited', *Continuum* vol 2 no 2, 1989, pp 77-96.
11 Cited in Geoff Dyer, *Ways of Telling: The Work of John Berger*, London: Pluto Press, 1986, p 96.
12 *ibid*, p 104.
13 *ibid*.
14 And even the television crime of poor taste in the choice of the shirt Berger wore on camera – as identfied by Tom Lubbock in his preview of the series in *The Independent*, July 30 1994, p 28.
15 Jan Bruck and John Docker *op cit*.
16 Michael Schudson, *Advertising, the Uneasy Persuasion: its Dubious Impact on American Society*, New York: Basic Books, 1984, pp 210-218.
17 See, for example Lubbock *op cit*.

4

Postmodernism, television and the visual arts
A critical consideration of *State of the Art*

John Roberts

The short history of TV's critical representation of the visual arts is a fairly uninspiring one. In fact to talk of a history of the critical representation of the visual arts on TV is to validate an area of work that is on the whole ad hoc and untheorised. From John Read's profile of Henry Moore in 1951 (incidentally – and ironically – the first full-length BBC feature on any of the arts) to Robert Hughes' pan-national extravaganza, *Shock of the New*, in 1980, the visual arts on TV have suffered perhaps more than any of the others from that familiar mixture of ruling class paternalism and bourgeois ahistoricity. Television has used art either to bolster the Reithian virtues of good taste and disinterested connoisseurship or for the purposes of ridicule. A good example of both these approaches was Kenneth Clark's *Civilisation* (1969) whose mandarin historiography and scoutmasterish moralism – culture as a Job Well Done, to paraphrase *Monty Python* – did little to undermine the received image of art as the hot-house product of embattled genius.

There have of course been exceptions to this rule, in particular writer John Berger and director Mike Dibb's *Ways of Seeing*, made in 1972 as a counter-blast to Clark's series, and the Open University's 'Modern Art and Modernism' course programmes (1983) produced by Nick Levinson. If *Civilisation* demonstrates the barest grasp of historical and political causality, *Ways of Seeing* and the Open University course make it their raison d'être; art is remapped within the discourses of social production. However, both programmes have a tenuous link with contemporary practice; their status as cultural interventions is ostensibly historical and methodological. Moreover as teaching aids the Open University programmes were made outside the constraints of mainstream broadcasting. Thus, although we can point to both

series as dislodging the positivism and cutaneous romanticism of the conventional profile or dramatised biography, their field of reference was retrospective and generally academic. It wasn't Until *Shock of the New*, which borrowed the lecture format from *Ways of Seeing*, that an attempt was made at contextualising contemporary art and its diverse trajectories in any large-scale popular sense. However, if Hughes, as a full-time jobbing art critic for *Time Magazine*, avoided the querulous scepticism of TV's in-house presentation of modern art, his swaggering authorial diktats, rapid costume changes, and reinforcement of the Story of Art disappointed hopes for a programme on contemporary art that took on social context as more than picturesque backdrop.

Under such an onslaught of mystification and populism it is no surprise that critics and producers in the Eighties should ask some searching questions about the way art is presented on TV. In a publication, *Broadcast Television and the Visual Arts*, funded by Television South West,[1] such questions are raised for the first time in some detail. As Nick Levinson says:

> on television, the history of how and why art exists, as well as why we have certain attitudes towards it, have not been prised apart from the values art has been given by the dominant classes. Although the broadcasting world has largely ignored such questions, they have become central to much art criticism, history and teaching in this country for nearly two decades.[2]

If Levinson's contribution sets the critical agenda – that there is massive room for improvement in the treatment of the visual arts – contributions from two of the other invited producers, Melvyn Bragg and Nigel Finch, outline just how entrenched the intellectual equivocations of mainstream arts broadcasting continue to be. This is rooted in what might be called the 'transmission problem': 'television itself will never provide the complete answer to the purist painter's problem for the simple reason that looking at a television set is different from looking at a painting' (Bragg).[3] 'Art itself on television, is at best...a tease, an introduction not a substitute for the real thing and the producer's function is to find a way of compensating on television for what has been lost' (Finch).[4]

Art is a poor or unstable partner of TV because at no point can it be adequately replicated. All art can do is make polite off-stage noises. Setting aside the

post-object media of performance and video and their singular broadcast potentiality (an area in fact that Finch has a certain amount of practical familiarity with), the obvious question is: why should the 'making up' for loss of visual accuracy be a question of compensation? In short, little discussion is advanced in Bragg and Finch's contributions to the effect that the inevitable gap between artwork and its reproduction might be a productive release for analysis. The assumption that TV has to be a convincing, vivid mediator of the direct encounter between spectator and artwork is simply the product of an unproblematised account of the recovery and production of meaning from art; the intractabilities of reproduction have become red herrings in a much deeper debate over art's relationship to knowledge. What makes art on TV potentially so interesting is its notational value. Which does not mean that works are thereby devalued but that their illustrative status is in a position to serve what television does best: the taking up and talking through of ideas.

It is this deeper debate over art's relationship to the conditions of knowledge post-*Ways of Seeing* and the Open University course that has formed the basis of a series of critical initiatives over the last few years from John Wyver and the Illuminations production company, who have to a great extent been at the centre of the re-theorising of the art documentary. Like Levinson, Wyver seeks a distance from the 'primacy of vision' model. Unlike Levinson, though, Wyver is a critic of the lecture format, the profile and the dramatised biography. As he argues in his own contribution to *Broadcast Television and The Visual Arts*, all three forms 'share certain fundamental features which can offer only a narrow and limited range of understandings of the visual arts'.[5] These are a focus on the singular presentation of opinion and information and a residual moralism. The words of the expert or critic' are presented as an unmediated 'truth', and only on the rarest of occasions are they challenged or contradicted or undercut'.[6] For Wyver therefore, what art documentaries have conspicuously lacked is not simply an emphasis on 'social context', but a critical acknowledgement that cultural artefacts are the product of competing value-systems. As such, if art documentaries are to be beholden to the complexity of their subject then there must be a materialist commitment to the foregrounding of contradiction. That this has become a commonplace within post-'trivial-realist' film theory does not detract from its novelty and practicality within an area of documentary work which, as Levinson has said, has dragged palpably behind other areas of film production.

Illuminations' first attempt at what has provisionally been called a postmodernist documentary by Wyver was their critical overview of the New British Sculpture (Woodwork, Cargo et al), *Just What Is It That Makes Today's Sculpture So Different, So Appealing*.[7] If this was a generally lightweight treatment of the emergence of a much publicised sculptural 'movement' (too insistent, with its declamatory atonal soundtrack by David Cunningham, on not being a conventional documentary), it nonetheless offered a range of strategies and forms that placed the discussion of art outside the closures of the centralising authorial presence, be it Clark's connoisseur or Berger's intellectual-as-caring-person. A mixture of interviews with artists, their dealers and critics (pro and con), situation shots and studio shots and images of publications, provided an intertextual grounding for the acknowledgement that the meanings of art are multiply authored and reproduced.

It is this distance from the positivism of the conventional profile and the sanctity of the expert's presentation that forms the televisual framework of Illuminations' most ambitious production so far, *State of the Art*.[8] Produced by Wyver, directed by Geoff Dunlop, written by Sandy Nairne, and co-funded by Channel Four and WDR Cologne, this six-part series on contemporary art in Britain, Germany, the USA and Australia in fact offers, by virtue of its resolute displacement of the objective professional art historical voice, a putative paradigm shift for the art documentary. As Sandy Nairne says in the preface to the book which accompanied the series:

Cultural artefacts are the product of competing value systems...

I proposed that the divisions of the programmes would not be based on national schools, particular styles or chronological change, but on issues current both in art and in society as a whole. Secondly, the films would not be about the lives of the artists, their eating or sleeping habits, nor indeed about artists at all. What we have produced is a discussion of art itself, seen through extensive interviews with them, focusing on the ideas that have helped form their art and circumstances in which it is viewed and interpreted. It was clear that there would be no objective position, that many of my ideas had been formed by what I had read and those I had listened to. Nor could our project be independent from the circulation of ideas and assessments in the artworld.[9]

But even if such a series vindicates Wyver's Benjaminesque call for a dialectical use of quotation and image in its distance from the profile and dramatised biography, it would be a mistake to assume that *State of the Art* is simply a reaction against the weaknesses and omissions of these forms. For *State of the Art* is the direct product of a distinct set of theoretical interests that have burgeoned over the last ten years or so. In short, the series is the product of that critical culture of the image that we now take for granted as Cultural Studies: the rise of Film Studies, The New Art History etc, etc. The absence of a central authorial presence is thus not just a formal acknowledgement of the objectifying powers of representation but a structural recognition. The space for the intellectual or critic as universal commentator has been eroded in the face of the proliferation of art's contents across many subject positions, ideological fronts and expressive resources. *State of the Art* therefore reflects and participates in the wholly transformed culture of the visual since *Ways of Seeing* in 1972 and the re-theorization of modernism during the late 1970s and early 1980s. The extensive reorientation of critical agendas in the art schools (the generation of new content spaces outside the 'figurative' and modernist abstraction canons in the wake of the advance and employment of specialist discourses in relation to the 'new media') has broken down the received hierarchies of competence, value and interpretation that Kenneth Clark was reinforcing and Berger reacting against. This is not to say that this revolution of means and ends in the 1980s has been completely victorious (Jocelyn Stevens' closure of the Environmental Media department at the Royal College is one of the more widely publicised recent attacks on such gains) or that certain conventional modernist prejudices still do not hold (in some cases for good reason against the earnests of the post-auratic) but that the twinned myths of the Great Western Tradition and unmediated expression which

allowed modernism to speak for a narrow range of – predominantly white, male, middle-class – interests, are in retreat.

State of the Art's commitment to the work of women artists and artists of non-European origin or background is a clear indication that the relationship between art and its production and history is in the process of being decisively transformed. The false democracy of TV can of course be deceiving (as I will discuss later) but nonetheless it is extraordinarily gratifying to see a number of women artists and black artists not just offering up forms of ghettoised opinion, but participating in an international culture of the image. And if there is a general political point that the series makes then this is it. For in jettisoning the critical machinery of conventional art historiography (biography as the authentic ground of artistic intention, stylistic comparison) the programmes draw out the content of the work in relation to those categories, discourses, real tendencies in the real world, that gives the art its place and legibility within the broader culture of ideas as a whole. A familiar approach maybe – even within certain sections of progressive broadcasting – but a wholly new model for the presentation and discussion of the visual arts.

The series is divided into six critical thematics: 'History, the Modern and Postmodern', 'Value, Commodity and Criticism', 'Imagination, Creativity and • Work', 'Sexuality, Image and Identity', 'Politics, Intervention and Representation' and 'Identity, Culture and Power'. Each programme employs interview material (direct to camera), spoken quotations (from critics, sociologists, writers, etc), situation shots, contextual 'scene setting', social footage and occasional music.

Working within the orbit of a post-Godardian aesthetic (whose anti-narrative strategies Wyver actually traces back to the early, and fragmented, English modernist documentary tradition[10]), the juxtaposition of quotation and image serves to dynamize the relationship between artworks, events and ideas. However, this is not to say there is lots of fast editing (on the contrary Dunlop, Wyver and Nairne tend to slow the pace down in the interests of scholarly contemplation) but that location shots and quotations continually call the art back to struggles in the real world. Thus if we are to distinguish the series from the basic juxtaposition techniques of the modernist documentary tradition alluded to (if we can characterise it as a tradition at all), it lies in the systematic and self-conscious use of quotation and contextual material as a means of showing that art, ideas and the world of objects and events interact

and interpenetrate as parts of a single process. In this distinction lies a world of philosophical difference. Before I address myself to the postmodernist implications and assumptions of this intertextual approach, it is necessary to present a brief synopsis of each programme.

HISTORY, THE MODERN AND POSTMODERN

The programme opens with a melange of urban noises and languages, in recognition of our global electronic culture as the motive force of capitalist hegemony. 'Everything is being totalised and at the same time atomised' says Leon Golub. The post-war capitalisation of communications technology is thus presented as the primary focus for the self-understanding and critical perceptions of artists. Faced with the injuries of modernity and the binding logic of mass culture where do the responsibilities of artists lie? The main body of the programme takes up this question in the response of three European history painters (the Italian neo-classicist Carlo Maria Mariani and the German allegorists Jorg Immendorf and Anselm Keifer) and American installation-artist and dream-collator Jonathon Borofsky, to the post-war Western experience of modernity. The engagement with, and retreat from, modernity in the work of these artists supplies the postmodernist framework of the series: the freeing of the artist from the linear (from modernist evolutionism and technological determinism, hence the redemptive emphasis on painting history) and the universal (the myth of the artwork or artist speaking for the whole).

VALUE, COMMODITY AND CRITICISM

Programme two considers five places in which 'validation and valuation' occur: the private gallery, the private collection, the public museum, the art magazine and the public site. How is critical evaluation arrived at and what are the economic interests that underpin it? Interviews with dealers Michael Werner and Mary Boone, the director of the Deutsche Bank's collection Dr Zapp ('the bank has never, in its 120 year history, seen itself as a purely financial institution') and the producer of *Dynasty* and *The Colbys*, the collector Douglas Kramer ('I'm obsessed with owning') give a clear insight into art as a paranational industry and increasingly consumerist source of social value

(particularly in the USA). In the following section – an interview with Richard Koshalek, director of the Museum of Contemporary Art in Los Angeles – the part the big museums play in the ratification and extension of this process is examined, in particular their mediation between artists and industry on collaborative urban gentrification projects. These forms of managerial control (of both resources and meaning) are then placed up against the 'independence' of art's critical culture. The programme ends with interviews with the editor of *Artforum*, Ingrid Sischy, and one of its regular contributors, Thomas McEvilly, who states: 'Criticism clearly has its role as negative criticism. Criticism means really to criticise everything.'

IMAGINATION, CREATIVITY AND WORK

Working with a post-romantic view of artistic skills as the product of training (the development of cognitive interests), programme three offers an overview of the vicissitudes of artistic creativity. In interviews with Joseph Beuys, Anthony Gormley, Miriam Kahn, Howard Hodgkin and Susan Hiller, the status

State of the Art – demonstrating a post-romantic view of artistic skills as a product of training.

and process of artistic production is variously contrasted. 'For me a nurse is also an artist, or of course, a doctor or a teacher' (Beuys). When I create these landscapes... I'm not actually in control' (Kahn). 'I find it very difficult to think of my activity as an artist in social terms' (Hodgkin).

SEXUALITY, IMAGE AND IDENTITY

In programme four we are back in the world of commerce and business. The programme opens with the preparation for a photographic school for *Woman's Journal*. As with the preceding programmes, the 'real' serves to focus the site of art's contestation and operation, in this instance the circulation of images of woman as desired object. There are interviews with Cindy Sherman, Alexis Hunter, Eric Fischl, Mary Kelly and Barbara Kruger. The interview with Kruger presents one of the key motifs of the series' postmodernism: cultural politics as a particularist struggle across many fronts. 'I think to label something political within culture today is really to disarm it in a way, and I think that it tends to ghettoize particular activity. I think that there is a politic in every conversation we have, every deal we close and every face we kiss.'

POLITICS, INTERVENTION AND REPRESENTATION

The programme opens with a shot of the offices of Independent Television News in London. Stuart Hall is quoted, arguing that the function of the media is to provide an underlying ideological unity through which disagreement takes place. The question of the political in art is taken up further as a multivalent resistance to this logic in interviews with Leon Golub and Terry Atkinson on history painting, Hans Haacke on intervention within the museum structure, Victor Burgin on male sexuality, and Pete Dunn and Lorraine Leeson on community photography.

IDENTITY, CULTURE AND POWER

The final programme takes up the centre/periphery debate in relation to cultural identity. In a sense, the last programme negotiates the 'positive' side of

The Sydney Biennale – the suppression and release of localised cultural differences.

paranational late capitalism: the break-up of national cultural boundaries. The suppression and release of localised cultural differences has become the global terrain of postmodernism's 'war of position'. The programme singles out Australian art as a vivid example of this, given both that white Australian artists feel marginalised in relation to Europe and the USA and that Aboriginal culture stands in a marginal and oppressed relation to Australian settler culture. There are interviews with Terry Smith on the Sydney Biennale, Thomas McEvilly on the question of 'cultural diffusion', the Aboriginal painter Michael Nelson Tjakamarra on his painting 'Possum Dreaming' and the Australian artist Imant Tillers on the virtues of working small: 'For an artist to be producing Kiefer-size canvases and expecting them to be shown outside Australia, it's absolutely ridiculous'. The programme then switches to the condition of emerging black art in Britain in interviews with Lubaina Himid, Donald Rodney, Sonia Boyce and Sutapa Biswas. However, if black art here is shown to be essential to the renewal of British culture, in the final section, which

documents the recent media collaboration between Andy Warhol and Jean-Michel Basquiat, the pitfalls of being absorbed into the art market as exotic spectacle are graphically depicted. Nevertheless, the series ends on an upbeat note, a quotation from Amilcar Cabral: 'Liberation for us is to take back our destiny and our history.'

In terms of those interviewed, places visited, works filmed and issues raised, *State of the Art* is a successful attempt at mapping out the complexities of art production under capitalism today. The series reveals in all its variation just how massive the extension of art's production (and theorisation) since the late 1970s has become under a Western economy that has both increased in real terms the spending power of those in employment and released those without full-time employment – and no prospect of full-time employment – into self-determined activities. As the series notes, approximately 35,000 students graduate from visual art courses in the United States every year, 1,400 in Britain, 1,900 in West Germany and 850 in France. Admittedly only a small percentage continue to work professionally in any successful sense, but nonetheless the yearly accumulation of numbers (and burgeoning reputations) has brought about an unprecedented expansion of commodity production in the 1980s. This, in turn, has generated a huge amount of promotional/theoretical work as the commodity struggles to enter discourse and public validation.

However, if *State of the Art* reflects these conditions in its extensity of reference, its critical terminology makes clear that the expansion of the day-to-day culture of art, as in the Victorian salon system, offers no comparative expansion in the critical reception of art – quite the opposite. Given the huge amount of kitsch and transparently cynical work being produced and defended under the rubric of this so-called aesthetic flourishing, the judgements the series makes about certain kinds of work – its critical adequacy – on the whole 'get it right'. Whatever one thinks individually about Leon Golub, Terry Atkinson, Susan Hiller, Mary Kelly, Victor Burgin and Joseph Beuys, as representatives of positions within, broadly speaking, a culture of capitalist resistance; their work is unavoidable. It is this sense that, despite the seeming richness of the culture of art today, certain critical values still hold (the raising of 'truth-claims') that gives the series its intellectual integrity and clarity. If one were to point to a single achievement of the series it would be its attempt to secularise art's production and consumption. By showing that art participates in the world, is

made out of extant cultural and cognitive materials, it also shows art to be at work on the world.

If my praise appears fulsome here, the series nonetheless does not escape substantive criticism. This rests on the very form in which this secularisation is presented. For although the structure of the programmes – context shot, quotation, interview – creates a dialectical interchange between work, world and discourse, the accumulated effect is one the equalisation, and at times de-contextualisation, of contents and positions. As a privileged viewer I may be able to sort out who's who and why they are there and what kind of reputation they have, but for someone without the relevant information, the relentless flow of uncontextualised information can be perplexing. This is not to have a clarification mania where every reference has to be flagged – ambiguity and inference are of course integral to the pleasures of reading/viewing – but a concern with the fact that the extensive use of quotation and artists deracinated from their specific histories can lead to a glossing over of differences. Thus, for example, in the final programme we are neither made aware that the work of the black British artists is on the whole the product of a very young (and marginalised) culture, nor that the quotation from Rasheed Araeen which introduces the section is from an artist whose work and writing has done much to lay the foundations for the culture the young black artists are discussing. Twenty-five years of work are swept aside.

Similarly, although all the artists seem to be participating in an art world that is free and equitable in its exchange of ideas, given the basis of such ideas in differing ideologies, the economic positions of the artists remain very different. The series fails to explain the (by no means fixed) hierarchy of values that the market attaches to certain media and contents. As a result the anomalous link between economic and critical success is blurred. Such differences of course can be extrapolated (it is fairly obvious that the market success of Howard Hodgkin's work is dependent upon its modernist-picturesqueness, or that the success of Jean-Michel Basquiat's 'voodoo' painting rests on the art market's appropriation of the graffiti phenomenon) but are never made part of an explicit argument. This has a lot to do with the programmes' perception of such issues as being 'internal' to the art world and therefore of a distracting, specialist nature. If the absence of specialist jargon is to be commended however, the absence of discussion around why certain artists have made certain choices is regrettable. Thus we don't learn about the political intentions that are bound up with certain choices and the effects that follow. Why do

Mary Kelly, emphasising the importance of art as a cultural practise.

Leon Golub and Terry Atkinson choose to be history painters, or why do Barbara Kruger and Peter Dunn and Lorraine Leeson choose to work as photographers, on the whole, outside the gallery network?

This levelling out of issues around means and ends (who is speaking to whom and for what reasons and to what effect) has much to do with the loss of causality which inevitably results from anti-narrative film strategies. But it can also be attributed to what I would call the 'culturalist postmodernist' framework adopted by the programmes. By this I mean a tendency to view the expansion of forms, interests and contents of art since American abstraction and the reified counter-tradition of social realism from a 'substitutionalist' political perspective, ie, as a contributory progressive force in the putative radical extension of bourgeois democracy. As Sandy Nairne says in the conclusion to the accompanying book of the series:

In the end all art is political in its resistance to the global culture, which

is intent on suppressing views and values that resist its spreading and monotonous patina. As artists challenge the assumptions of conventional history in the making, they create the fragments of a resistance, working to discover not simply who they are, but how we all might be.[11]

In one sense this is of course true – art does have emancipatory effects – but in the series the multiplicity of art's points of resistance to the values and interests of global capitalism are presented outside any political programme that would make such prefigurative truths democratically available. Thus the programmes tell us why art is important but do not articulate the basis upon which such human flourishing might be democratically achieved; the word socialism is conspicuously absent. In essence we are not told straight what the political stakes for artists, 'working to discover not simply who they are, but how we all might be', actually are in our culture. The absence of any class perspective on art's 'fragmented resistance' – the huge gap between art and the working class – leaves the aesthetic truths of art stranded from any real transformative political programme.

Behind the series' articulation of art's expansion across subject positions, ideological fronts and expressive resources, there is a familiar intellectual and political theme: the automatisation of politics. Lyotard's theorisation of politics as linguistic 'jousting' (politics as competitive language games)[12], Laclau and Mouffe's Eurocommunist line on politics as discursively constructed and separate from any non-discursive material interests[13], and the post-structuralist legacy of the dissolution of politics into powers, in short the whole critical machinery of the New Revisionism, is at work behind the series' failure to sort out, or rather make explicit, the real structural limits placed upon art's democratic extension. This is not to say that the art the series deals with is not the product of real democratic transformations within the Academy or that a Gramscian 'war of position' is not the best option within the institutions of our culture, but that particularism no matter how radical, can only serve as a cover for capitalist interests. As Ellen Meiksins Wood has argued:

> Of course an attack on capitalist hegemony must take the form of challenging this ideological division and expanding the meaning of democracy, but the problem is hardly just a linguistic one. The divide between the spheres in which capitalism can permit democracy to operate (and even here it can do so only up to a point) and those in which it cannot, corresponds to the insurmountable divisions between

antagonistic class interests. Here, if not before, there must be a break in the continuum from one form of democracy to the other.[14]

State of the Art fudges this – and I say this because what is important about the series is that art is shown to be dealing with ways of doing and being that might have a say in the way a culture not determined by capital might be organised – by presenting the democratic interests of art as if they were participating equitably within bourgeois democratic culture. Thus it is one thing to say there is a politic in every conversation we have and every face we kiss, but another to equate the political effects of different subject positions.

However if I am critical of the series' conflation of postmodernism with a culturalist, conjunctural politics, it is not my intention to deny the validity of postmodernism as a category. *State of the Art* is clearly right in contextualising postmodernism as a proliferation of critical contents and forms after the closures of high modernism. In these terms it has real explanatory power. However, much contemporary art theorising has tended to extrapolate from the aesthetic-cognitive to the epistemological-political, insofar as a break with the linear in modernist aesthetics has been conflated with a break in the 'grand narrative' of class politics – Lyotard being the egregious link figure. That this fails quite baldly to pass the first test of 'theory takeover'– the plausible explanation of large amounts of data – has not prevented a large amount of silly, ameliorist and pessimistic writing on the death of the 'new', 'reason', 'modernity', etc. If *State of the Art* avoids the worst excesses of this (though Lyotard is given his tuppence worth) the particularist politics of the series nonetheless defers to the view that postmodernism has ushered us into a post-Marxist epoch. That such an important issue is not debated within the programmes is perhaps the biggest disappointment of the series.

The use of a systematic intertextual aesthetic as the basis for documentary work therefore has both advantages and disadvantages. On the one hand, it clearly offers an advance in the complexity and texture of argument over the profile and lecture, but given the tendency of anti-narrative strategies to weaken causality, it can also reduce ideas to a heterogeneous soup. The liberation from the 'pretence of relaying a Real'[15] (a Real that is traceable back to the interests of a single author) can just as easily fall into a politics of representation which is as much assimilative and relativist as 'dialectical'. Generalisable political interests are immobilised by the self-censorship of white, male, middle-class guilt. As such, *State of the Art* is to be judged as a series that has made real advances in its intellectual disregard for the

'transmission problem' and yet is as prey to the formulaic as any other documentary mode. In the acknowledgement of such a gap lies the basis for future critical initiatives.

NOTES

1 *Broadcast Television and the Visual Arts*, Television South West, 1984
 (co-published in *Arts Monthly* February–July 1984).

2 Nick Levinson, 'History of Mystery', *ibid*, p 43.

3 Melvyn Bragg, 'Twilit Intensity', *ibid*, p 18.

4 Nigel Finch, 'Margins of Error', *ibid*, p 36.

5 John Wyver, 'From the Parthenon', *ibid*, p 25.

6 *ibid*, p 28.

7 Broadcast on 3 March 1984.

8 In between *Just what is it...?* and *State of the Art*, Wyver produced a
 series of artists' videos, *Ghosts in the Machine*. These were broadcast
 on Tuesday nights between 7 January and 11 February 1986.

9 Sandy Nairne in collaboration with Geoff Dunlop and John Wyver,
 State of the Art: Ideas and Images in the 1980s, London, Chatto and
 Windus. 1987, p 9.

10 John Wyver, 'From the Parthenon, op cit.

11 Sandy Nairne et al op cit, p 245.

12 Jean François Lyotard, *The Postmodern Condition: A Report on
 Knowledge*, Manchester, Manchester University Press, 1984.

13 Ernesto Laclau and Chantal Mouffe, *Hegemony and Socialist Strategy:
 Towards a Radical Democratic Politics*, London, Verso, 1985.

14 Ellen Meiksins Wood, *The Retreat From Class: A New 'True' Socialism*,
 London, Verso, 1986, p 135.

15 John Wyver, 'Television and Postmodernism', *ICA Documents 5:
 Postmodernism*, London, Institute of Contemporary Arts, 1986.

5
All that's solid melts on the air
Art, video, representation and postmodernity

Steven Bode

Fredric Jameson's key postmodern primer, 'Postmodernism, or The Cultural Logic of Late Capitalism',[1] as perhaps befits an old head reflecting on a sudden hubbub of changes in the air, is not without its sense of History, or indeed its sense of occasion, being published slap in the middle of Modernism's *annus miserabilis* of 1984. If ever one wanted to make or mark one's break from some of the (more moribund) positions of the Modernist aesthetic, there could hardly be a time more propitious, or more pointed, to do it than this. As George Orwell's *1984*'s famous history-lesson has it: 'He who controls the past controls the future. He who controls the present controls the past').[2] One may flinch from putting it quite so strongly, but a similar dialectic might be claimed for the practice of criticism as well. As postmodernism emerges, within Western culture, as our new 'cultural dominant', a process and a trend Jameson's work most clearly defines; it is perhaps he or she who best understands the failures of modernism who is in the best position to comment on what comes next.

1984 – the myth, maybe more than the year as such – was always going to be something of a bugbear for modernism and the Left; a kind of admonitory nadir or awful negation of a positive modernist ideal; a vision of society, furthermore, whose relation to the TV screen perhaps reflects the dark underside of our contemporary seduction by the image. Yet, if Orwell's projected dystopia did not – in reality – turn out quite as black as he painted it (more used as a catch-all scare against a contracting, centralising cultural Left by its political and stylistic opponents); the year itself brought into focus a number of contemporary epistemological challenges. By 1984, and throughout the early 1980s, many of the representational mainstays of modernism, also, were either in crisis or in retreat. Just as the notion of a modernist high culture might seem

to have collapsed under the pressure of a commodified consumer culture with its intricate mediations, so might pre-eminent forms of representation seem challenged or contradicted by a new proliferation and saturation of images, with a consequent call for new perspectives to help picture this density and diversity in our midst. Grand narratives and dominant readings were sensed to have broken down and more multiple strategies were sought. Although modernism had actively embodied the salient values – of crisis, of progress, of disjunction – of a radical avant-garde, many of these values had become absorbed to the point where, in time, they seemed just another set of conventions. In short, as Jürgen Habermas puts it, modernism seemed 'dominant but dead'.[3]

As Jameson's article records however, the first signs of an abandoning of a number of significant modernist tenets, the first sense of an End (of the Novel: in Burroughs, Pynchon and the nouveau roman; of Art: in Warhol, pop art and beyond; even of the human subject itself: in the structuralist speculations of Foucault and Lacan) could be glimpsed well in advance of any extra promptings this millenial bench-mark might have bestowed. Postmodern approaches had affected literature, dance and the visual arts, but they could be seen most early and most emphatically in architecture, where the fault-lines of an, as it were, in-house crisis began showing themselves even before actual cracks started appearing in the concrete high-rise buildings and estates that starkly represented the modernist style ascendant. It would not take much to read the observable flaws of modernist planning somehow as metaphors for cracks in a crumbling modernist ideal; an indictment that is in a way too simple by half, yet one that is at the same time pressing, palpable and, moreover, popularly upheld and understood. Which is important, since many of the debates about the whys and wherefores of postmodernism and the way one relates to one's culture have often gone on, to excuse the pun, over people's heads.

If architecture supplies a clinching logic for at least the merits of a postmodern case, it also acts as a useful touchstone for the movement's quantum shifts. Jameson, in his Postmodernism article,[4] is at his most heady and inventive describing the new architectural phenomena that, in his words, engender a qualitatively different kind of relation of the individual to their urban milieu. Distinctive Postmodern set-pieces like Los Angeles' Bonaventura Hotel – with its elaborate walkways and shifting perspectives – elicit his attention for exhibiting the varied elements of an emerging Postmodern style for everyone to

see. A style that looks forward as it looks back, making use of classical and ornamental motifs within an overall conception that is avowedly populist in tone: a kind of rococo-retro that 'without principle but with gusto cannibalizes all the architectural styles of the past and combines them in overstimulating ensembles'[5]. For Jameson, this particular imperative lies in the forefront of the transformations Postmodernism might be seen to effect: a 'shock of the new', with the emphasis less on the new and more on the (sensory) shock; a kind of electric overload or excess that mixes up familiar elements into something pleasurable and disorientating by turns.

At another point in the essay, in a moment in which we are perhaps meant to divine a wisp of the city poetics of Benjamin on Baudelaire,[6] Jameson looks down from the surrounding hills over the hazy, apparitional Los Angeles skyline, a shimmering corporate downtown whose gleaming, depthless two-dimensionality has replaced the bustling fabric of modern city life. Where the city could in the past have been conceived of as an engine, a dynamo of modernist thinking, here the overriding impression is one of surface, abstraction, silence: the complex lines of electronic communications and the myriad flows of multinational capital unseen behind the facades; the bright mirror-glass exteriors of these buildings providing a vaguely glimmering spectacle for the gaze but no kind of purchase or insight as to what goes on behind. (It is one of Jameson's themes that we have an image, but no way of adequately 'mapping', the complex inter-relationships of capitalism, technology and the media on which a postmodern sensibility rests.) If there is a Benjaminesque sense of loss underscoring such a perspective, it is one that might nevertheless be made up for in a changing spatial dynamic that opens up new types of possibility for the postmodern flâneur: a new kind of hyper-space or hyper-reality in which to wander and make connections yet which, in its fluid nature, demands that traditional modes of discourse and conventional ways of seeing be re-tested or re-thought.

Just as these key postmodern features – a promiscuous pastiching of styles, the 'de-centring' effect (in the viewer) of such a turn-round of images, a collapsing of the distinctions between 'high' and 'low' culture, a stress on surface rather than depth – might be said to increasingly mark the direction of the fields of architecture and design so equally might they be seen to configure one or other salient aspects of video or art. Though the hybrid yet high-tech aesthetics of video – and particularly the cross-cultural phenomenon of the pop video –

would seem to have an obvious place within the postmodern landscape Jameson describes, discussion of popular or experimental manifestations of the form is limited, in the Postmodernism article at least, to a brief consideration of the work of the video artist Nam June Paik. In plushly sculptural installations like Paik's *TV Garden* – in which blossoming beds of flowers are arranged around banks of monitors showing flickering images of prime-time TV – Jameson senses a striking example of a particularly postmodern mode. Certainly, watching the installation the viewer is left in a particularly postmodern fix. An old allegiance to a single unfolding thread of narrative, a central (dominant) image, or, in this case, an individual screen, gets one nowhere, especially with other – different – sights clamouring for attention out of the corner of one's eye. Yet, as Jameson notes, the postmodern view, here, like increasingly everywhere, where the surfeit of significant images bombards us everyday, is 'asked to do the impossible', to absorb all the sources at once, to engage with them 'in all their radical and random difference... in (their) discontinuous variety'.[7] Standing back from the work, however, in an attempt to stretch or shift one's perspective, to accommodate the overwhelming array of signs, one is left all the more with an overriding impression: one of dressed and decorative flux. Evaluation of the piece, on any set of merits, is as complex as the piece itself. Even so, there is much in its attention and scale that chimes concordantly – in a sense unconsciously – with our complex, often fragmentary, understanding of the contemporary image-world and much, equally, in its clear associations – to the TV walls and garden arrangements that line the consumer paradises of our indoor shopping malls – that begins to provide a sense of the flows of commerce and of capital that underpins it. In its form, however, without wanting to overstate it, the piece embodies something of the compellingness and the dilemmas of postmodern styles of representation; ones that move beyond some of the commonplaces or closures of modernism to reflect a more contemporary disparity or diversity, yet in doing so run the risk of being read as chaotic, or confusing, in themselves.

In the contemporary form of the pop video also, these features and preoccupations can be seen to recur. As critics like E Ann Kaplan have more or less subtly drilled home,[8] one finds in the pop video a general abandoning of even the pretext of linear narrative, with an emphasis instead on the 'textual' 'intensities' of elaborate clusters of images and special effects. Pop videos also revel and proliferate in a particular postmodern collage or cross-referencing of styles. They, as a matter of course, under the fast-moving imperatives of

fashion, refer reflexively back to, and try to top, their immediate stylistic antecedents. Yet they also clearly pastiche classic genres or motifs; not only – most notably – from Hollywood Film but also – and indiscriminately – images and devices from the plastic arts; or indeed, for that matter, from any 'high' or 'low' cultural source. One might expect to see, in the sealed world of the pop video – a place where literally anything can happen – the mis-en-scene of a well-known movie, the imagery of a famous painter and the plotline of a popular cartoon brought deliriously together in what seems a perfect analogue of Jameson's description of postmodern architecture's 'overstimulating ensembles'.

Such a rush of stimulation and self-conscious simulation, likewise produces a strange kind of de-centredness in the viewer, which, in keeping with the logic of commodification of contemporary consumer culture relies on the next video – the next burst of momentary stimuli – to correct. In 24-hour music stations like America's MTV, visual (over)stimulation reaches almost narcotic levels. In

The work of Susan Hiller, emphasising how as different media cross over into or evoke each other, the play of changing relations offers a greater textual richness which might act as the measure of a new kind of 'media art'.

disc-jockey parlance, the hits keep on coming – to the point where distinctions are relative, where differences blur. As with all alluring commodities, and like the adverts with which they share air-time and which they so closely resemble, pop videos are more concerned with the glossy image on the surface and less with questions of content and depth. Sharing, as it does, an intimate relation with commerce, advertising and the art of media manipulation, the pop video might also be taken to prefigure – in an extreme but exemplary manner – the encroaching commodification that haunts a significant aspect of postmodern representation. The formal contradictions that inhere in a pastiching, an admixing of disparate styles, are literally glossed over in an over arching imperative of style; where, as in advertising, the image (or, at least, its effectivity) is the bottom line, and a free slide of signifiers, cut off from their (referential, historical) signifieds, is left to its own (visual) devices; where, as in music television, the solid oppositions of 'culture' and 'kitsch', of 'image' and 'reality' that had sustained so much modernist thinking, suddenly melt, as it were, on the air.

As contemporary art practice either becomes entangled in or embraces the worlds of commerce and the media, quintessentially postmodern forms like the pop video can seem bland, dispiriting proof of a coming, all-encompassing trend. Nevertheless, this new situation – in its very complexity – cuts both ways. As different media cross over into or evoke each other, a play of changing relations with the promise of a greater textual richness might act as the measure of a new kind of 'media art'. Similarly, as more documentary-based forms become more open to different techniques and less tied to linear, univocal conventions, new tactics of bricolage or deconstruction might come to be adopted by critical artists to make different textual or political points; a way of showing up or breaking down received ideas or everyday perspectives that has an equal visual reward for both the 'privileged' and the 'popular' viewer. Even so, especially in a culture that is invested and influenced as much by textual cross-over as by ambivalence and confusion, a line needs to be drawn between astute and conscious bricolage as a practice and a merely superficial stylistic mélange; though, to a degree, such a line depends on a critical distance from one's object that postmodern structuralist thinking might be said to have undermined. Moreover, it is a line that can, again, be easily blurred when so many visual forms are increasingly focused and read at the surface.

To an extent, such a consideration may have played a significant part in the critical reception of scratch video, whose generally didactic representations of superficial, or shocking TV imagery might in a number of cases, be read as much as celebration as deliberate critique. Similarly, specific video art pieces which seek to problematise particular issues or styles of representability or representation, and practiced in opposition to more 'commercial' forms of video and TV, might, in their use of eye-catching visuals, again be seen – at the surface – as a simple matter of visual play. For example: George Snow's *Muybridge Revisited* – in its admittedly dazzling digital animation of original images by founding photographer, Eadwaerd Muybridge – uses those images in a decorative aesthetic approach that is very much a matter of postmodern pastiche. Simon Robertshaw's *Biometrika*, on the other hand, uses similar Muybridge images, with similar high post-production values, in a multi-levelled visual essay that challenges our views of 'normality' and our representation of the mentally ill. There is obviously a danger that the critical edge of the latter will become less and less noticed under a dominant perspective that goes no deeper than the surface effect.

For all that, video technology, with its ability to access and animate, augment and amalgamate, any number of individual components from our vast cultural storehouse of images, has indisputably been a shaping factor in determining a particularly postmodern and potentially rewarding reflection on art. Playing on or with images, for instance, is not just creatively in vogue but, with advances in digital equipment, increasingly in reach. Often this kind of artistic play, especially in the new form of video where technical innovations often help mask a return to an older set of ideas, has sensed a kindred spirit (and a re-exploitable set of trademarks) in art movements that were signally playful themselves (Surrealism, Pop Art, Dada, the vivid cryptic dreamscapes of Duchamp and Magritte).[9] To take one example of this process in evidence in the realm of video art: Joan Jonas's video interpretation of Paul Simon's song 'Rene and Georgette (Magritte)', which, as a piece in its own right, best exemplified the more 'popular' strand of programming in Channel 4's showcase *Ghosts in the Machine*. Here, images slide and spin into compositional arrangements evocative of Magritte; a slow-motion sequence describes a mood of delicate surreality; a number of key works of the painter are – either in figure or framing – pastiched. The overall tone is one of affectionate irony, even of wistful hommage. Yet, while the tape presupposes a knowledge – however minimal – of art history and in particular movements like Surrealism for its

effect, it tells us nothing, in its playful allusiveness, its apparently new combinations, beyond any sense we might already have had. Its free-floating images have a context but they lack any real co-ordinates; provide no insight as to how the qualities of fantasy and imagery free-play once had a particular rationale for artists like Magritte.

In a similar vein, video artist Steve Hawley's *Trout Descending a Staircase* takes it line, and its punchline, from the painting 'Nude Descending a Staircase' by Duchamp – and, in the spirit of such an illusion, enacts an elegant visual joke. Using the myriad possibilities of a video paintbox, Hawley electronically 'paints' on to a television screen, offhandedly using a number of unusual-cum-ordinary objects including flower stalks, vegetables and the eponymous trout. Though the tape's impish pastiching and deliberately throwaway reference to a canonical art-historical work might be felt to be markedly postmodern features, it would obviously be wrong to too hastily identify types of play with emergent technology with a particularly postmodern mode. Forms of video painting, as for instance features on BBC Television's series *Painting With Light*, seem at a nascent, exploratory stage; their frequent combination of figured and abstract forms as easily explained by their tentativeness or speculativeness as by any more self-conscious approach. Nevertheless, the grounds for a significantly postmodern meeting of fine art, popular art and technology are obviously there; as is the possibility that, with advanced computer/image techniques, new forms will arise to transcend or transform existing genres or styles. Video paintings like Brian Eno's *Thursday Afternoon* or *Mistaken Memories of Mediaeval Manhattan*, or his gallery installation *Paintings with Sound and Light*, for all their concern with creating a new kind of mood or environment, seem more readily placed within a Modernist tradition of meditative, ambient work.

Lest one always associate the relation of art and video with representational complexity or high-tech innovation, it should be noted that video has played an important role – in the main because of its ease of use and distribution – in chronicling particular art events (such as the *Luminous Image* installation compilation from Amsterdam's Stedelijk Museum) or in completing documentary/archival records of particular art-historical figures and trends. In terms however, of a video arts documentary which attempts to use significantly postmodern devices and forms of address, Nam June Paik and Shigeko Kubota's *Allan and Allen's Complaint* stands out. A parallel, increasingly multiple, study

of poet Allen Ginsberg and performance artist Allan Kaprow (provocatively claimed by the makers as the two most important post-war American artists), the tape constantly swaps styles and shifts gear. Flash-backs and jumps-forward regularly occur; the tape is rewound, moved on and started again; the screen is filled and fragmented with special effects; the programme's (already eccentric) frontperson has his voice speeded up and slowed down – moments that disrupt and bring new light to a more familiar documentary pattern of personal interviews and glimpses of the artist at work. Many of these effects, it has to be said, seem to derive more from Sixties pranksterism than any specific postmodernism. Yet there are times – most notably in the closing split-screen sequence featuring Allen Ginsberg and his father – where an elliptical opening up of the traditional arts documentary format has an especially striking case. (Though whether such a device is intrinsically postmodern or is only made more to seem so in the overall context is obviously a matter for debate.)

More successful perhaps in pointing to the shape and significant potential of a postmodern arts documentary is Triplevision's remarkable *Prisoners*. Bringing a myriad resonance to the story of Ridely Scott's celebrated 1984 commercial for Apple computers, the tape, in both its structure and its context, raises and embodies a number of particularly postmodern questions as to the way media representation, consumer capitalism and postmodernism are intimately interlinked. Not the least significant factor in this is the advert itself, a visually compelling pastiche of a popular Orwellian vision: its set, and its throng of extras, dominated by an image of Big Brother on a massive video screen. An advert that was at the time, the most expensive ever made, and one lent a singular aura by the money that went into its production, the publicity that surrounded its making and the fact that it was only ever to be screened once, during the United States Superbowl.

Prisoners is an assemblage of different elements concerned with the making of Scott's 1984 commercial: footage shot by Triplevision and later (with an added soundtrack featuring Irving Berlin's 'Putting on the Ritz') used as a corporate promotional video for Apple Computers; the advert itself, first 'quoted' in part then shown in full; Triplevision's interviews with a number of extras on set, many of whom were members of skinhead groups (shot independently of the rest of the footage used); plus salient passages quoted from Orwell's *1984* – all played off and contrasted against each other so as to foreground the contradictions inherent in the advert's text; both through juxtapositions in the

editing and through the use of a number of complex video effects. The advert itself is the centrepiece around which the tape's whole visual essay turns: opening with an astonishing visualisation derived from the themes and scenarios of Orwell's book and culminating in the image of 'Big Brother' on a massive video screen being shattered by a hammer blow. The advert ends with a voice-over announcing the company's new computer, one that will ensure that '1984 won't be like 1984'.

In its brief format, the advert presents a vision of a future totalitarian dystopia, whose power and effectivity is broken through a burst of inspired individual action, whose force, effect and significance is paralleled to the perfection and production of a new model of computer. This obviously involves the mobilization of a complex bank of images and associations (principally those of *1984*), whose broader implications are suppressed in the advert through both its pace and the narrative closure affected by its voice-over. All that is disavowed in the construction of the advert is however returned, in all its awkward complexity in *Prisoners*; the power of the advert, like the power of the image in general, being signalled in a number of different ways. Even so, a voice-over ends the tape on a note of caution; one that could be applied to all visual critiques that situate themselves within the same forms, and which (in an attempt at criticism and/deconstruction) must necessarily re-present the original image again:

> it seems as though the sheer weight of the image has overcome any intention – strangely this has also happened in the adverts; the simple voice-over cannot regain the ground lost...

But despite the video's own qualifiers, *Prisoners* situates the imagery of Scott's advert in a fuller, more complex context than its original and thereby works against any single dominant message the advert might be attempting to communicate.

In a culture where postmodern forms of representation are felt to frequently efface, conceal (or at best) blur the contexts of their production; the tape, with its shifting, multi-faceted and distinctly postmodern perspectives, is exemplary in providing an insight into the often complex realities that underlie the production and perception of images in contemporary western society. Within its modest project, *Prisoners* points to the possibility of constructing a progressive textual form, within a postmodern aesthetic, whose acuity and effectivity belies the blanket perception of all that is postmodern being

inevitably hollow and necessarily devoid of any possibility of (intertextual) depth.

NOTES

1 Fredric Jameson 'Postmodernism, or the Cultural Logic of Late Capital', *New Left Review* 146, July/August 1984.

2 George Orwell, *1984*, London, Martin, Secker and Warburg, 1949, Chapter IX.

3 Jurgen Habermas, quoted in Hal Foster 'Postmodernism: A Preface' in Foster (ed) *The Antl-Aesthetic: Essays on Postmodern Culture*, Port Townsend (California), Bay Area Press, p x.

4 Jameson, 'Postmodernism, or the Cultural Logic of Late Capital' *op cit.*

5 *ibid.*

6 See Walter Benjamin *Charles Baudelaire: A Lyric Poet in the Era of High Capitalism*, London, New Left Books, 1973.

7 Jameson, *op cit.*

8 E. Ann Kaplan *Rocking Around the Clock: Music Television, Postmodernism and Consumer Culture*, London, Methuen, 1987.

9 Jameson cites Duchamp as an honorary postmodernist *avant la lettre*, see Jameson *op cit.* p 56.

6
British TV Arts coverage in the Nineties

John Walker

Currently, television output in Britain remains dominated by four terrestrial channels: BBC-1, BBC-2. ITV (a network of regional companies owned by shareholders) and Channel 4. A fifth channel and digital terrestrial television are still on the horizon. Satellite and cable television services are gradually increasing their market share (5 million homes now subscribe) but they can be ignored because their coverage of the visual, fine arts is virtually nil. British television institutions underwent radical organisational, management and cultural changes during the 1980s and 1990s as a consequence of pressure from the Conservative Government for more competition, cost-cutting and greater accountability and efficiency. Commercial television was subject to a 'blind bids' franchise auction that even Mrs Thatcher came to regret, the BBC, under a new director-general John Birt, laid off staff, casualised other staff by means of short-term contracts, and adopted a new method of programme-making called 'Producer Choice', based on the notion of an internal market. Even the BBC's transmitters are being sold off to private enterprise. Following the 'publishing house' precedent of Channel 4, a proportion of the BBC's output was also contracted out to independent production companies. The latter change was positive in certain respects.

Victims and critics of some of these changes claimed that a 'grotesque bureaucracy' had been created and that 'chaos and disaffection' were rife within the BBC. At the 1995 Edinburgh International Television Festival, Janet Street-Porter, an erstwhile pioneer of youth programmes, delivered a speech entitled 'Talent versus Television' in which she complained that power had shifted from creative people to accountants. Television, she maintained, was not dominated by grey individuals characterised by four Ms: male, middle-

class, middle-aged and mediocre. Other observers agreed that the business ethos and bureaucratic revolution had undermined public service ideals and lowered the production values and standards of programmes. In regard to arts programming, there does seem to have been a decline towards the end of the period under consideration.

ARTS PROGRAMMES ON BBC-1 AND BBC-2

On BBC-1 the flagship arts strand continued to be *Omnibus* (1965-). Among the visual artists whose lives and works it explored were Paul Cezanne, Piero della Francesca, Van Gogh, Antoni Tapies, Joseph Cornell, James Whistler and Damien Hirst; plus the architect Norman Foster, the Brazilian photographer Sebastiao Salgado, the film-maker Peter Greenaway and the pop singers Boy George, Prince and the rock group Pink Floyd. Programmes were also devoted to the propaganda art of the Third Reich and to the genre of portraiture.

Arena (1976-), historically BBC-2's most original and experimental strand, addressed such subjects as Louise Bourgeois, Otto Dix, Derek Jarman, Anselm Kiefer, Cindy Sherman, the work of Robert Rauschenberg's foundation ROCI, the design skills of the Spaniard Javier Mariscal and the films of the directors Oliver Stone and Isaac Julien. Duchamp's porcelain urinal ready-made 'Fountain' (1917) and the subject of the human face were also analysed. *Arena* found it difficult to surpass its earlier achievements, partly because new ideas are now rarer and partly because so many of its innovations had been imitated by other arts strands. (Studies of popular, 'cult' objects and cars have become commonplace on British TV in the 1990s). Imitation resulted in homogenisation, therefore it proved harder for an arts strand to establish a unique identity. In 1995 it was decided that *Arena* would cease to be a weekly series and that only occasional, special programmes capable of attracting substantial audiences would be made. One such programme was *The Burger and the King* (BBC-2, January 1996). Its trivial subject matter – Elvis Presley's unhealthy eating habits – implied that a point of exhaustion had been reached.

BBC-2's *The Late Show*, founded in 1989, a magazine-type strand that appeared four evenings per week for forty weeks of the year, provided unprecedented coverage of arts news during the 1990s. Matthew Collings and other visual art critics presented filmed reports on the work of a variety of fine

artists – Arman and the New Realists, Marcel Broodthaers, Alexander Calder, Willem de Kooning, William Green, Damien Hirst, Donald Judd, Ron Kitaj, Jeff Koons, Rene Magritte, Henri Matisse, Niki de Saint Phalle, Richard Serra, Rachel Whiteread – and reviewed art exhibitions at home and abroad. Meanwhile, in the studio, stimulating debates took place about such issues as aesthetic quality, 'high' versus 'low' culture, and the relations between the arts and science/politics/violence.

For a time an eclectic, pick 'n' mix approach was adopted but, in 1994, this gave way to a more thematic approach in which the different arts and media were examined in rotation. The minority appeal of *The Late Show* was summed up by Waldemar Januszczak's hyperbolic observation that it 'seemed aimed at four and half people who lived in Highgate'[1]. In reality audience figures ranged from 250,000 to 500,000. (For the purpose of comparison: there are 40 million sets in Britain and leading soap operas attract audiences of 15 to 20 million). Despite its appeal to the intelligentsia and its many achievements, the BBC decided in 1995 to decimate the strand. (A rump remains: a Thursday-evening, round-table studio discussion entitled *Late Review*, chaired by Mark Lawson, about new books, plays, films, etc). Since *The Late Show* was highly praised by its various editors, some regular viewers wondered why it was axed. Newspaper 'obituaries' suggested various reasons: cost-cutting, scheduling problems, a sense of exhaustion, and the need to compete more effectively with Channel 4.

A major one-off, six-part series called *Relative Values* was transmitted on BBC-2 in 1991. Keith Alexander was the executive producer and Philip Dodd acted as consultant (and Dodd and Louisa Buck wrote the text of a tie-in paperback). *Relative Values* was a serious, well-researched examination of the cult of art, its values and infrastructure. Its themes were: the monetary value of art/auction house sales; the power of wealthy collectors and patrons; dealers in art; nationalism and tourism; the role of museums; the image and myths of the artist. In spite of its considerable virtues, this series was somewhat laboured and uncritical. There was little fresh information about the financial operations of the art-world and the vexed question: 'Is aesthetic value an objective property of artworks or a subjective response on the part of viewers?' remained unanswered.[2]

Television producers seek to capitalise upon the interest and publicity associated with important arts events, consequently major exhibitions in London are generally complemented by one or more arts programmes. For

example, the exhibition 'Picasso: Sculptor/Painter' (Tate Gallery, February 1994) prompted BBC-2 to mount a twelve-day season of programmes. In addition to *Yo Picasso* – a drama-documentary starring the actor Brian Cox as the artist – and *Richardson on Picasso* – three new programmes by the artist's principal biographer John Richardson – archive films and old television documentaries dating from the Fifties and Sixties were screened. Viewers with the stamina to watch all these programmes were deluged with information about Picasso. They were also given a rare opportunity to compare a range of different types of programme, and to compare past and present styles of arts television.

Another chance to measure present achievements against those of the past was made possible with repeat screenings of Kenneth Clark's famous pundit series *Civilisation* (BBC-2, 1969) in 1993 and John Berger's equally famous *Ways of Seeing* (BBC-2, 1972) in 1994. When television was primarily a live medium, most of its output was, naturally, new. But today, of course, the technologies of recording and reproduction have resulted in schedules that are a mosaic of the live and recorded, the historic and the contemporary.

In spite of the objections theorists such as myself have made against the presenter-as-hero syndrome, BBC producers still felt the need for them and bemoaned the fact that could not find a new John Berger.[3] Eventually, they did discover an eccentric personality who was to prove popular with many viewers, especially female ones. This was Sister Wendy Beckett, a 63-year old, art-loving nun who lived a spartan existence in a caravan parked in a Norfolk field. Perhaps television producers thought that a committed Christian was needed to fulfil the medium's missionary goal of taking art to the people. Art, Beckett believed, was an indirect experience of God.[4] (So much for modern art that was pagan, anti-clerical and blasphemous). Beckett visited galleries in various European cities in order to present an art appreciation series called *Sister Wendy's Grand Tour* (BBC-2, March 1995). While Beckett conveyed her enthusiasm for art, her commentary was far too light-weight for some viewers. Germaine Greer argued that since Beckett was a virgin, she was hardly qualified to discuss the erotic images she sometimes encountered.[5]

One presenter who, in my view, triumphed over all objections was the writer and performer Alan Bennett. In *Portrait or Bust* (BBC-2, April 1994) he visited Leeds City Art Gallery and recalled his own childhood school trips. His evocative and wryly humorous reflections exactly characterised the varied pleasures associated with provincial gallery-going in the post-1945 era. Later, in a

restaurant in Italy, Bennett was mistaken for David Hockney. The programme was not in the least academic, nevertheless it was a notable contribution to the study of art institutions and the popular reception of art. *Portrait or Bust* demonstrated that it is possible for programmes about fine art to entertain as well as enlighten.

In spite of record figures for museum-going, millions of Britons remain baffled by abstract painting and so-called 'conceptual' art. This was confirmed by *The Art Marathon* series (BBC-2, 1995) produced by Keith Alexander in collaboration with the Orchard Gallery, Derry, Northern Ireland. Six ordinary citizens were invited to tour galleries and studios looking at art of every kind and quality in order to select examples for a 'Punters' Art Show' to be held in Derry, their home town. At times their silence, laughter and derision in the face of bad or opaque contemporary art was refreshing, but predictably what they liked best was figurative examples, that is, photographs, amateur kitsch art and the undemanding naturalistic animal paintings of David Shepherd. The idea of 'taking people to art' (rather than 'art to the people') is not a new one; it has been tried several times before. Unfortunately, the results are usually meagre; mostly there is no meeting of minds between viewers with little previous knowledge of visual art and artists with little desire to communicate with the general public. (In this instance, however, intensive exposure to contemporary art did result in some changes of attitude and the final exhibition feature a wide range of work.) It has to be admitted though that such programmes can make for fascinating, if somewhat excruciating, viewing.

Today, the ideology of liberal pluralism results in new arts strands consisting of films about disparate subjects made in different styles by different directors. Witness *Tx* a series BBC-2 commissioned John Wyver of Illuminations to generate in 1995. He in turn commissioned programmes from various film-makers. (The strange title of the series derived from television jargon for a future transmission date). Among the topics the first eight *Tx* programmes tackled were: meditations on responses to a Cy Twombly abstract painting; reactions by football fans around the globe to a World Cup final penalty shoot-out; body artists who merge with machines; music students who took part in the 1960's Chinese cultural revolution; and a recitation of T S Eliot's poem 'The Wasteland'. Given such diverse themes, one presumes the audience was not the same for two weeks running. Self-indulgent, experimental films were followed by conventional, historical documentaries. Such strands have the virtues of

surprise and variety but, by the same token, their choice of subjects seems arbitrary and the quality of film-making is often uneven. Also, their conception of 'art' is so broad as to be almost meaningless.

ARTS PROGRAMMES ON ITV AND CHANNEL 4

Commercial television's equivalent of *Omnibus* is *The South Bank Show* (1978-, over 450 editions). It is ITV's only networked arts strand. Melvin Bragg, London Weekend Television's long-standing arts supremo, continued to edit, commission and present the weekly programmes transmitted late on Sunday evenings. Celebration, rather than critique, has been Bragg's watchword. Since his show covers the whole spectrum of the arts, profiles of visual artists are not that frequent. However, during the 1990s programmes were made about Francis Bacon, William Blake, Elizabeth Frink, Jeff Koons and Roy Lichtenstein. Popular music subjects included: Jimi Hendrix, the Pet Shop Boys and the making of the Beatles' *Sergeant Pepper* LP.

Rightly, it has been accepted practice for some time that arts strands feature examples of mass culture alongside examples of elite culture. More and more film, television and pop music stars are being profiled as arts strands seek to maximise ratings in order to justify their existence and to prevent them being assigned a graveyard slot. (The latter is a problem Bragg has had to contend with.) However, the co-existence of 'mass' and 'high' culture has generated much concern in the press about the concepts of the canon, quality and value. Many commentators have expressed the view that traditional standards of judgement have been abandoned. When, for instance, in November 1995, Bragg devoted a whole programme to the popular, romantic novelist Dame Barbara Cartland, Joanna Coles – a television critic - lamented that a 'degeneration into pulp viewing' had occurred.[6] Bragg, in addition to his novel-writing and LWT duties, chairs a Monday morning, culture/science/book review discussion programme on BBC Radio 4 entitled *Start the Week* which, on the whole, is more intellectually challenging than *The South Bank Show*. It appears, therefore, that Bragg thinks radio is a medium more suited to ideas than television.

Waldemar Januszczak, who had been a somewhat erratic and controversial art critic for *The Guardian* during the 1980s, was appointed commissioning editor for the arts by Channel 4 in 1989. A year later he launched a new, presenter-

free, arts strand called *Without Walls*: 26, 50-minute programmes annually, with a tight budget of 2.5 million pounds. Januszczak opposed any ranking of the arts in terms of high and low; he aimed to increase the viewing figures for arts programmes by adopting a more accessible and non-sycophantic style, and by extending the variety of the topics addressed. (Amongst the latter were: art and drugs, Benetton advertising, Brigitte Bardot, Ken Russell, the Kinks, the Animals, Tony Parsons on the banned film *A Clockwork Orange*, and Camille Paglia on 'The Penis Unsheathed'.) While, on occasion, this policy resulted in some memorable programmes, overall it made for patchiness and inconsistency. Two commissioned items that stood out were: *Shooting Star* (November, 1990) an Illuminations film directed by Geoff Dunlop about the brief career the New York painter Jean-Michel Basquiat; and *This is Tomorrow* (June, 1992) a documentary directed by Mark Jones which explored a fine arts/pop music connection, that is, the influence of the pop painter and art school tutor Richard Hamilton on the singer Bryan Ferry (formerly of Roxy Music).[7]

Jeremy Bugler of Fulmer Television was subcontracted to produce *J'Accuse*, an iconoclastic component of *Without Walls* in which the reputations of masters like Van Gogh and Leonardo were attacked by art historians/critics like Griselda Pollock and Brian Sewell. These programmes certainly proved a welcome antidote to the adulatory type of arts coverage so prevalent in the past – Bragg's uncritical profiles of artists on the *South Bank Show* for example.

An annual autumn ritual of the London art world is the Turner Prize competition/exhibition organised by the Tate Gallery for the purpose of extending public appreciation of contemporary British art. Four living artists are selected to compete against one another for the modest sum of £20,000. (Arguably the competition is ageist because artists over 50 are excluded. This means that someone like John Latham [b 1921] – a genuinely radical artist in my view – is ineligible.[8]) Some critics regard the Turner Prize as a publicity gimmick that demeans the artists who agree to take part. However, London art students have found the event useful: they have assembled outside the Tate to mount protests about government under-funding of student grants and art education.

Currently, the Turner Prize is sponsored by Channel 4 Television which naturally transmits a programme about the event. The cosy relationship between the Tate and Channel 4 means that negative criticism of the Prize is unlikely to be aired on the latter. To some critics there seems to be a contradiction involved in

employing a popular medium such as television to popularise what are, in the main, non-popular kinds of art. If one asks: 'What is the most popular 'art' discussed on British television?' then the answer has to be 'Cookery!'[9]

The Turner Prize is a social institution which has given rise to an anti-institution known as the K Foundation. The latter's spoiling tactic has been to offer twice as much money to the 'worst' artist in the Turner Prize competition. In 1993 the sculptor Rachel Whiteread enjoyed the dubious honour of winning both awards! The K Foundation (1993-) consists of Jim Cauty and Bill Drummond, two 'cultural terrorists' who were previously pop stars with the band KLF (Kopyright Liberation Front). They decided to infiltrate the art world and to that end performed an action in which they (allegedly) burnt one million pounds of their own money. If this was a way of buying publicity then it worked because BBC-1's *Omnibus* (November, 1995) devoted a whole hour to the K Foundation and their banknote bonfire. It was, however, a thin programme lacking any historical or anthropological contextualisation, and no one asked the questions: 'Assuming this destructive gesture is art, is it any good?' 'Does it have any aesthetic value?'

Although we do not live in a post-modern age, the preceding era of modernism continues to trouble certain thinkers who ask themselves: 'Where did modernism go wrong?'. Witness the four-part series *Hidden Hands* (Channel 4, October-November, 1995) that Januszczak commissioned from various film-makers. The series covers modern artists; the role of the CIA in promoting abstract expressionism as part of America's Cold War propaganda; the compulsion towards hygiene in modern architecture and design; and the collaboration of leading modern artists with fascism during World War Two. Clearly, this was a revisionist, debunking approach to the history of modernism. Indeed, Januszczak's declared aim was 'to uncover more dirt with which to stain the modernist carpet'.[10] The programme contained some fresh insights but their tone and quality was extremely variable. The editor himself described them as: 'deliberate cut-up minimalism, cleverly disguised as four short films with nothing in common'.[11] Also, *Hidden Hands'* news about the behaviour of the CIA was hardly hot: art historians exposed and documented these machinations as long ago as 1974.[12]

EDUCATIONAL PROGRAMMES

Since educational programmes have a limited, fixed audience of students and have no need to justify their existence by high viewing figures, they can be pitched at a more demanding intellectual level than the general output of television. Arts programmes designed for higher education maintained the high standard of commentary set by the Open University's television production unit since the mid Seventies. In 1993 the OU transmitted a series of programmes as part of the A316 course *Modern Art: Practices and Debates.* One programme – *Flag* – a close reading by Fred Orton of Jasper Johns' 1954 painting of the Stars and Stripes was especially useful because it foregrounded the issue of art-historical method: it used different approaches – the biographical, the socio-historical – while at the same time probing and evaluating them. While some of my students of Middlesex University found Orton's verbal discourse difficult to follow, in the end he did explain the ambiguous, undecidable character of Johns' painting/flag. There was a witty final touch: as the credits rolled, the distorted sounds of Jimi Hendrix's electric guitar parodying *The Star Spangled Banner* were heard.

CONCLUSION

For the first few years of the 1990s, Britain's four terrestrial channels gave the visual arts extensive coverage. But, in spite of the fact that many informative programmes and series were made, there was a perceptible decline in both quantity and quality towards the end of the period under review. Furthermore, some critics found arts television guilty of 'cultural relativism': serious art was being neglected in favour of meretricious pop culture; arts pundits were also afraid to discriminate, to make value judgements of the type 'John Keats is a better poet than Bob Dylan'.[13] Dramatised biographies of artists and in-depth, critical studies of the works of the art of individual painters and sculptors became rare; fresh, imaginative ideas were in short supply; performance and video artists found it harder to gain access to mainstream television.

During 1995 relations between ITV and Channel 4 became fraught as a consequence of disagreements over their interlinked funding arrangements. (Channel 4 currently pays an annual subsidy of £75 million to ITV.) Melvyn

Bragg, in an article critical of Michael Grade (Chief Executive of Channel 4), claimed that the Channel's commitment to the arts had reduced by half (from 4 per cent to 2 per cent).[14] Channel 4 responded by asserting that its 1996 budget for the arts would be increasing by 25 per cent.

In my view, one of the reasons for television's retrenchment was the parlous state of the object of study: in recent decades there has been a massive over-production of art, most of it poor quality. (In this I am at odds with dealers, curators and museum directors who in 1995 claimed that London was the world's liveliest arts capital and that Britart, like Britpop, was 'brilliant'). Given lacklustre material, there was little incentive to make exciting arts programmes. The contrast with science subjects was striking: a comet and atmospheric probe crashing into the planet Jupiter inspired *Equinox* (Channel 4, December 1995) to make a highly dramatic programme containing astonishing, apocalyptic images.

Aware of the pervasiveness and publicity power of the mass media, a number of contemporary artists resorted to what may be called 'stunt art' in order to satisfy the media's appetite for sensational stories about weirdo creators and objects. Damien Hirst (winner of the 1995 Turner Prize), a darling of the media and arts establishment, constitutes a prime example. His habit of preserving and dissecting dead animals such as sharks, sheep and cows excited much interest even though it is, arguably, taxidermy displaced from the Natural History Museum to the Tate Gallery. Genuinely radical art with socio-political objectives of the kind associated with socialist, revolutionary, situationist, feminist, community, black and gay artists – those seeking a transcend the confines of the artworld in order to re-integrate art into everyday life – became virtually inconceivable because the so-called 'avant-garde' had been so fully institutionalised by the private gallery/museum system and the mass media. Such art is now part of the establishment; it is official culture. Furthermore, constant change and novelty are now as much marketing necessities in the art trade as they are in the fashion business.

While some arts programmes were complicit with the hyping of new, 'advanced' art, others attempted to debunk it. For example, in June 1991 Muriel Gray produced, wrote and presented a satirical, five-part series for Channel 4 entitled *Art is Dead . . . Long Live TV* in which the pretensions of avant-garde art were savaged via interrogations of leading practitioners (all of whom turned out to be fictional). Also, during the winter of 1992-1993, a number of

newspaper critics poured scorn on conceptual art exhibitions. This prompted a *Late Show* discussion on the death of the avant-garde (BBC-2, February, 1993).[15] Four critics and art dealers with opposed views debated the issue. The discussion rapidly became acrimonious and deadlocked. Sarah Dunant, the Chair, cut the speakers short the moment the issue of social class was raised. One was left with the impression of a fragmented culture with fundamental divisions of taste and judgement even within the London artworld.

Rather than end on a negative note, I will cite a few examples of impressive and illuminating programmes and series. The film-maker Karl Sabbagh of Skyscraper Productions (named after his *Skyscraper* series, Channel 4, 1989) continued his commitment to serious, ambitious documentaries about major architecture, design and engineering projects undertaken not by lone geniuses but by large teams of designers, managers and skilled workers. In the Autumns of 1994 and 1995, Channel 4's *Equinox* strand screened his reports about the design and manufacture of a new American airliner, the Boeing 777. The kind of films Sabbagh and his camera crews make have been called 'process' and 'saturation documentaries' because they involve years of filming every aspect and all the phases of projects. Editing the raw material for the *Boeing* series – 250 hours – also took years. The series' budget exceeded £800,000.

In September 1993 *The Story of the Roman Arena* was transmitted a part of BBC-2's *Timewatch* strand. This programme was unusual in that it demonstrated the relation between culture and political power, architecture and barbarism. The glories of ancient Rome were based on the military conquest of other tribes, a system of slavery and forms of public entertainment in which captives and animals were killed in huge numbers. The latter took place in massive amphitheatres, such as the Colosseum in Rome, which tourists now admire as ancient monuments. A chilling account of the cruelties and slaughter that went on for hundreds of years in the Colosseum was given in the *Timewatch* programme, which also paid due heed to its design and structure. Significantly, *Timewatch* is a general history strand not an arts or architecture strand. Arts programmes about buildings rarely consider the issue of social and political functions in such detail.

The Look, a mini-series transmitted on BBC-2 in 1992, supplied a sustained critique of the fashion business. Janet Street-Porter was executive producer for the series while the films themselves were produced and directed by Gina and Jeremy Newson of Freelance Film Partners. The same team subsequently made

a similar, second series – *The Music Biz* (BBC-2, 1995) – that examined the rock music industry. The Newsons approached the world of fashion with the cool, objective eyes of outsiders; their analysis was at once factual and sceptical; it also utilised anthropological concepts. Fly-on-the-wall documentary footage by various film crews was interspersed with interviews with fashion designers, buyers and press critics. Connecting the component parts was a voice-over commentary, delivered by Jeremy Newson, that was the most incisive and acerbic I have ever heard on television. Relations between culture and commerce, between design, desire and dollars, have never been so clearly explicated. What the Newsons' two series made vivid were the human lusts for fame and glory, status and power, publicity and money that fuels the global cultural industries in question. 'Demystification' is a word that is not as fashionable as it once was, but it aptly describes the intention and impact of the Newsons' series. The Roland Barthes of *Mythologies* would have been proud of them.

NOTES

1. Januszczak quoted in Hugh Herbert, 'Culture Mulch', *The Guardian*, 1 November 1995, p 12.

2. A more detailed account of *Relative Values* is provided in my book *Arts TV: A History of Arts Television in Britain*, London, Arts Council & John Libbey, 1993, pp 185-7.

3. A view expressed by BBC-2 staff to the author in 1990 when he was consulted regarding the content of one of the *Relative Values* programmes.

4. Martin Wroe, a journalist, reported Sister Wendy's view that 'Art is a small door to God. The big door is the Church', 'Art Star Sister Wendy Happy Silent Role', *The Observer*, 8 May 1984, p 11.

5. Greer's opinion was cited in 'Pass Notes No. 364: Sister Wendy's Beckett', *The Guardian*, 7 March 1994, p 3.

6. Joanna Coles, 'Provocations: Art Takes the Low Road', *The Guardian*, 20 November 1995, p 9.

7. Ferry has a BA degree in fine art. He was a student of Hamilton's in Newcastle-Upon-Tyne from 1964 to 1968. Roxy Music was founded in the early Seventies. See my book *Cross-Overs: Art into Pop, Pop into Art*, London & New York, Comedia/ Methuen, 1987, pp 26-7.

8. For an account of Latham's art see my monograph: *John Latham: The Incidental Person – His Art and Ideas*, London, Middlesex University Press, 1995.

9. Delia Smith is a cook with her own television series. The fact that her 1995 tie-in book *Winter Collection* was an instant best-seller implies that the 'art' which the majority of British people enjoy is cookery. (This at a time when some poor people in Britain are reported to be suffering from malnutrition...) In addition to our bellies, we British are fond of romance and heritage. Well-acted, middlebrow television costume dramas based on classic English novels such as *Middlemarch* and *Pride and Prejudice* have attracted millions of viewers. One unforeseen consequence of these series was a greater appreciation of the built environment: the towns and country houses which provided the settings for the costume dramas were later inundated with tourists keen to view the locations.

10. W. Januszczak, 'All Mod Cons', *The Guardian*, 20 October 1995, pp 6-7.

11. *ibid.*

12. Eva Cockcroft, 'Abstract Expressionism, Weapon of the Cold War', *Artforum*, vol 12 no 10 June 1974, pp 39-41.

13. Televised debates (e.g. *The Great Cultural Debate, The Late Show* [BBC-2, 25 February 1992]) about these matters proved inconclusive. In my view, there was a failure to distinguish between two, separate issues: first, the issue of comparing different types or levels of culture; the second, the issue of distinguishing quality. Qualitative differences can surely be discerned *within* different categories and genres.

14. See 'Hostilities Rage on Channel 4 Funding' and M. Bragg 'Pennies from Brookside', *The Guardian*, 13 December 1995, p 5 and p 17; and John Willis, 'True to our Aims', *The Guardian*, 18 December 1995, pp 14-15.

15. While *The Late Show* envisaged the death of avant-garde art, what it did not envisage was its own demise two years later.

7
Artists' Mythologies and Media Genius, Madness and Art History

Griselda Pollock

In the growing Marxist literature on the history of art considerable attention has been paid to the defaults of current art history: the failure of that discipline which purports to provide a history of art, to engage with, or even acknowledge, any but the most simplistic, recognisable notion of history, let alone of production, class or ideology. Crucial questions have not been posed about how art history works to exclude from its field of dicourse history, class, ideology, to produce an ideological, 'pure' space for something called 'art', sealed off from and impenetrable to any attempt to locate art practice within a history of production and social relations. The absence of such work is critical on many accounts. It is a major impediment to radical practices within and on art history – for without an analysis of the ideologies of art history, radical studies of artistic production have no effect as an intervention. They can be represented by the art historical establishment as a marginal alternative, dismissed as an unwarrantable extension of other academic disciplines, such as sociology, or as political ideologies, which are considered extrinsic to art history's 'proper' concerns. Above all, they are rejected as self-evidently anti-'art'. Without identifying the effects of art-historical ideologies as guarantees of dominant notions of art and the artist, the different kind of work on the history of this area of cultural production is prevented from having any effect on art history and other areas of cultural analysis and practice. That specific area of cultural production known as the history of art is marginalised. It is either dismissed by leftist populism as an elitist extension of high culture or is simply unexamined through ignorance of either art history or its effects. Furthermore, when some attempts are made to reclaim art for history, they tend to occur within a liberal ideology of art as document of social history. This

chapter is primarily an account of the dominance of the ideologies of art history across a wide and extended field of cultural discourse, sites of cultural consumption and areas of cultural practice. In this chapter I shall concentrate on the central constructions of art and the artist produced by art history and secured by its hegemonic role throughout this network. The prime area of attention is the figure of the artist. In 1949, the Marxist art historian Frederik Antal wrote a paper 'Remarks on the Method of Art History'. He considered the historical development of the discipline and the various tendencies within different schools of art history which had emerged since the late nineteenth century. He concluded the survey, which is still pertinent, with the following observations:

> although lately it has become fashionable to introduce a few historical facts, these may only enter the art historical picture when confined to hackneyed political history, in a diluted form, which gives as little indication as possible of the existing structure of society and does not disturb the romantic twilight of the atmosphere. The last redoubt which will be held as long as possible is, of course, the most deep-rooted nineteenth century belief...of the incalculable nature of genius in art.[1]

This core, against which all attempts to investigate modes and systems of representation and historical conditions of production (ie a social history of art) break, is signified by the most typical discursive forms of art historical research and writing – the monograph (a study of the artist's life and work), and the *catalogue raisonné* (the collection of the complete oeuvre of the artist whose coherence as an individual creator is produced by assembling all of his or (rarely) her work in an expressive totality). But there is more to this than collecting diverse fragments in order to unite them by a designated author, a category problematized and analysed by Foucault and taken up in debates in *Screen* in the late 1970s.[2] The preoccupation with the individual artist is symptomatic of the work accomplished in art history – the production of an artistic subject for works of art. The subject constructed from the art work is then posited as the exclusive source of meaning – ie, of 'art', and the effect of this is to remove 'art' from historical or textual analysis by representing it solely as the 'expression' of the creative personality of the artist. Art is therefore neither public, social, nor a product of work. Art and the artist become reflexive, mystically bound into an unbreakable circuit which produces the artist as the subject of the art work and the art work as the means of

contemplative access to that subject's 'transcendent' and creative subjectivity. The construction of an artistic subject for art is accomplished through current discursive structures – the biographic, which focuses exclusively on the individual, and the narrative, which produces coherent, linear, causal sequences through which an artistic subject is realised. I think it is useful to apply some of these categories of the analysis of narrative to the writing of art history, which not only narrates certain events but constitutes them as a narrative, subjected to a teleological impulse, while also enjoining 'narrativity' from the reader by the presentation of the events narrated in the coherence within the orders of temporality and causality. Art history can be therefore designated as a *literature* rather than a history or a historical discourse.

The material for my argument comes from a detailed case-study of a nineteenth century Dutch painter, Vincent Van Gogh (also cited as VG[3]), who occupies a special place in both art history and 'general knowledge'. VG is *the* well-known and popular artist. No other Western European painter is so universally familiar. More reproductions are sold of his work than any other artist of any country, school or period. Exhibitions of his work draw large crowds throughout the world from New York to Korea. He is the subject of innumerable books, films (like *Lust for Life* (1956)), novels, television documentaries and so on. A large museum is now dedicated to VG – the Rijksmuseum Vincent Van Gogh in Amsterdam – and displays a permanent exhibition of his paintings and drawings while also selling books, postcards, calendars, slides and other memorabilia to tourists from all over the world. VG reproductions adorn school corridors and dentists' waiting rooms. An exhibition in 1979 at a museum in Groningen in the Netherlands documented a movement in the 1940s and 1950s for the improvement and modernization of taste and decoration in working class homes. Reproductions of VG's paintings were conspicuous on the walls of these model homes.

This exceptional status and degree of popular knowledge can be relied upon as mediation between these publics and 'art' in general. For instance the title of a touring exhibition sent in 1979 by the Dutch Government to Japan and the Far East was packaged as 'Dutch painting in the Century of Van Gogh'. On 14 November 1979, a large and expensive exhibition of European painting from 1880-1905 entitled 'Post-Impressionism' opened at the Royal Academy in London. One example of attendant publicity for this show was the cover of the *Observer Colour Supplement* which reproduced a portrait by Van Gogh and was

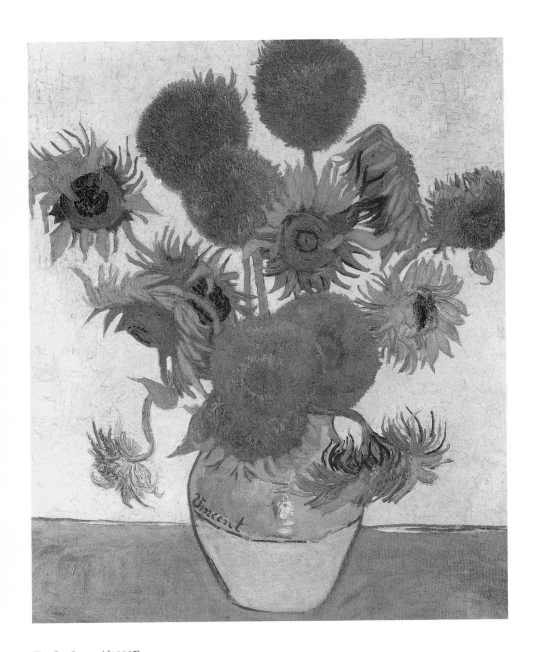

'The Sunflowers' (1888?)

captioned: 'The Post Impressionists-William Feaver on a major new show of paintings by Van Gogh and other artists.' Post-Impressionism, the designation of a period of art practice, is personalised and individualised as a group of artists, the Post-Impressionists. But it was the name Van Gogh, the artist represented by a characteristically accessible and humanist portrait, that was used as the publicity draw. This 'popularity', this status evidenced by the use of 'Van Gogh' as a signifier of artist, as a sign in an advertisement for an art exhibition, as the mediator between general publics and 'other artists', and indeed other art, present in this variety of sites and texts, indicates that 'Van Gogh' has become a paradigm of the 'modern artist'.

Closer reading of the variety of texts through which this figure 'Van Gogh' is constructed produces a more complex signification. Around his life and work what appears to be a particular form of discourse has developed – a special way of discussing the artist and his works which is presented as if it were only a response to, a reflection of, his exceptional special individuality, his genius. By investigating the constitution of this special discourse in art historical literature, and in many other tests which address 'Van Gogh', it is possible to show the contrary. These modes which offer themselves as appropriate and singular approaches to a discrete individual are, in effect, the paradigmatic modes of art history's construction of the artistic subject, and the category of art.

Although this argument is based in part on moving out of the area of art historical discourse and tracing 'Van Gogh' across a number of texts and representations, the important effect of this mapping out of the reading of VG is that it returns us to art history, to its curatorial role in culture, producing and ensuring particular constructions of art and definitions of the artist.

This can best be examined by taking two examples from art historical texts in which two authors who occupy respected and influential positions within art history have addressed the issue of VG's popular status and appeal, Novotny and Hammacher. In 1953 the Viennese art-historian, Fritz Novotny, published a study on 'The popularity of Van Gogh'[4] in which he attempted to refute the idea that Van Gogh's renown was falsely based on a fascination with his unhappy life. Novotny's article opens by quoting a 1947 radio broadcast in which it was argued that VG's popularity was spurious. It resulted from the over-exploitation of the human interest of his biography, the dramatic events of his life, his suicide, 'sentimental factors' and 'curiosity' about his 'abnormalities'. However, as I shall show, the apparent distance between the popularising and the art

historical correctives which follow is little more than appearance. What is at stake is power, control over what is said and how it is said in order to retrieve VG from popular humanism – 'he was a bit odd but really he suffered just like the rest of us' and to relocate him in that special sphere, art, the domain of art history.

In Novotny's opinion, Van Gogh's popularity was genuinely 'a quite extraordinary phenomenon – great art becomes popular in the true sense'. For Novotny it was VG's greatness as an artist and the accessibility of his art that produced VC's widespread appeal. Novotny discounted his life or personality as pertinent to an understanding of VG's art. He sought to explain why 'Van Gogh's art has proven approachable for an astonishingly great number of people'. A number of problems inherent in Novotny's formulations are immediately apparent – his categories of great art and popular appeal, his notion of an absolute separation between the personality of the man and the character of the artist, his constant surprise that great art should attract a great number of people, as if there were no interests and institutions at work in the manufacture of the books, the organisation of the exhibitions, the production of broadcasts, and so on.

However, Novotny's argument is not as radical a departure from the position he is criticising as it might at first appear. In the place of the psychobiographical over-emphasis on Van Gogh's life and personal misfortunes, he offers a reading of the paintings that is in fact profoundly psychobiographical. I use the term psychobiographical to characterise the psychologistic emphases which occur in both art historical and related literature on VG. These studies are not merely narrations of the events of VG's life and work but psychological interpretations whose main drive is to discover the subjective 'truth of the artist'.

Novotny constructs from the careful analysis of VG's paintings and drawings an artistic subject, the personality of the painter. The distinction I perceive between Novotny and those he is criticising is one between the subjectivity of an individual expressing itself in painting and the subjectivity of a painter revealed through the paintings. The distinction may seem slight but the emphasis is crucial because what is at issue is the notion of an unhappy man who paints and, on the other hand, an artist into whose 'artistness' all other facets and circumstances of his living are subsumed. Novotny wrote in order to challenge the tendency to mistake Van Gogh's personal biography for an artistic biography. And it is the production of that exclusively artistic subject that is the main project of art historical practice.

In place of, for example, Irving Stone's biography of a man who was an artist, *Lust for Life* (1935), the art historian produces the monograph which, while, in effect, not more than an illustrated biography, traces the life of a special kind of person, the artist, from life to death,within the narrow limits of only that which serves to render all that is narrated as signifiers of artistness. The monograph is paralleled by the catalogue raisonné – the chronological ordering of the products of this 'artistness' through which can be reconstructed the linear development of an artistic biography. The catalogue raisonné also performs an economic function, for it is the main means by which art history services the art maker through authentication, dating, and providing provenances ('pedigrees' of the painting's previous owners back to the moment it left the artist's workshop or studio), back to its creative origin. The economic value of a painting depends also on the status of its author. A painting by Rembrandt is more valuable than a work by a lesser known contemporary, primarily because a 'Rembrandt' has a documented place within an oeuvre, an oeuvre which has a subject – the 'Rembrandt' produced within the overlapping discourses of monograph and catalogue. It is easy to trace the correlation between the 'rediscovery' of a hitherto unknown artist, the production of a catalogue of all the known works by that artist, the publication of a monographic study and the rise and stabilisation of high prices for works by that artist on the art market.

The first catalogue raisonné of the work of VG was published in the 1920s, revised in the 1930s and re-edited and republished in a lavishly illustrated form in 1970. The introductory essay, by A M Hammacher, entitled 'Van Gogh and the Words', surveyed the main tendencies of Van Gogh literature, since his death in 1890, to 1970. Hammacher also addressed the popular status of VG and asked:

> Do people go in crowds to queue at exhibitions out of love of the myth
> of painting and sculpture, out of love for a style, or is it, where Van Gogh
> is concerned, a popularity that is aroused via the intermediary of *Lust for
> Life?* Are the words, Vincent's and other men's words, unavoidable on the
> way to the paintings.[5]

Such a passage raised further questions – it implies the possibility of a 'pure' response to and an unmediated experience of VG's paintings. Words, whether VG's or others, are seen as obstacles on the way to the paintings. Hammacher's text typifies an assumption which one encounters amongst artists, art students,

art historians and in texts which pose themselves as 'radical' alternatives. Paintings are proferred as the repository of VG's meanings of and for himself, and the viewer is positioned as witness to him and his meanings, through direct visual or perceptual 'experience'.

In a subsequent passage, Hammacher expresses his pleasure at the spectacle of countless Japanese, from the Emperor to shoeshine boys, filing happily through the 1958 VG exhibition in Tokyo concluding 'One may safely forget the art slogans of "democracy" and "socialization" [mistranslation for socialism I presume]'. The genuine 'popularity' of VG is presented as having trans-class, trans-cultural accessibility. Bourgeois humanism – the category of man as a universal figure above and outside of class relations – is reproduced within the notion of art as the embodiment of an artistic subject which is available to direct perception. The multiplicity of readings of VG's paintings from different class and cultural positions are subsumed into a notion of his accessibility sustained by the construction of art as a visual experience of a self – exposed in paint on canvas.

It is here that we encounter the manoeuvres of art historical writing to secure the dominance of its discourses, its frames of reference, over all other words on art. The discipline lives by producing and selling its words – a literature; it disdains and seeks to displace all non-art-historically formulated words – like, for instance, Stone's fictional biography of VG. The regulated, institutionally trained, professional literature of art history uses its own words to produce a notion of art as ineffable, pristine, discrete – a non-verbal experience rooted in the difference of the artist, who is simultaneously distinct from other men and yet the epitome of universal man. It thus simultaneously separates art from social history and protects its own position as the privileged producer of a 'literature of art'.

If VG is produced as the paradigm of the artist, that place is supported by the assimilation of VG to another historical representation, the correspondence of 'madness' and 'art' – the myth of the mad genius. All aspects of VG's life story and the stylistic features of the work culminating in VG's self-mutilation and suicide has provided material to be reworked into a complex but familiar image of the madness of the artist – 'sensitive, tormented, yet incredibly brilliant' as an advertisement for a limited edition of gold medals struck with reproductions of VG's most famous paintings in a *Sunday Times Colour Supplement* aptly restated it.

The question presents itself: Why do we need VG as mad genius? This can best be considered by recognising that the notions of madness and art which produce the category 'mad genius' have little to do with clinical pathology or definitions of sanity, but circle around categories of difference, otherness, excess. They concern those special and distinct modes of being which set the artist ineffably apart. Some have argued that the madness attributed to the artist is a means of displacing the threat of rupture of discourse produced by artistic practices. I find this suspiciously romantic: it is already part of the myth of mad genius. For the present I want to suggest that the discourse on madness and art operates to sever art and artist from history and to render both unavailable to those without the specialised knowledge of its processes which history claims for itself. The art historian, the trained professional, stands as the necessary mediator of art to the public: art historical words function as exegesis or translation; historical analysis is replaced by what Macherey designated as 'interpretative criticism'. This practice attempts to dismantle the art work or text to liberate and extract an immanent but singular meaning.

> translation and reduction: focusing the apparent diversity of the work in
> a single signification. [And]; Thus we have posited the principles of an
> immanent criticism: the work encloses a meaning which must be
> released; the letter of the work is a mask, eloquent and deceptive which
> this meaning bears; a knowledge of the work is an ascent to this central
> unique meaning.[6]

In terms of art history and tendencies to such interpretative criticism, the meaning extracted from an artistic text is that which produces as meaning an authorial subjectivity, the artist. The implication of genius and madness serves to secure that subjectivity as the revealed meaning of the work of art.

Art historical practice takes place within specific but diversified conditions of production – both the production of knowledge of definition for art, and the production of books and related commodities that purvey that knowledge. Van Gogh occupies a particular place in art publishing, not only in terms of large, expensive and weighty tomes, like the three volumes of his letters (often presented as diaries of an autobiography) translated and published in numerous languages, the catalogue raisonné, and the costly volumes of redatings of the letters and redating of the paintings with letter extracts. All of these construct a linear, sequential narrative of VG's journey to death. The largest section of VG publications are those monographic studies simply

entitled 'Van Gogh', with a portrait or self-portrait on the cover. These, with the proliferating essays of psychologistic and psycho-symbolic interpretations, far outnumber the relatively scarce studies of aspects of an artistic practice.

There are a number of historical factors that have made VG available for this appropriation, commencing with the reception and critical assessment of his work by Symbolist and Expressionist critics and artists, who first produced a 'Van Gogh' which would be a potential candidate for a place in art history. For instance, in Germany, the Expressionist movement took up the figure of VG not so much as an artistic resource, but as an artistic subject. He figured as hero in a novel, Meier Graefe's *Roman eines Göttsuchers* (1932), and was subjected by authors and playwrights to dramatic characterization in accordance with their own ideological and aesthetic positions. Carl Sternheim, for instance, published a short story *Gaugin and Van Gogh* in 1924 to argue a position current in German Expressionism. But even in one of the very first critical essays in France on VG, published before his death in January 1890 by a Symbolist critic, Albert Aurier, one finds the shape of his now established historical persona critically prefigured. The article was influentially entitled: 'Les Isolés – Vincent Van Gogh' and was published in the first issue of *Mercure de France* in 1890. In this, Aurier stated:

> it is permissible to make certain deductions from his works about Vincent Van Gogh, about his temperament as a man, or rather as an artist – a deduction which I could corroborate from biographical details if I wanted. What characterises his whole work is excess, of force, excess of nervous energy, of violence in expression In his categorical affirmation of the character of things, in his often fearless simplifications of forms, in his insolence in challenging the sun head-on, in the vehement expression of his drawings and of his colour, even to the least particulars of his technique, he reveals himself as powerful, a male, a daredevil, frequently brutal and sometimes ingeniously delicate. And even more, one can guess, from the almost orgiastic. expressiveness of everything he has painted, here is a man of exaltation, an enemy of bourgeois sobriety and minutiae, a sort of drunken giant, *a terrible and maddened genius*, often sublime, sometimes grotesque, always rising to a level that comes close to *pathological* states. [my emphasis]

It is possible to make a checklist from Aurier's article of all the elements of the traditional myth of artist as mad genius. Aside from his own use of the term,

there is 'excess', 'mania' and 'pathology'. These are coupled with the intention to find a biography and read the personality of this artistic subject off from the paintings in which it is so transparently expressed. Such a combination of myth and psychobiography not only informs later art historical readings but finds its fullest realisation within what Hammacher calls *la vie romancée* – the fictional biography or the romanticised life – terms which distinguish the popular fiction from art historical narrative.

Attempts to dislodge these readings of VG as the paradigmatic figure of artist and mad genius encounter not only traditions of interpretation, lodged within the discursive practices of art history, but the wide dispersion of such myths, the whole ideological project typified by the construct VG throughout all these facets of production of a literature of art. A further constraint is publishing practice.

In 1978 a colleague, Fred Orton, and I were approached by Phaidon Press to write a short book on Van Gogh for their series on major artists and important movements. The initial title suggested by the publishers was *Van Gogh: The Tortured Sun*; our alternative was rather more prosaic: *Rooted in the Soil – A Van Gogh Primer*. We suggested that the cover illustration should bespeak the book's intention to mark a different reading of VG which was to examine more closely the major concerns of the work and reassess its intervention in the history of modern art. Yet the book was published (in September 1978) with a cover showing a self portrait and the title *Vincent Van Gogh, Artist of his Time*. The latter represented a major concession to our 'novel' suggestion that Van Gogh had lived and worked in a particular historical period and that this intriguing fact in some way pertained to our reading of his work. The decisions at Phaidon were not, we discovered, editorial. In order to sell yet another book on Van Gogh, the jacket and title had to conform to a brand identity and signify 'Van Gogh' – to present a recognisable and saleable commodity.

The opening words of our text made clear that we had laid aside biographic interests and considered his epileptic condition as irrelevant to the study of the work. However, we were sent a jacket blurb to proof which said that 'everyone knows that Van Gogh went mad and killed himself but here is a new interpretation of the artist's work'. In so far as we intended to provide an historical study of paintings and drawings in the form of a pictorial essay, a special distinction was drawn for our book by the publishers between 'the man' and his 'art'. But his familiar identity as the mad genius was placed as a kind of

frame within which our alternative approach could be situated and contained.

One of the most prestigious academic journals in art history is the *Burlington Magazine* and its section for reviews of current publications is significantly titled 'The Literature of Art'. There our book was reviewed in July 1979. The fact that we had attempted to locate VG within the historical moment 'of his time' presented considerable problems for the reviewer and necessitated a careful refutation:

> another recurrent theme in the essay is the notion that Vincent felt the 'need to assert a specific and increasingly anachronistic' (here a certain tendentiousness of thinking perhaps creeps in) 'view of the necessary relations between men and the earth'. This is seen as what above all else marks the 'underlying thematic unity' of his whole career whether directly expressed as in the *Potato Eaters* or dialectically as in the British Museum's F 1424 with its 'old' horse drawn buggy and its little railway train. It would be unjust and unfair to complain unduly of what may be felt to be a somewhat Procrustean application of social-historical conceptualisations. The authors are able to adduce contemporary documentation: and have not the space to develop their argument, but the *ex post facto* is here hovering in the wings.

Such a passage assumes once again that any historicising or socialising analysis is extrinsic (what writing of history isn't *ex post facto?*) to the self-evident integrity of art works. We are told that VG's practice is not there to be studied as cultural production within historical conditions. However, the problem is that self-evidence, that givenness, the discrete integrity of art and artist, has, of course, to be produced, secured, and protected from those who argue for a history of artistic production, for art history as part of other histories, of the history of social relations and ideological representations.

Art history has to be recognised as a complex and paradoxical practice in which art is differentiated from all other areas of knowledge, secured by the positioning of a centre, the artist as the cause of all art. Art is distanced from history – produced as an autonomous, transcendental condition of human subjectivity and creativity. And, as importantly, art history is differentiated from all other discourses which attempt to reclaim art from that space and reconstitute it as a historically determined practice while deconstructing the centrality of the artist as subject of and for the work of art. Art history lays

claim to this terrain through particular operations. In the second section of this chapter I want to examine in detail a variety of art historical and non-art historical areas, to trace the dispersion of its ideologies in a network of overlapping discourses which offer guarantees to art history.

VAN GOGH AND THE PATHOLOGICAL SYNDROME

On 29 July 1890 a Dutch painter named Vincent Van Gogh died from self-inflicted gunshot wounds. This event has determined the constructions of the artistic subject 'Van Gogh'. It is both the climax to and necessary closure of the narratives from which VG is produced. The suicide is taken to be an artificially significant event in terms of the artist who was both its agent and of whom it provides the explanation.

For some two or three years before July 1890 the Dutch painter is known to have suffered periodic fits during one of which he mutilated a small section of the lobe of his right ear. Speculations have been numerous on the nature and cause of these fits and associated actions. Because the painter spent a year in a mental asylum (May 1889-90) it has been readily assumed that VG was mentally ill. But in so far as the subject of this unspecified mental illness has been positioned as an artist, this madness, whether labelled schizophrenia, manic-depression or epilepsy, has been accommodated to and offered as support for a pre-existing artistic myth, that of mad genius.

In their book on the changing notions of the artist in European history since the Sixteenth century, *Born Under Saturn* (1963) R and M Wittkower provide a brief history of this category – including the Platonic idea of 'mania' – of artists as subject to an inspired and socially dangerous form of excessive behaviour, an unreasonable but creative madness which is synonymous with enthusiasm, and visionariness. They cite Seneca: 'There has never been great talent without a touch of madness' and Schopenhauer: 'Genius is nearer to madness than average intelligence'. But significantly, by the late Nineteenth century, morbidity and death are added to the beliefs about the abnormal condition of great art, as in, for instance, an article in the *Popular Science Monthly* in 1893 entitled 'Genius and Suicide' in which we find 'that evidence is not lacking that genius is a mortal condition'. The main elements of this category of artist to whom is ascribed mania, inspiration, insanity or creatively disordered intelligence, eccentricity or dangerous and abnormal behaviour,

found new support in the modern period from the emergent discourses of psychiatry. But at the same time, in so far as there was already a category of madness associated with creativity, psychiatry could claim artists as subjects for their discourses. In the overlap of psychologies of creativity and art history, the myth of the mad genius was reconstituted. The condition of art as akin to madness, as a socially disruptive force or a personally dangerous one, is remade as the condition of the artist's creativity. The artistic persona takes precedence over either the private or the social persona. So in the case of VG, unspecified illness becomes doubly secured as artistic madness. It is treated not only as a facet of his artistness but a confirmation of it. Moreover the art, which of course arises from within this 'mad' artistic subject is examined not only for confirming signs of madness as a general condition of being an artist, but the particular styles and meanings of the art are seen to result exclusively from the maddened state of the producer. In some interpretations, this madness is presumed to be the cause of his creativity. So for instance, the sudden change to brilliant colour which occurred in his works after 1888, coincident with the first documented fits, is explained by the inspiring effect of 'descent' into madness.

A substantial area of the VG literature addressed VG from a psychiatric 'perspective' – what Hammacher labelled the 'pathological syndrome'. One of the first examples of this was published in 1922 by philosopher and psychiatrist, Karl Jaspers.[7] In the next decades books and articles proliferated. There are two main tendencies in the literature on the pathological syndrome. The first is an attempt to diagnose VG's mental illness by conflating periodic fits with his uninterrupted activity as a painter to secure the image of the mad genius, and the second reveals a desire to correlate the interpretation of his art with a specific psychosis.

Jaspers deduced that VG was schizophrenic. His diagnosis was based in part on the limited number of paintings he had seen but predominantly on translations of VG's letters. In order to confirm his diagnosis Jaspers called for the preparation of a comprehensive catalogue raisonné of the paintings and drawings of VG. He would then have a sound chronological framework which would enable him to chart the development of the psychosis. In the absence of such a tool, Jaspers nonetheless attempted to divide Van Gogh's works into stylistic periods, to analyse the characteristics of each stage of his production, and to establish the relationship between stylistic changes and the symptoms of schizophrenia.

The last months of Van Gogh's life were spent in a northern French village, Auvers, where his palette softened, and the paintings evidence a greater dependence on tonality, as opposed to colour, and new methods of drawing in colour emerged. However, from Jaspers' conviction that VG was suffering a deteriorating psychotic condition these changes were interpreted as impoverished, unsure and monotonous. Having established the overall pattern of the years 1888-90, within which he detected the progressive signs of schizophrenia, Jaspers concluded his study with a significant passage which reveals the interaction of early Twentieth century analysis of schizophrenia with traditional ideas, generalised and mythic, about the creative relationship of madness and genius:

> in fact, through its release of certain forces, the mental sickness allowed for the onset of a period of productivity which previously had been precluded. The sickness freed him from certain inhibitions, the unconscious began to play a greater role and the constrictions of civilization were cast aside. From this source as well, there developed certain similarities with dream experiences, with myths, and with the spiritual life of children... It is not only through this form of stimulation that an enhanced productivity is achieved, which also leads to the discovery of new means which are then added to the general artistic nomenclature, but also new powers are aroused. Such powers are, in themselves, intellectually viewed neither healthy nor sick, but they themselves flourish on the bedrock of sickness.[8]

Jaspers links sickness with increased productivity, liberation, and imagination. Psychosis is connected with a particular kind of creativity – creativity perceived as a departure from the adult conscious norm, from civilised restraint, into the liberation of the unconscious – paralleling the child, the dream, the myth. It is both asocial and primitive.

In 1932 Françoise Minkowska disputed Jaspers' diagnosis. Following the opinions of his doctors in the South of France, Peyron and Rey, she concluded that VG suffered from epilepsy. Her analysis is, however, based more directly on his paintings (VG's doctors of course studied the patient who presented himself for treatment and whom they forbade, for the most part, to paint during the time he spent under their care). Teleological inevitability marks Minkowska's readings and so in the search for evidence to support her diagnosis she looked to the pattern of his work, concluding thus her discussion of what she took to be his last painting:

without doubt, in this his final work, the artist had given striking symbolic expression to opposing, inner forces. In our own prosaic manner we can say that these two movements, one of elevation and one of fall, form the structural basis of the epileptic manifestations, just as the two polarities form the base of the epileptoid condition.[9]

In her formal analysis of the paintings, she perceives signs which parallel the epileptic condition she assigns to the artist. In opposition to Jaspers, Minkowska does not seek to establish periodisation and stylistic change. Epilepsy is not progressive or deteriorating. Instead she tries to isolate a psychotic condition in the structural and compositional elements of one and all of his paintings. However, both these authors concur more than they differ. Minkowska's and Jaspers' choice of diagnosis is determined on the basis of presumed characteristics of VG's art. Further, the psychiatric readings, however different in conclusion, both echo typical art historical procedures – periodisation, chronology, or formalist analysis. They both attempt to establish parallels between the nature of art and the condition of psychosis. Finally, both accept that art and psychosis are not only compatible but reflexive – the latter being responsible for the emergence of a distinctive and individual artistic character – VG's style.

This process by which all potentially disparate or conflicting elements of the life and work of VG are unified and rendered coherent is exemplified in another indicative passage from Minkowska:

> the life, the psychosis, the oeuvre of Van Gogh *form an indivisible unity*. Thus, I am unable to speak of a basic stylistic change. In this instance psychosis has not destroyed or modified anything profoundly. In its liberating role, it adds a new note by embodying at its summit the inner tragedy of the artist. [my emphasis][10]

The specific identity of and categorical distinctions between the social and historical circumstance of an individual's life (Life), the production and meanings of objects, paintings and drawings (oeuvre), the intrusive, disruptive and non-productive force of mental illness (psychosis) are thus effaced. Like Jaspers, Minkowska sees VG's condition as liberating and productive, but she adds a new effect – revelation. The unity of life and work that is asserted and the positive effect attributed to the psychosis on that life and work serve a common function, to give access to the inner tragedy of the artist, and thus to make visible the organising subjectivity of the artist.

Such texts can both be criticised for the inadequacy and lack of rigour in diagnoses as well as for the invocation of mythic notions about the artist. But what is most striking and relevant for my purposes is the correspondence between the psychiatric analysis of an artist and the typical modes of art history. The premises may differ but the effects are not dissimilar – a chronological and in some cases teleological approach, the reading of paintings for the signs of the artist, the production of the artistic subject from the traces of his work, the unification of all experiences and products of an historical individual, Van Gogh, as the seamless unity of the artist.

An accurate diagnosis of the condition from which the Dutch painter suffered is necessary, not because I am suggesting that there is a real and different VG to be reclaimed from the myth, nor because I am simply suggesting that these authors did not do their research properly, but for the reason that on the terrain of biography or, more correctly, psychobiography, within which Van Gogh is constituted, historical material can be adduced which categorically disallows the kind of totalisation that is the project and effect of this literature.

The doctors Rey and Peyron, first in the hospital at Arles and later in the clinic at St. Rémy, consistently believed that Van Gogh was an epileptic.[11] In letters to his family, and particularly his brother Theo, Van Gogh exhibited considerable interest in this condition. These texts, as documents, were available to earlier writers and their words are decisive. According to them the attacks were clearly terrifying and disturbing experiences. But in a letter from the asylum of 1889 (LT 592) Van Gogh wrote that the doctors had been reassuring. Not only did others experience the hallucinations and hearing of voices but had been known to injure themselves in a similar manner; one epileptic had also attacked his own ear. Some months later Van Gogh wrote:

> I think Dr. Peyron is right when he says that I am not strictly mad
> for my mind is absolutely normal in the intervals, even more so than
> before. But during the attacks it is terrible, then I lose consciousness of
> everything. But that spurs me on to work and to seriousness, like a miner
> who is always in danger and makes haste in what he does. (LT 610,
> October 1889)

Recent research has supported this contemporary diagnosis, which has always been recognised by those not involved directly in the VG industry. However, two forms of epilepsy have been suggested: some believe that Van Gogh suffered from what is known as psycho-motor epilepsy, probably caused by slight brain

damage at birth; a recent essay by Margaret Ochocki[12] convincingly argued that VG may have developed symptomatic epilepsy through his consumption of absinthe, which VG first encountered when he moved to Paris in 1886. He was known to take it in vast quantities as a substitute for food during his time in Arles (1888-9). In both psycho-motor and symptomatic epilepsy, the effects are similar, that is to say, periodic and intense attacks of a few minutes' duration, preceded by seconds or minutes during which perceptions and sensations may undergo a change, succeeded by longer periods of lethargy and exhaustion, lasting perhaps a month at the most, and followed by complete recovery. Between 1887 and 1890 Van Gogh suffered approximately seven fits, some of which were experienced only as spells of faintness.[13] Their incidence is therefore confined to a brief period in his mid-thirties. They were of limited duration and occurred in some cases only on visits from the asylum to Arles where VG may well have drunk absinthe. It is also worth noting, as Ochocki does, that the common treatment in the late Nineteenth century was the prescription of bromide, itself now known to be a possible inciter of epileptic attacks. Bromide can accumulate in the body and contribute to a later development of 'nervous disorders' after the treatment has ceased.

Such knowledge of the poisonous nature of absinthe or the deleterious effects of bromide, which we now have, was not current in the Nineteenth century although the connection between alcohol and epilepsy is hinted at in one of VG's letters (LT 585). The ways in which VG and his doctors could make sense of or represent this condition were therefore historically specific and the term that recurs is that of a 'nervous condition'. VG himself was positioned within historical practices and discourses which proposed some correspondences between abnormal conditions, excess and the practice of art, or the life of an artist. It is not surprising that Van Gogh should have taken note of an article in *Le Figaro* about another artist who suffered from a 'nervous condition' which is now known to have been psycho-motor epilepsy, namely the Russian author, Dostoyevsky. In a novel, *The Idiot* (1868), Dostoyevsky offered a representation of the condition of psycho-motor epilepsy through the character of Prince Mishkin. At one point in the novel this character is given an interior monologue in which he tries to describe the state that occurred just prior to the onset of an epileptic fit. It is worth quoting from:

> he was thinking, incidentally, that there was a moment or two in his
> epileptic conditions almost before the fit itself... when suddenly amid the
> sadness, the spiritual darkness and depression, his brain seemed to catch

fire at brief moments, and with an extraordinary momentum his vital forces were strained to the utmost all at once. His sensation of being alive and his awareness increased tenfold at those moments which flashed by like lightning... All his agitation, all his doubts and worries seemed composed in a twinkling, culminating in a great calm, full of serene and harmonious joy and hope, full of understanding and the knowledge of the final cause... for it was not abnormal and fantastic visions he saw at that moment, as under the influence of hashish, opium or spirits, which debased the reason and distorted the mind. He could reason sanely about it when the attack was over and he was well again. Those moments were merely an intense heightening of awareness – if this condition had to be expressed in a word – of awareness and at the same time of the most direct sensation of one's own existence to the most intense degree.

Such a representation does not offer us a truth about epilepsy, but a way of reading it which points to a very different set of possibilities with regard to VG and the epileptic condition. It is absolutely impossible to determine what use VG may have made of the visions he may have had preceding the onset of one of the few fits he endured. Such representations as we do have in the texts of the letters tend to correspond with Dostoyevsky's picture of brief moments which could be reconsidered and reworked during the prevailing periods of lucidity and calm. VG's letters speak of other kinds of experiences, religious visions, for instance, which he found loathsome and rejected, or times when a fit came on but he was able to complete a painting on which he was working before unconsciousness overcame him. It is unwarrantable, however, to argue that the condition determined what or how he painted. VG cannot be positioned as mad in the sense of a continuous or progressive alteration of mental states; but as epileptic, Van Gogh was subject to rare but periodic inconveniences (terrifying as the onset of a fit may have been), of attacks which rendered him momentarily unconscious, exhausted and unable to paint until the effects wore off.

Such arguments and alternative readings, however, are not sufficient to refute the construction of Van Gogh as mad artist, precisely because the base of that construction is neither clinical pathology nor readings of historical evidence. The pathological syndrome is both a support for and arises within the dominant narrative and psychobiographical structures of the literature we call art history.

I mentioned earlier that Karl Jaspers' interpretation of VG called for the production of a catalogue raisonné, the chronological ordering of the complete works which could provide access to the psychic and artistic profile of VG. In the majority of studies of VG, general discussion of his crises of fits is subsumed into an exclusive concentration on the two most dramatic incidents, posed as revealing self-mutilations. In one, a small section of an ear lobe (not the whole ear) was sliced at the height of a crisis in December 1888. The other is the quiet and determined suicide which has been constructed from the act of shooting himself in the stomach in July 1890.

An article in *Horizon*[14] put forward a quite convincing argument that VG would not have died had a doctor been called in time. Morgan, rather unwarrantably, points the finger at the homeopathic doctor Gachet, under whose auspices VG was staying in Auvers, for not having brought in proper medical treatment for what were not fatal gunshot wounds. It has always been assumed that Van Gogh shot himself in the lower lungs or stomach and not his heart because of the disturbed and therefore incompetent state he was in. But it is not beyond the bounds of reasonable conjecture that VG actually shot himself, not to kill himself, but to bind his brother and sole source of financial support to him more closely, to blackmail him as he had done many times before in order to ensure VG's own financial security. His death may have been no more than a fatal mistake.

However, these two disparate and probably inexplicable events provide material for the myth. They are conflated to signify the suffering and madness of the artist. They have become vital clues to the interpretation of his painting, because his madness is subsumed into the fact of his being an artist. But since this suicide put an end to his painting as well as to his life it has been necessary to rewrite the narrative of Van Gogh's artistic practice as leading inevitably towards that death.

In order to explore the ramifications of the above I want to look at the one painting by VG that occupies a crucial place in the literature on VG, serving as the visual and psychological climax of art historical, fictional and filmic representations of his life and work.

There is only one painting by Van Gogh (known as 'Crows over the Wheatfields' [Amsterdam Rijksmuseum Vincent Van Gogh]) that immediately offers itself for

'Long Grass with Butterflies' (1890?)

misrecognition as symbolic of personal anguish, psychological dissolution and loss of power. Until a relatively recent thesis established a correct dating of the paintings of VG's last months, this one painting was universally assumed to be the last work and testament.[15] Indeed so over-determined was this work that it was used to signify Van Gogh on the cover of the 1970 catalogue raisonné. It was, in fact, painted in the first week of July 1890 and not on July 27, the date on which he wounded himself, two days before he bled to death. The last major Van Gogh exhibition in England was held in the Hayward Gallery in 1968. The sequence of the hanging was not only strictly chronological but dramatic in its effects. The visitor was taken on a journey through VG's life and struggle and the exhibition concluded with two canvases, one of which was 'Crows over the Wheatfields', for which the catalogue entry disingenuously reads:

'Corn field with Cypresses' (1889)

this painting is not in fact Vincent's last work, though the force of the imagery makes it appropriate for the position.

To give some impression of the kind of exegesis to which this painting has been subjected I quote three examples from different kinds of literature. Françoise Minkowska:

there is here a heavy and menacing sky which weighs down upon the earth, as if wishing to crush it. The field of wheat moves tumultuously as if wishing to escape the embrace of the hostile force watching over it. It makes a desperate attempt to raise itself towards the sky, but the descending black crows accentuate further the imminence of destruction, the fall, the annihilation. Everything is engulfed in the inevitable shock.

All resistance is useless. Van Gogh put an end to his life and work.[16]

The World of Van Gogh Time and Life Books (1968):

> the sky is a deep and angry blue that overpowers the two clouds on the
> horizon. The foreground is an ill-defined crossroads. The wheat itself rises
> like an angry sky to contend with the stormy sky. In this picture Van
> Gogh painted what he must have felt – the world was closing in on him
> and the roads of escape were blocked.[17]

Meyer Schapiro 'On a Painting of Van Gogh':

> in the 'Crows over the Wheatfields' these centres have fallen apart... the
> great shining sun has broken up into a dark and scattered mass without
> a centre, the black crows which advance from the horizon towards the
> foreground, reversing in their approach the spectator's normal passage
> into the distance; he is, so to speak, their focus, their vanishing point. In
> their zigzag lines they approximate with increasing evidence the unstable
> wavy form of the three roads, uniting on one transverse movement the
> contrary directions of the human paths and the sinister flock. But the
> stable, familiar earth, interlocked with the paths, seems to resist
> perspective control. The artist's will is confused, the world moves
> towards him, he cannot move towards the world. It is as if he felt himself
> completely blocked, but also saw an ominous fate approaching.[18]

Meyer Schapiro occupies an interesting position in art history – he wrote for
the left-wing magazine Partisan Review in the 1930s, has published articles on
the semiological analysis of medieval art and is now enjoying somewhat
belated reappraisal in both Marxist and establishment art historical circles. In
1953 he published an article in Anthropology Today entitled 'Style' in which he
assessed the range of positions in the analysis of artistic style and his
concluding section on 'explanations of style by forms of social life' based on a
development of Marxist theory is that which he himself endorsed in this text:

> only broadly sketched in Marx's work, the theory has rarely been applied
> systematically in a true spirit of investigation such as we see in Marx's
> economic writings... A theory of style adequate to the psychological and
> historical problem has still to be created. It waits for a deeper knowledge
> of the principles of form, construction and expression and for a unified
> theory of the processes of social life in which the practical means of life
> as well as emotional behaviour are compromised.

It is therefore pertinent to examine Schapiro's text not only as a representative academic art historical text. Its significance lies in the fact that in the work of this art historian, who can be claimed for a position within the attempted development of a marxist art history, we can detect the operations of those tendencies in art history which I have indicated as categorically opposed to a Marxist conception of history and artistic production. The article opens thus:

> among Van Gogh's paintings the *Crows over the Wheatfields* is for me the deepest avowal. It was painted a few days before his suicide, and in the letter in which he speaks of it we recognise the same mood as in the picture.

As an art historian concerned with the principles of style, form and expression, Schapiro's subsequent discussion of the painting begins with an outline of the syntax of the work; he attends to its construction – the disrupted perspective, the organisation of colour and the animated facture (that is the mode of application of paint and its effects). He initially remarks upon the format of the canvas used, a doublesquare format measuring 50 x 100 cm. He finds the shape strange, causing a disturbing inversion of the perspective lines. The doublesquare 50 x 100 canvas was, in fact, the most typical of Van Gogh's canvas sizes in the period during which 'Crows over the Wheatfields' was painted (see for example F 770, F 771, F 772, F 773, F 775, F 776, F 777, F 779). Also canvases were by this date mass-produced, their sizes determined by production processes.

Schapiro further draws attention to the colour sequence but he presents it as 'symbolic' of defensive enumeration, an exertion of control over Van Gogh's experience of personal disintegration. Moreover Schapiro tries to locate the painting in the context of VG's letters of the period in which the work is discussed. He has to admit that there is some discrepancy between his anxiety-ridden interpretation and VG's statement about the painting's purpose – to show the restorative forces he perceived in the country while painting the picture. The explanation proposed by Schapiro runs like this: faced with his personal experience of disintegration, symbolised by the 'pathetic disarray' of the perspective in the canvas, Van Gogh used painting as a means of defending himself against his own fears:

> just as a man in neurotic distress counts and enumerates to hold onto things securely and to fight a compulsion, Van Gogh in his extremity of anguish discovers an arithmetical order of colours and shapes to resist decomposition.

Painting is presented as a cathartic process, through which the painter defends himself against himself. VG's painting, according to Schapiro, was an act of high intelligence which forestalled the oncoming collapse. Until 'In the end his despair destroyed him'. Schapiro's analysis is more penetrating, the language of formal analysis and interpretation is more sophisticated than the direct expressionist reading in the Time-Life book. The art historian introduces a problem, however. He allows for paradox, even for disjunctures, but only on the superficial level of apparent conflicts of the evidence. He proffers more knowledge. He searches back into earlier periods to find how VG viewed the act of painting. But nonetheless Schapiro's account is merely a more compelling and sustained investigation into and presentation of the artist's subjectivity. For although VG's art and state of mind are placed in a different relationship (for instance, he is presented as neurotic and tormented, a man more like other men, rather than beyond the edge of reason; his art is the site of VG's resistance to himself) it is still VG's despair, unexamined and safely couched in the seductive language of emotional excess that destroys the artist and therefore explains this painting. Not only is the work once again bound back into the subjectivity of VG, but the work itself serves as its index and revelation. The meaning of the painting results exclusively from psychological causes within VG as revealed by a parallel investigation of other paintings and verbal texts for such symptoms.

So what else could we find in the painting, what other VG? What I want to propose is not merely another 'interpretation', nor a sign by sign analysis of the elements, colour, size, perspective, crows, wheatfields, the country and so on. Rather I want to disrupt and counter these dominant 'expressionist', 'symbolic', 'sentimentalist' interpretations based on narrative and biographical modes of interpretative criticism and provide some suggestions for the ways which one can locate art historical work on Van Gogh. Instead of offering the paintings to be consumed as articulations of a personality, they have to be located as practices within historically determined and therefore class constituted positions. The search for unities has to be abandoned.

'Crows over the Wheatfields' was produced in the early months of July 1890, by the painter Van Gogh. But, apart from the paintings, Van Gogh also wrote an extended body of texts in the form of letters addressed to his brother Theo Van Gogh, an art dealer in Paris and sole source of financial support for VG's continuing practice as a painter. These texts are a supporting discourse produced by the painter within the uncertain conditions of art practice in late Nineteenth century Europe. In them, the work of VG as painter is represented

by Van Gogh the writer. They can be read, not as direct historical evidence for the paintings, but as parallel historical texts which are part of a network of practices and representations. Inevitably they provide information from which the account I can provide is drawn; in doing so I have used a 'historical' mode of writing but it should be clear that the presence of an already constituted account, so full, so seductive, so reflexive, creates real problems in writing or speaking about VG. But without these texts the history we could write would be very different and VG would be a very different sort of figure in art historical discourses.

'Crows over the Wheatfields' is dated to early July 1890. In the last weeks of June, VG had visited Paris to see his brother and family. Theo was on the verge of a nervous collapse, partly as a result of a renewed phase of difficulties with his employers, the large Parisian firm, Boussod et Valadon & Cie who saw little profit in patronage of unsaleable artists with whom Theo Van Gogh was commercially engaged, and also as a result of early symptoms of the general paralysis of the insane that finally killed him in 1891. Theo Van Gogh was the sole financial support for his wife, young son and VG himself, and also sent money to members of his family in Holland. His son was ill, his job was in jeopardy. VG returned to Auvers extremely worried about his own future. See, for instance, LT640 after a visit to Paris in early July:

> back here I still feel very sad and continue to feel the storm which
> threatens you weighing on *me*. What is to be done – you see I generally
> try to be cheerful, but *my* life is also threatened at the very roots, my
> steps are *also* wavering. [My emphasis.]

Note the construction intended to ingratiate himself with Theo but ensure that Theo is aware of the implications for him, Vincent. VG painted three canvases shortly after his return to Auvers, all on the same doublesquare format, two of which were called 'Vast Fields of Wheat under Troubled Skies' (F778 and F779 Amsterdam Rijksmuseum Vincent Van Gogh) and the third he called 'Daubigny's Garden' (F776 or 777 New York Kramarsky Trust or Basle Offentliches Kunstsammlung) the garden of the house in which the French 'Barbizon' landscape painter Charles Daubigny (1817-1878) had lived and worked in Auvers. All three paintings are about 50 x 100 cm. The painting F779 is more commonly known as 'Crows over the Wheatfields'. Writing to Theo of these canvases, on 9 July VG stated:

> they are vast stretches of wheat under troubled skies and I did not need

to go out of my way to express sadness and extreme loneliness. I hope
you will see them soon – for I hope to bring them to Paris as soon as
possible, since I almost think that these canvases will say what I cannot
say in words, the health and restorative forces that I see in the country.
(LT 649.)

All three paintings were painted for his brother. The letter invites Theo to
be moved by the 'sadness and loneliness' that he, Vincent, was experiencing.
The painting was addressed to Theo in a language which Theo, who
had been subjected to Van Gogh's cryptic and metaphoric verbal and visual
communications for ten years, was meant to decode as both a warning and
an invitation.

One could call wheatfields a 'major sign' in VG's oeuvre. He painted twelve
canvases of them in June–July 1890 alone; 20 in the previous summer in St
Rémy, 12 in 1888 in Arles, and from the Dutch years 1883–1885 they are very
numerous. One of the first was painted in Drenthe, a remote northern province
in Holland, in the autumn of 1883, when Theo once before threatened to give
up his job, and 'abandon' Vincent to his own fortunes; when Van Gogh first
decided that he was a painter and made his first essays in the painting of
landscape in the manner of Daubigny.

A few general remarks about paintings and drawings of wheatfields will
provide a working picture. Many of them have a high horizon line, some show
storms of rain slashing across the wheat or corn, others place flocks of birds
over the fields. All these devices are part of VG's rather unsuccessful attempt to
master the established language of picturesque landscape painting. They also
belong to his major project as an artist, derived from the positions he took up
in Drenthe in 1883, that the painting of the life and work and seasonal
rhythms of the country, in the manner of Millet and other French landscape
painters, was the core of modern art. See LT 418 July 1885:

> just think over whether you do not find this true. They started with
> peasant's or labourer's figure as 'genre', but at the present, with Millet
> the great master as leader, this is the very core of modern art.

and W 4 1889, about Barbizon painters as the true modern artists and
continuing leaders of European art, and LT 593 on 'the eternal youth and
unsurpassed example' of Barbizon painters.

So wheatfields belong in a wide context of cycles of paintings in which seasons

are signified by typical forms of agricultural work associated with them and reintroduced into Nineteenth century modes of representation through painters like Millet and the novelist Zola. Especially in the novel 'La Terre' (1888), Zola attached metaphorical significance to agricultural tasks as signs of growth, life and death, signifiers in a cyclical conception of human life and society. For VG, for instance, the wheatfield with reaper signified the yearly death of the harvest and therefore of humanity (LT 617), while the sower was his biblical opposite. VG's enterprises in this mode stem directly from the use he made of the series of wood engravings of the 'Twelve Labours of the Field and Four Hours of the Day' by Millet, which VG copied as a preliminary exercise in drawing in 1880-81 and to which he had returned in the autumn of 1889. By that date, in addition to reworking the wood engravings in the medium of oil painting, he had copied a print of a painting by Millet 'The Harrow' (F 632) which shows a vast, desolate and empty field under snow over which a flock of crows are wheeling. The painting included cornstalks and a darkening sky. Direct copies occur relatively rarely in Van Gogh's work. When they do, they serve an explicit purpose to reassert an allegiance to the work of certain artists whom VG took to be the key figures in a tradition of painting he wanted to revive and continue. It is rather more common to find an intentional utilisation of motifs which activate reference to paintings and the positions occupied by the painters. These artists' work not only provided VG with a model for his own work and its subject matter. They were invoked and reworked as part of his attempt to retrieve the meanings, and indirectly the conditions, of social life proposed through forms of painting that had arisen prior to capitalist industrialisation.

It is important to consider VG's position within the class structure of Dutch society in the late Nineteenth century. The old civic bourgeoisie or burgher class had assumed political, economic and social dominance in the United Provinces (now called the Netherlands) with the development of mercantile capitalism in the Seventeenth century. In the Nineteenth century this civic patriciate opposed industrialisation (railways and early industry in the Netherlands were financed largely by foreign capital) and modernisation (national integration of the provinces). The complex manoeuvres in both VG's paintings and letters have to be read with reference to the conflicts within the bourgeoisie(s) of the Netherlands in the second half of the nineteenth century. Liberal bourgeois elements were in government after the revision of the Constitution in 1848. It is clear from innumerable letters that VG perceived these elements as leading Holland into decline and decadence. He aligned

'Chair and Pipe' (1888?)

himself with the traditional civic burgher ruling class whose dominance and interests were being challenged economically and politically both from within the Netherlands as well as from international capitalism

Misrecognition of these determinations, coupled with the refusal of the notion of class as a structural determinant, has allowed VG's use of 'Millet' as a model and the agricultural labour in subject matter represented by what he called 'peasant painting' to be assimilated to humanist bourgeois interpretations, such as that proposed by Schapiro of another famous signifier of VG, 'The Potato Eaters' (Amsterdam Rijksmuseum Van Gogh) of which he wrote:

> conceived as a summation of Van Gogh's work and study up to that time (1885), it also expresses most strongly his social and moral feelings. He was a painter of peasants, not for the sake of their picturesqueness – although he was moved by their whole aspect – but from a deep affinity and solidarity with poor people, whose lives, like his own, were burdened with care.

In addition to the use of emotional explanation so firmly reinforced by the language of this passage, one sees at work here the processes of binding the work and the artist together by proposing a unity of interests between the artist and the fictions of his own work, who are taken (mistaken) for real people, real peasants rather than as images produced by a bourgeois painter using members of the rural proletariat who modelled for money during periods of prolonged unemployment. This process is even more apparent in a Schapiro passage on a painting of a weaver at a loom from the same text:

> Van Gogh gave to the image of the worker at the machine a high solemnity and power. In the earnest skilful weaver, he felt, no doubt, a kinship with his own artistic work.

VG's reworking of systems of representation available in the late Nineteenth century, using prints of paintings by Millet, paintings by Daubigny and so on, in combination with VG's practice of painting directly from the motif and the model, produced contradictions and disjunctures in his practice. When he set up his easel in front of a scene, VG saw that scene both in terms of modes of representation current fifty and even two hundred years previously (Seventeenth century Dutch art). He painted the scene before him in order that it might represent his own civic, mercantilist bourgeois reaction to 'progress' and modern urban society. However, he encountered great difficulties as a result of this. The paintings rarely worked to represent that position, and in

doubt, Van Gogh reverted to virtual imitation of such painter's work as he could reproduce. One of these was Daubigny, who had lived and worked in Auvers and who painted broad fields of corn on wide horizontal canvases, usually in a doublesquare format (100 x 200 cm) with high horizon lines, compressed space and shallow depth of field. There are for instance two paintings now in the Kroeller-Mueller Museum in Otterlo entitled 'Cornfield Under a Stormy Sky' and 'Young Corn'. In the former, a path leads centrally into the fields of corn only to disappear in their midst. In the latter, the painting is divided in the centre horizontally between heavy sky and billowing wheat and a path enters the field centrally but disappears into it while to either side rough, unsown ground skirts the field to be closed off by the stalks of the growing corn. In 1873 Daubigny had exhibited at the Paris Salon, which Van Gogh had visited, a vast and snowy scene entitled simply 'Snow of Winter' (100 x 200 cm) (Paris, Louvre). There, in a vast and empty expanse of snow-covered ground, a dark clump of trees stand out and a flock of crows roost in their bare branches or peck the frozen earth beneath. Van Gogh associated flocks of crows with both Daubigny and Millet, for in a letter of September 1880 he had written of a winter scene in Belgium, 'I also noticed flocks of crows made famous in the paintings of Daubigny and Millet.' (LT136)

Crows and wheatfields had not only an extensive context within Van Gogh's practice, but a purpose within his vocabulary and a place within the representational formula of a particular group of late Nineteenth century painters. In dwelling on these motifs I am hoping to indicate something of the complexity of a single Van Gogh painting, the multiplicity and potential range of meanings signified by a few motifs within one such landscape; a set of resonances which has to be unravelled across a variety of texts and within a reconstruction of VG's highly ambitious and problematic project as an artist in the 1880s in France and Holland. In order to return to the painting in question it is necessary to place VG's use of landscape painting in relation to the signification of the city for him, as centre of speculative commerce in opposition to the organic, natural world. In a letter of October 1883, Van Gogh had written to Theo one of many diatribes against the city in the hope of persuading Theo not to emigrate to America but join him in the country and become a painter. The argument was posed in the idealist terms of Nature opposed to the city, signifying modern urban industrial society, and characterised above all by a market economy. He was thus attempting to persuade Theo to leave the world of dealing and speculation in the art market and partake in the great Carlylian worship of supernatural nature.

Van Gogh read Thomas Carlyle's *Sartor Resartus* (1831) in 1883, from which he derived the vocabulary for articulating his idealist and pantheistic conceptions of nature, and within which he remained fixed until the last years, painting, for instance, the famous 'Starry Night' (1889 F 612 New York Museum of Modern Art) according to Carlyle's prescriptive symbolism:

> ...then sawest thou this fair Universe, were it the meanest province therefof, is in very deed the star-domed city of God; that through every star and every blade of grass, and most through every living soul, the glory of a present, God still beams. But Nature, which is the Time-Vesture of God, and reveals Him to the Wise, hides Him from the foolish.

In LT 332 of 1883, this formulation occurs:

> ...if at the same time you wandered through the cornfields and moors, to renew what you yourself express as 'I used to feel part of nature; now I do not feel that way any longer'. Let me tell you, brother, that I myself experience so deeply, so very deeply what you say there. that I have been through a period of nervous, arid overstraining – there were days when I could not see anything in the most beautiful landscape just because I did not feel part of it. It is the street and the office and the care and the nerves that make it so.

Rural analogies were adopted and adapted for a longing to return to an eternal order, signified by the idea of nature. In a later letter to Theo we find:

> ...but in order to grow you must be rooted in the earth. So I tell you don't wither on the sidewalk. You will say there are plants that grow in the city – that may be but you are corn and your place is in the cornfield.
> (LT 336.)

In VG's letters one finds a wealth of material which throws light on the events of June 1890 and suggests a way of reading the 'statement' made by a painting of crows over a wheatfield accompanied by a letter, both addressed to Theo. Both were intended to convey 'the health and restorative forces' of the country.

In the letters of the later part of July 1890, up to and including the one apparently found on VG after his death, the difficulty of relations between living artists and the dealers in 'dead artists' was repeatedly addressed. VG constructed Theo as a different kind of dealer, stressing his unique and 'creative' contribution to the making of modern art, namely the work of VG himself, through his continuing financial support. However, the letters suggest

that VG represented these difficult conditions of art practice to himself in terms of public misunderstanding, ideologies of vanguardism and the search for what he called 'sympathetic' lovers of art. A previous threat of withdrawal of Theo's financial support had occurred in 1883 and in the letters of autumn 1883 the absurd ignorance of public opinion on art is compared to the 'Croaking of Ravens'. (LT 339). I am not suggesting that crows or ravens or any other birds of prey simply equal dealers of 'absurd' public opinion – that would be to collapse the letters into the paintings – but such a conjunction of concerns and metaphors throws light on the network of signs and meanings which structured VG's texts and which must condition the way we make readings of VG paintings. At the same time, it points to the problems that were inherent in the artist's attempts to produce meaning through the signifying process of painting in and against the signifying processes of writing. The painting, 'Crows over the Wheatfields' of July 1890, far from being presented, therefore, as the culminating climax of a sequential narrative, the revelation of the artist, has to be approached as a complicated text, which calls for a different kind of work, not of narration or interpretation, but decoding. Attention has to be paid to broad fields of Nineteenth century discourse, to the conditions of production, to practices of representation which are not coherent, legible or consistent but uncertain, and contradictory.

LUST FOR LIFE – ARTIST AND MEDIA

Despite the resistance by art history to the production of discourses outside of its privileged place in the literature of art, particular discursive structures, both narrative and psychobiographical, are common to both the texts of *la vie romanceé*, the popular fictional biography, and art history. It is perhaps the coincidence of narrative structures which render art history and Stone's novel *Lust for Life* translatable into filmic narrative. In this section I want to consider the construction of Van Gogh in another site of the production of representations of the artist, the film, *Lust for Life*. This was directed by Vincente Minelli in 1955 for MGM with Kirk Douglas in the lead role. It was based upon Stone's novel, one of the prime texts in Hammacher's category, *la vie romanceé*, the popular fictive biography. At the same time, the film *Lust for Life* operates in a different area of consumption and can therefore be examined as an example of dispersion of the effects of art historical discourse.

MGM had bought the film rights to Stone's novel but the option was due to

expire in December 1955. Stone, anticipating the revocation of the rights, was already planning a film version of his own, as was Kirk Douglas who was preparing, through his own production company, a film on Van Gogh's life in which he would star. The film was in fact made by MGM, in five months between June and December 1955, and was released in 1956.

Minnelli believed Van Gogh had been hereditarily insane and saw motifs in his work as symbols. The sun, for instance, was a symbol of the repressed turmoil of the 'maelstrom he was always fighting'. Such a reading served to set Van Gogh apart while subjecting him to voyeuristic representation – the artist as irrecuperably mad and driven towards self-destruction while the art remains as his testament of struggle – echoing that reading made by Schapiro discussed above. It is hardly surprising to find that the culminating climax of the film is a representation of Van Gogh shooting himself in the wheatfield as he tries to paint 'Crows over the Wheatfields'.

According to Minnelli the film received the best reviews of any of his pictures. Time magazine concluded that it was 'Hollywood's most profound exploration of artistic life'. Indeed the film was sold as a biography, collapsing the artistic work into personality. The *Sydney Morning Herald* wrote 'something of a Van Gogh painting inhabits this sincere and absorbing biography of that strange and disturbed man'. Such an effect was no doubt strengthened by all the meanings the star Kirk Douglas brought into the visual reconstruction of Van Gogh and it is tempting to recall, in relation to Douglas' screen persona, Aurier's words describing Van Gogh: 'powerful, a male, a daredevil frequently brutal, sometimes ingenuously delicate'.

Dissenting voices were raised however – the *Time* critic took issue with the Minnelli presentation of VG as mad, commenting that VG was known to be epileptic, adding, 'Van Gogh's epilepsy halted his painting but does not explain it'. This critic also draws attention to effects of the narrative necessities and drives of the filmic process:

> the film captures the fierce drive and bitter tragedy of the life of Van Gogh... But because the Hollywood story builds relentlessly to Van Gogh's ear slicing for its climax... Lust for Life falls midway between being a first rate art film and a high pitched melodrama.

In Minnelli's film the narrative economy of the film drives towards the climax of self-mutilation and release through the death which is anticipated by a series of personal rejections and physical sufferings and mutilations. It lingers

over the minor incident in which VG is said to have put his hand into a flame to prove the durability of his love for his cousin; draws out the suspense of VG's dramatic attempt on Gauguin's life and situates the build up to the cutting of his own ear through brutal music and lush, reddened colour. Just prior to that event, Van Gogh/Douglas is placed before a mirror so that his attack on himself is constituted as a rejection of himself by himself. His final releasing act of suicide is located within one of his own paintings, the wheatfields with the crows. His last words as he dies are 'I want to go home', a phrase which not only effects the closure of his life but the filmic narrative; it releases him and the audience.

The film tries to visualise VG's life in terms of his paintings. We are shown reconstructions of scenes he painted. They are not only offered to us as he painted them, without any suggestion of mediating practice, but serve to render transparent this same process of mystification of production with regard to the film's construction. On the one hand we see him opening a window in Arles onto an orchard in blossom which dissolves into VG paintings of blossoms, as if they were no more than his inner mental images as he looked at the scene and not representations made of a scene. Alternatively, his paintings are carefully and faithfully reconstructed as sets, so that Van Gogh becomes virtually a figure in his own paintings. Much is made of his sitting like one of the all-night prowlers in the reddened interior of the 'Night Cafe' (F 463 New Haven Yale University Art Gallery), a painting á propos of which he, the fascinated bourgeois flâneur in working class haunts, stated that it was a place one (but not we, the bourgeois) could go mad in. The film 'places' VG, eliding his imputed state of mind with his own paintings, refusing to recognise those works as representation and as practice – realising in full the effects of the written texts on VG.

In the text already quoted, Schapiro made much of the disturbing perspective he thought he saw in the 'Crows over the Wheatfields' painting. Marks in the painting which signify birds are spoken of as if they were real animate birds flying around the painting, yet simultaneously operate on a connotational level as harbingers of death (Schapiro refers to these birds as 'figures of death'). The effect is apparently produced by distortion of single point perspective, or its reversal. Within the realist conventions of the film *Lust for Life*, such illusions of real objects in motion can be produced, and the photographic single-point perspective systems operate to direct this represented motion towards the spectator of the film. In the penultimate episode of the film Van Gogh/Kirk

Douglas is shown painting this painting, a scene of extensive wheatfields around which crows are hovering. His work as a painter is thus presented at one level as direct transcription from a real scene. Suddenly, however, the crows move in, but not towards the spectator. They close in on the figure of Van Gogh whom they harass and attack. The artist is positioned as the object of the attack. The effect of this is to contain the attack within the perspective system of the film and to shift a scene of painter and motif into a different connotative reading – to signify VG's disturbed state, to make the signs of his paintings the signifiers of his mental condition which is then played out, dramatically. Van Gogh gives up his painting and, scribbling a note which reads (roughly) 'I cannot take any more', shoots himself.

In *Lust for Life*, the spectator is positioned as viewer of pictures produced by photographic representations through which Van Gogh is placed as a figure in his own landscape paintings. At the same time, these landscapes are offered as externalised, visualised images of the artist's 'inner' landscape. These dual processes not only foreclose notions of the production of art as a signifying system but propose that the meanings of works of art are available to direct visual experience which can be represented unproblematically, simply reconstructed in a film. Through the narrative organisation of a filmic biography, lavishly illustrated and illustrating, what is realised and confirmed is the construct of the artist as the effect of his works, the hero of the story, the character whose 'truth' is to be sought and visualised, reconstructed and made plain. The unity of artist and art, a unifying classless subjectivity, paralleling the psychobiographical impetus of art history as manifested in the tests on VG quoted above, is accomplished within cinematic representation in *Lust for Life*. That such a coincident representation is both possible and accepted, with only the minor qualifications from critics that I quoted above, is itself significant. The translation from art history to *la vie romancée* and to the film *Lust for Life* is founded upon not only the dispersion of art history's ideological figure of the artist as cause and effect of art, but upon the discursive structures through which such ideologies are produced, the literature of art, the narrative practices of art history.

CONCLUSION

The purpose of my analysis of some of the discursive practices, structures and categories of art history and their dispersion across a range of practices of representation, exceeds, as I suggested at the beginning of this article, the internal problems of the practice of a Marxist social history of art. That art history can be analysed as a practice of 'interpretative criticism', a hegemonic practice, the site of the production of bourgeois ideas about art and artist, is of course central to identifying the modes and manoeuvres by which art is evacuated from history, history from art history, precluded even. Marxist art historical work faces above all the problem of historicising a specific practice of representation but of a particular mode – visual representation. This means producing modes of analysis both appropriate to the historical specificity of that practice while simultaneously deconstructing the notion of art as a visual experience. Take for instance the reviewer of the work of feminist artists like Mary Kelly, Susan Hiller and Alexis Hunter at the Hayward Annual Exhibition in 1978, Tim Hilton, who considered their work the weakest part of the show:

> ...much of this is instructive, in its way, but it is not instructive to the eye. In many ways one is encouraged to read this exhibition rather than experience it visually (*Times Literary Supplement* 27 June 1978)

The effects of an informed Marxist intervention will itself exceed the discrete domain of art history however because of the effects of art historical discourses beyond art history's apparent boundaries – into art practice, art criticism, representations of art and the artist, indeed into current conditions of the production of art. It is time we began to take art history seriously as a significant site of Marxist work and challenge the bourgeois ideologies of art and artist on the terrain in which their hegemony is produced and secured.

NOTES

1 Frederick Antal, 'Remarks on the Method of Art History', reprinted in
 his *Classicism and Romanticism and other studies in art history*,
 London, Routledge and Kegan Paul, 1966.

2 Michel Foucault, 'What is an author?' and Sue Clayton and Jonathan
 Curling 'On Authorship', *Screen*, vol. 20 no 1, Spring 1979.

3 I have called the artist either VG or Van Gogh, switching between the
 two, rather arbitrarily I am aware, but as an attempt to distance
 myself from the artist, of whom it is the custom amongst VG scholars
 to speak in the familiar, Vincent. (He signed himself as Vincent, in
 part because his name is unpronounceable in any other language
 than Dutch, and in part in honour of the Seventeenth century
 portraitist of the civic bourgeoisie with whom he intended to be
 compared, who also used only his forename, Rembrandt van Rijn.) In
 my article paintings are referred to with their F numbers – these are
 for easy reference in the Jacob Baart de la Faille catalogue raisonné –
 The Works of Vincent Van Gogh – his paintings and drawings, London,
 Weidenfeld and Nicholson, 1970. Letters (originally written in Dutch
 or French) are prefixed by LT (ie letter to Theo) or W (ie letter to
 Wilhemina) as numbered in the *Complete Letters of Vincent Van
 Gogh*, London, Thames and Hudson, 1958

4 Fritz Novotny 'Die Popularitat van Goghs', *Alte und Neue Kunst*, vol. 2
 no 2, 1953; translated and reprinted in B Welsh-Ovcharov (ed) *Van
 Gogh in Perspective*, Englewood Cliffs (New Jersey), Prentice Hall,
 1974. In future references to Novotny it is this translation and
 edition I shall cite.

5 Abraham M. Hammacher 'Van Gogh and the words' in Jacob Baart de
 La Faille op. cit.

6 Pierre Macherey, *A Theory of Literary Production*, (English translation
 by Geoffrey Wall), London, Routledge and Kegan Paul, 1978.

7 Karl Jaspers, *Strindberg und van Gogh*, Leipzig, Ernst Birchner, 1922;
 translated by D Grunow and D Woloshin (as *Strindberg and van
 Gogh*), (University of Arizona Press, 1982). By 1931 the proliferation
 of conflicting interpretations enabled A Hutter to publish an article
 'De Vijf Diagnoses van de Ziekte van Gogh' (The five Diagnoses of the
 illness of van Gogh), in the *Nederlandsche Tijdschrift voor
 Geneeskunde*, 14 February, 1931.

8 ibid.

9 Françoise Minkowska 'Van Gogh: Les Relations entre Sa Vie, Sa
 Maladie et Son Oeuvre', *L'Evolution Psychiatrique* no 3, 1953.

10 ibid.

11 See letter to his sister Wilhemina (W 4) 1889 'The physician here has been to Paris and went to see Theo. He told him that he did not consider me a lunatic, but that the crises that I have are of an epileptic nature.'

12 Margaret Ochocki, 'Van Gogh a Psychological Study', BA thesis (unpublished), Sunderland Polytechnic, 1979. Chapter Two, 'Epilepsy', pp 14–20. See also D Scott, *About Epilepsy*, London, Duckworth, 1969 and B Bihari, 'Marshall McLuhan and the Behavioural Sciences', *Art Language*, vol. 1 no 3, 1970, p 15 ff.

13 In W 11, Van Gogh told his sister that he had had four crisis and three fainting fits, some of which can be dated by other evidence to December 1888, February 1889, July 1889, January 1890 and 24 February 1890. It is also possible that he had either a crisis or breakdown of some sort in Paris in the late summer of 1887.

14 T Morgan, 'The Strange End of Vincent Van Gogh', *Horizon* vol. 16, Autumn 1974.

15 D Outhwaite, 'The Auvers Period of Vincent Van Gogh', MA thesis, London University, 1969.

16 Minkowska, *op. cit.*

17 (caption to reproduction of 'Crows over the Wheatfields')

18 Meyer Schapiro, 'On a Painting of Van Gogh', *View* series 7 no 1, 1946, reprinted in her *Selected Papers Volume 2 Modern Art: 19th and 20th Centuries*, London, Chatto and Windus, 1978.

19 There is a great deal of work to be done on the status of the VG myth in America in the 1950s and on the role of VG within Minnelli's oeuvre, both in relation to melodrama and in terms of the artist and the figures of the neurotic.

8
The Architect as Übermensch

Julian Petley

Although a good deal has been written about architecture in the movies in terms of set design, less attention has been paid to the representation of actual architectural practice. Admittedly, two films – *T Dan Smith* and *The Belly of an Architect* – touch on it, in very different ways, but the central concerns of each film actually lie elsewhere. There are, however, at least two films which are most definitely 'about' architects and architecture – *The Fountainhead* (1949) and *Andreas Schlüter* (1942). Both films are the product of very different cultures – the former, Eisenhower's America, the latter, the Third Reich – and yet, curiously, both exhibit certain remarkable similarities in the depiction of their architect heroes. That they do so is the result of their common ideological impulse – that of radical individualism.

Andreas Schlüter is but one of a whole range of German 'geniuses' celebrated in the cinema of the Third Reich (other figures included Frederick the Great, Bismarck, Friedrich Schiller, Paracelsus, Robert Koch and Gustav Diesel). According to Dr Fritz Hippler, the Reich script adviser:

> ...the one essential requirement for a historical film is that it should have
> authenticity on a grand scale. The only possible subjects for a successful
> historical film are personalities and events from the past which people of
> today know about or can identify with, be interested in or find relevant.
> To put it in the broadest terms, this is as it were proof of the meaning of
> life, the authority and historical significance, the timeless authenticity of
> particular historical events, situations and personalities.[1]

For Hippler the great figures of history should be represented as 'inestimable in human terms' and as the personification of a 'life giving ideal'.[2] It goes without

saying, of course, that the 'events, situations and personalities' in question were German and the 'meaning' and, 'historical significance' with which they were to be imbued would reflect specifically National Socialist conceptions of Germany's past – not to mention its present and future.

Of course, Third Reich films are hardly unique in their glorification of Great Individuals, nor in their ransacking of the past to suit the ideological needs of the present. As E H Carr has pointed out 'the cult of individualism is one of the most pervasive of modern historical myths',[3] and one has only to look at the wartime British and American bio-pic to realize that history (of a kind) had its uses well outside the confines of Hitler's Germany. On the other hand, National Socialism did lay a particularly acute emphasis on individualism, raising it almost to the level of a cult or fetish. The clearest example of this, of course, is provided by the all-important *Führerprinzip* itself, whose ultimate embodiment wrote in *Mein Kampf* that:

> ...science, too, must be regarded by the folkish state as an instrument for
> the advancement of national pride. Not only world history but all cultural
> history must be taught from this standpoint. An inventor must not only
> seem great as an inventor, but must also seem even greater as a national
> comrade. Our admiration of every great deed must be bathed in pride
> that its fortunate performer is a member of our own people. From all the
> innumerable great names of German history, the greatest must be picked
> out and introduced to the youth so persistently that they become pillars
> of an unshakeable national sentiment.[4]

In the case of *Andreas Schlüter* the 'great name' is the sculptor and architect once known as the 'Prussian Michelangelo' who built a new Berlin in the Eighteenth century modelled on the spirit of ancient Rome. His patron was Frederick III, Elector of Brandenburg who, in 1701, became the first King of Prussia – an important stage in Prussia's rise to statehood and thus, also, in the German unification process. The rebuilding of Berlin is thus a highly visible symbolic act – the city becomes the image of the nascent, virile Prussian spirit.

Schlüter's architecture is here recreated on the grand scale by Robert Herlth, famous for his work on films such as Lang's *Der Müde Tod* and Murnau's *Faust*. It represents a specifically Prussian variant on the baroque style and its spirit has been neatly summed up by Francis Courtade and Pierre Cadars as:

> ...monumentalism, glorification of Germanic values, violent reaction
> against the French influence, a ferocious desire to impress the world by a

new national grandeur, all of which seem to prefigure the designs, conceptions and style of Hitler's sculptors and architects Breker, Speer and Troost.[5]

Schlüter's Prussian baroque may not look much like Nazi neo-classicism but the spirit which animates the two are remarkably similar. For both, architecture is ideology made visible – and immortal. As one character says of Schlüter's creations, 'his work will still be here when we have all long since departed', a sentiment which is echoed by the architect's remark that 'Life is short, but art is eternal'. Again, one has only to look to Hitler, the architect manqué, to discover the contemporary resonances of these sentiments. For example, in *Mein Kampf* he bemoans the absence of 'monuments dominating the city picture which might somehow be regarded as the symbols of the whole epoch' and contrasted the modern city with the ancient, whose characteristic aspect

Architecture as the glorification of German values – *Andreas Schlüter.*

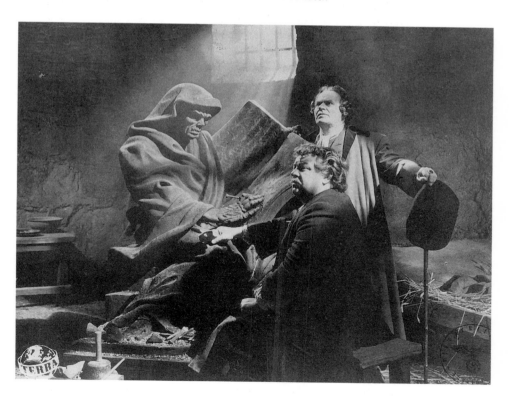

lay not in 'private buildings, but in the community monuments which seemed made, not for the moment, but for eternity, because they were intended to reflect, not the wealth of the individual owner, but the greatness and wealth of the community'.[6] Speaking in Nuremburg in 1937 Hitler spoke of National Socialist architectural creations as 'mighty witnesses to our communal existence' whose aim was to 'unify and strengthen our people more than ever', and referred to them as being the only 'truly stable element in the rash of all other phenomena ...This is why these buildings should not be conceived of for the year 1940, or for the year 2000. Like the cathedrals of our past, they will tower over the milennia of the future'.[7]

Allied to *Andreas Schlüter's* insistence on the national significance of architecture is its discourse of radical individualism. Like so many Third Reich film heroes Schlüter is quite explicitly represented as Man of Destiny. Even if 'the times and people are against me' he must be as he is: 'even God can't change that'. Like Schiller, Koch and the rest, Schlüter is seen as a man ahead of his time, and his nationalistic aspirations make him very much a rebel figure in an age of petty, localised political concerns. There is nothing particularly surprising in the cinema of the Third Reich consistently celebrating figures such as Schlüter in overtly rebellious terms, for National Socialism always regarded and presented itself in decidedly 'radical' terms, and this 'radicalism' was intimately bound up with its nationalistic project. As Hitler himself put it: 'if, by the instrument of governmental power, a nationality is led towards its destruction, then rebellion is not only the right of every member of such a people – it is his duty'.[8] Certainly the forces which are ranged against Schlüter and his grandiose plans are represented as being inimical to the development of Prussia as an effective state, and thus of Germany as a modern, unified nation. The film clearly sets out to demonstrate the shortcomings of a still divided Germany ('decadent' foreign influences, kitchen cabinet politics) and the problems caused by artistic patronage lying in the hands of a largely dilettante aristocracy and royal family. Frederick the Great (Frederick III's grandson, and a major figure in the Third Reich cinema, witness *Der Alte und der Junge König, Fridericus* and, above all, *Der Grosse König*) regarded his grandfather as having been moved largely by vanity, a sentiment generally endorsed by nationalistic German historians and by the presentation of the king in *Andreas Schlüter* itself. Thus Schlüter himself has to endure prejudice, reaction and narrow selfish interest of the various Prussian ministries, the scheming and jealousy of his rival, the foppish Elosander, with what Schlüter

calls his 'French nonsense', numerous petty intrigues at court, and the suspicion and mistrust of both the merchants and workers. As he himself wearily puts it, after years of struggle against incomprehension, jealousy and back stairs politicking, 'the times and the people are against me'.

It is this representation of the architect as an idealistic but thwarted and misunderstood Übermensch (Superman) that forms the closest link between *Andreas Schlüter* and *The Fountainhead*, though the latter lacks the former's intensely nationalistic dimension.

The Fountainhead (directed by King Vidor) was released in 1949. It was based on a novel by the same name by Ayn Rand, who also wrote the screenplay. Rand, who had arrived in the States at the age of 20 in 1925 as a fugitive from the Soviet Union, was the founder of a school of philosophy known as

Schlüter as man ahead of his time.

Objectivism. In an essay on the film Raymond Durgnat sums up Objectivism's tenets very neatly:

> ...progress through history is owed to egoistic Supermen who, in the process of benefitting themselves, give their less dynamic fellows the benefit of a little spin-off... Today man's healthy egoism is the victim of mass society, which spreads a psychic plague of envy, jealousy, impotence, guilty altruism, Socialistic liberalism and Communism . In short, it is a philosophy of 'ego-über-Alles' selfishness.[9]

Hardly surprisingly Rand's ideas found a sympathetic audience in the 'Me Decade' and, later, on the New Right. To date, the book of The Fountainhead alone has sold over 5 million copies worldwide. Her work has been admired by both US Presidents Reagan's and Ford's advisors, and in the Eighties there was talk of a re-make of Vidor's film, and also a TV mini-series based on another of her philosophical novels, Atlas Shrugged, for which Stirling Silliphant wrote a screenplay. Hardly surprisingly, Rand stood on the political Right. During the Forties she joined the Motion Picture Alliance for the Preservation of American Ideals, testified before the House Un-American Activities Committee, supported Senator McCarthy and worked against Roosevelt in the 1940 presidential campaign. Later she threw her weight behind Barry Goldwater, but, interestingly, refused to support Reagan whom she apparently regarded as a typical conservative in his attempt to link politics and religion.

The central character of The Fountainhead is Howard Roark (played by Gary Cooper, himself hardly renowned for liberal views), a visionary architect whose grandiose schemes are rejected by all and sundry. His old mentor, equally isolated, dies from drink and despair leaving him with only one friend, Peter Keating. He too is an architect but has 'sold out' by working for the popular and fashionable firm run by Guy Francon. Amongst the many critics of Roark's work are the newspapers of Gail Wynand: especially negative is Ellsworth Toohey, the architectural critic of 'The Banner'. Wynand is married to Francon's daughter Dominique, who is attracted to Roark and has a tempestuous affair with him. Keating enlists Roark's aid in the design of a low cost federal housing project, and Roark agrees to help on condition that his designs are carried out to the letter. When the project is completed Roark sees that Keating has failed to keep his promise, and persuades Dominique to dynamite it for him. However, he takes full blame for the destruction and is brought to trial. By this time Wynand has come to respect Roark and uses his paper to defend him –

however, the paper suffers for this and Wynand eventually capitulates to public taste and writes an editorial attacking the architect. Roark defends himself at his trial, and the jury acquits him. Wynand commits suicide, but not before commissioning Roark to build the world's tallest skyscraper, the Wynand Building. The film ends with Dominique ascending the structures by lift to meet Roark standing triumphantly at the top.

As Donald Albrecht aptly puts it: 'Rand's ideological cartoon of a book pits the individual, whose undaunted ego is the fountainhead of all praiseworthy human activity, against the common man, Rand's rabble, who, fearing the individual, attempts to destroy or reduce him to its own base level'. In this scheme of things Roark is seen as a 'lone champion of modernism who must struggle to have his designs built against the machinations of critics and clients, the public, and even the vast, stupid majority of his own profession'.[10]

What is so interesting about the comparison with *Andreas Schlüter* is the similarity of the forces ranged against these two architect heroes It is not simply the fact that virtually everyone seems to be against them, either. Both are shown to be victims of a conservatively inclined system of patronage – Schlüter is shunned by the aristocracy, Roark by big business. Both are passed over in favour of a form of architectural classicism – Schlüter in favour of a French version of the style, Roark of an Americanised, academic neo-classicism. Both are explicitly contrasted with opportunistic 'society architects' – Schlüter with Elosander, Roark with Keating. Each enjoys a distinctly ambiguous relationship with an ally who, ultimately, lacks the vision to support them to the hilt. Schlüter with Frederick and Roark with Wynand. Wynand, like Frederick, is an ambiguous figure, an 'inauthentic' egoist as opposed to Roark's 'authentic one', a tough-minded idealist who has sold out by cynically pandering to the tastes of the masses and thus not becoming the strong leader that Americans deserve. Schlüter is opposed by short sighted and self-seeking politicians, and one of Roark's chief adversaries is presented in explicitly political terms. This is Ellsworth Toohey, a member of the intellectual Left, and the real villain of the piece. Toohey prefers Keating's buildings because he makes concessions to popular taste and hates Roark because he fears that such an independent thinker threatens his own hold over both the masses and the monied. Just to add to his negative traits he is also trying to unionise Wynand's main newspaper! As Durgnat puts it, Toohey, as represented by the film is trying to:

...sneak his way to power by simultaneously collectivising the paper and mystifying the rich – two thoroughly parasitical and mean-souled activities. For just as the critic creates nothing, merely cashing in on the artist's creativity, so the unionist creates no wealth, but merely negates and grabs, to build his paltry little 'empire' of also-rans.[11]

Thus the villainous Toohey isn't even allowed to believe in the socialist ideals which he professes, instead he is presented as a manipulator and power-seeker masquerading as an idealist and social reformer. In this respect it is worth pointing out that although Toohey lacks a direct parallel in *Andreas Schlüter* such negative representations of socialists (unsurprisingly) crop up time and again in other films from the Third Reich, in which, incidentally the function of the artistic critic was held in particularly low esteem.

Not only are Schlüter and Roark opposed by a remarkably similar coalition of

The skyscraper as triumph of the will in *The Fountainhead*.

The Fountainhead - architectural creativity linked directly to male virility.

forces but both are themselves represented in remarkably similar terms. Andrew Saint has called *The Fountainhead* 'an unsparing celebration of the architect as hero and genius'.[12] Never mind that Roark's designs would have been denounced in the Third Reich as 'architectural Bolshevism', both films quite explicitly adhere to the ideology of the architect as *Übermensch*. And whilst Schlüter is represented as requiring absolute devotion and faith from his unfortunate womenfolk, Roark's relationship with women (namely Dominique) is represented in similarly primitive, chauvinist terms and his work is celebrated

in overtly phallic images. Thus not only does *The Fountainhead* imply that creativity is an exclusively masculine capability but also that architectural creation is quite explicitly linked to the virility of man. This link is clearest in the film's two most famous scenes; in the first, Dominique visits a stone quarry where Roark is working and as she walks along the top of the quarry in the background, the foreground is filled with the image of Roark himself wielding a massive rock drill! The second is the aforementioned climax atop the Wynand Building, aptly referred to by Durgnat as a 'sociophallic apotheosis'.

To some extent Rand modelled Roark on a real-life architect, Frank Lloyd Wright. Indeed Warner Bros, the film's producers, actually approached Wright to design *The Fountainhead*, but found his fee of $250,000 too pricey. They then hired Edward Carrere to do the job. As Donald Albrecht points out in the final chapter of his 'Designing Dreams', there are significant differences between Carrere's and Wright's work, and one might add that there would have been points on which Rand and Wright would have come to blows. On the other hand both admired the same authors (Hugo, Herbert Spencer) and, as Saint points out:

> ...on the substantive questions of personal belief, in their admiration for individualism and enterprise as the pristine American virtues, in their contempt for the state, for mass culture and for compromise and in their propensity for hero worship, architect and author are in uncanny agreement ...The intellectual foundations of Roark and Wright are at all essential points, one and the same. Together they point to the primacy of a single, much admired stereotype; the creative individual manifesting his will in action.[13]

On the other hand it has to be admitted that although Rand clearly did her homework on the American architectural scene of the Twenties and Thirties, *The Fountainhead* is not primarily about architecture at all. Rather it uses the discourse of architecture as a means of projecting a personal philosophy, a heady mixture of Nietzsche and Herbert Spencer. Architecture here becomes a symbolic battleground where the individual struggles with the mass, capitalism takes on the Judaeo-Christian ethic, and a radical individualism asserts its supremacy over all forms of altruism. However, the ground chosen is an interesting one. Architecture is a subject about which most people have an opinion, not least because it is an art form which they encounter every day – unlike, for example painting or sculpture. This partly explains why the Prince of

Wales' views on the subject receive such wide coverage and, apparently, assent. It also explains why a Hollywood film of the late Forties is able to have a convinced modernist as its subject, whilst a similar film on, say, Schoenberg or Pollock would be unthinkable. Indeed, if contemporary audiences did have a certain taste for architectural modernism it is at least partly because cinema set design in the Twenties and Thirties had accustomed them to its look. However, this does not explain why two films about architects from two very different cultures should share such a remarkably similar ideology of profound, radical individualism.

We began by noting, via E H Carr, the pervasiveness of the cult of individualism, and it could be argued that this cult is especially strong in the field of architecture. In this respect Saint writes of the predominance of:

> ...the strain of artistic individualism which ascribes both merit in particular buildings and general progress in architecture according to a personal conception, usually of style, embodied in buildings and developed from architect to architect over the course of history. According to this ancient theory (first applied to art by the disciples of Plato), a building is significant or insignificant in so far as it incorporates an idea or ideas conceived by its individual designer and the history of architecture becomes the web of such significant ideas, worked out in special buildings. This understanding of architecture, long prevalent, shows only limited signs of receding today.[14]

This 'auteur' theory of buildings is propagated both by architectural critics, most of whom of have been trained in a tradition of the humanities which regards art first and foremost as an instance of individual expression; and by architects themselves, who want to see themselves primarily as artists and creators rather than mere draughtsmen or builders. It is a mark of the widespread prevalence of this particular manifestation of artistic mythology that both *Andreas Schlüter* and *The Fountainhead* should feature such peculiarly similar heroes, and that something of their single-minded obsessiveness can also be glimpsed in the characters which give *The Draughtsman's Contract* and *The Belly of an Architect* their names.

NOTES

1 Quoted in Leisner and Erwin. *Nazi Cinema*, London, Secker and
 Warburg, 1974, p 106.
2 *ibid.*
3 E H Carr, *What is History?*, Harmonsworth, Penguin, 1964, p 33.
4 Adolf Hitler, *Mein Kampf*, London, Hutchinson, 1969, p 387.
5 Francis Courtade and Pierre Cadars, *Histoire du Cinéma Nazi*, Paris,
 Eric Losfeld, 1972, p 94.
6 Hitler, *op. cit.* p 240.
7 Quoted in Berthold Hinz, *Art in the Third Reich*, Oxford, Basic
 Blackwell, 1979, pp 197-199.
8 Hitler, *op. cit.* p 240.
9 Raymond Durgnat, 'The Fountainhead' in *Film Comment*
 September/October 1973, vol 9 no 5, p 31.
10 Donald Albrecht, *Designing Dreams: Modern architecture in the
 movies*, London, Thames and Hudson, 1986, p 168.
11 Durgnat, *op. cit.* p 31.
12 Andrew Saint, *The Image of the Architect*, New Haven and London,
 Yale University Press, 1983, p 1.
13 *ibid*, p 14.
14 *ibid*, p 6.

9
The Childish, the Insane and the Ugly
Modern Art in Popular Films and Fiction of the Forties

Diane Waldman

Many art and film historians view the artistic modernism and mass cultural forms of the Twentieth century as separate and distinct developments, and prefer to study one or the other. Others, I think rightly, assert that the concern with pure form, the language of art, and the valorisation of the new in the artistic movements of the late Nineteenth and Twentieth centuries was a direct response to the 'massification' and commodification of art in that same period. As Linda Nochlin puts it:

> while this purifying, limiting operation can in one sense be interpreted as a continuation of Realist 'honesty' and 'truthfulness', it is also a successful way of limiting the audience of art to those whose taste is guaranteed by its purity of motivation at the very moment when mass communication, kitsch, and academicism were beginning to make art attainable to, and the business of, an ever increasing, ever less-educated public... Until the latter part of the 19th century, pictorial iconography might be difficult, but it could be made available to reason and reasoned explication. The idea that only an elect – an anti-Philistine elect known as the avant-garde – self-chosen and self-perpetuating – could respond to the work of art on the basis of its art qualities alone, is a social response, not merely an aesthetic one, to the tremendous social and institutional pressures on the production and consumption of art that went along with the more general upheavals of the 19th and 20th centuries.[1]

Proceeding from this assumption, this paper takes a look at what happens when mass cultural forms represent modern art. More specifically, I will discuss

the representation of modern art in some popular American films, fiction and essays from the period 1939-1949. Many of these films include a portrait and a sequence around a portrait as the occasion for championing an illusionist against a modernist aesthetic. Although it might be argued that they do this in order to affirm their own illusionism, I wish to go beyond this purely formal explanation. I will investigate the charges against modernism which surface in these texts – its 'incomprehensibility', its appeal to a narrow elite, its 'ugliness', its similarity to the work of 'children' and the 'mentally deranged', its political subversiveness. Although many of these attacks on modern art pander to the lowest common denominator, to anti-intellectualism, xenophobia and red-baiting of the worst sort, their pervasiveness points to the very real class nature of artistic taste, and the gap between 'high' and mass culture, often exploited for ideological purposes. It is especially ironic when nostalgia for the past and its representational forms surfaces in film – a medium created in and by the economic, social and technological change against which this nostalgia reacts.[2]

In 1939, the Museum of Modern Art celebrated its tenth anniversary with an exhibition entitled 'Art in Our Time.' On this occasion, a writer in the *Saturday Review* claimed that the exhibit 'reveals the progress of a quarter century, not only among the practitioners of modernism, but in the attitude of the public toward experimentalism in art.'[3] Referring to the violent reaction to the Armory Show of 1913, which introduced Cezanne, Gaugin, Seurat, Rousseau, Redon and the Cubists to the American public (and which, in the words of another, slightly later writer, burst upon us like an aesthetic atomic bomb'),[4] he reminded readers that 'vice crusaders discussed the morality of the 'Nude Descending a Staircase', Daniel Chester French denied that Maillol was a sculptor of talent, and art-students burned Matisse in effigy.' The author was pleased that:

> now, the financial stringencies of European countries geared to a war
> economy, and that ostracism of modern art by authoritarian regimes
> which drives artists-in-exile to America, have combined to make our
> country in a real sense the home of modernism.

He also commended the Museum for:

> ...the distinguished and influential part which the laboratory in West
> Fifty-Third Street has played in creating a more tolerant, a more
> genuinely critical attitude toward the eccentricities and the iconoclasms

of our time... Controversy with regard to the claims and accomplishments of those who distort and those who abstract now proceeds on a higher level of intelligence than in those days when wild men were accused of drawing 'crudely' because they could not draw 'correctly.'

He concludes:

if modern art has ceased to be considered a conspiracy by a subversive minority, and is studied and judged as a new approach not only to nature, but to man's task of turning to esthetic and practical advantage the new forms, the new materials a new age has provided, a large share of credit can be claimed by the institution whose tenth birthday coincides with The World of Tomorrow.

In retrospect this piece seems both premature and overly optimistic. Attacks on modern art were to appear in popular films, fiction and periodicals of the decade, in everything from *Harper's*... and the *Atlantic Monthly* to *Senior Scholastic*. The latter published an essay by a high school student which won fourth prize in the 1948 Scholastic Writing Awards: 'Peoples Iss Nuts Youst Lak Monkeys Iss.' It begins:

it certainly is a shame. It costs 35 cents to get in to see what nuts can produce after they crack up. They let these queers go around loose, unmolested and unleashed, while they lock up substantial and reliable people like murderers and maniacs.

The essay continues in this vein, describing four boys' visit to the Museum of Modern Art:

we entered the Museum of Modern Art warmly, taking careful note of all the exits, in case a hasty retreat was necessary. We quickly lost ourselves in the maze of rooms and hallways, stairs and alcoves. All of a sudden, Jimmy let out a scream of terror and Henry fell to his knees, babbling like an idiot. There before us, looming up out of nowhere, stood this awful thing, It covered the whole wall in front of us and mainly consisted of writhing devils' heads, broken arms, and feet; inanimate objects were being strangled and stabbed; cows had ears like dogs and noses like electric light bulbs. When my initial shock wore off, I crept closer to see who or what this thing was. The panel read '*Guernica* Mural – Picasso'

and told how everybody thought this was a masterpiece.[5]

Modern art fared no better in some of the adult magazines. In 'The Victory and Defeat of Modernism', George Biddle in *Harper's* similarly denounced the *Guernica* mural for its alleged 'escapism':

> and the crisis through which the world is now passing illustrates the
> frustration of abstract art when it attempts to face realities. Picasso did
> just that in his *Guernica* mural. In semi-abstract symbols he attempted
> to describe his horror of the Nazi brutality in Spain. I venture to say that
> these symbols would have a hundred different meanings to a hundred
> different people. If one speaks to be understood one must speak in a
> common language.[6]

He praised, on the other hand, Walt Disney and the trend by which art was being integrated with business ('International Business Machines, N.W. Ayer and Son and Abbott Laboratories have spent well over $150,000 in the past few years on commissioning or buying paintings from our leading American artists to advertise their commodities'[7]) and with Federal or State government.

But what of film, the art form of the Twentieth century? Recall that Walter Benjamin, in 'The Work of Art in the Age of Mechanical Reproduction' argued that 'mechanical reproduction of art changes the reaction of the masses toward art. The reactionary attitude toward a Picasso painting changes into the progressive reaction toward a Chaplin movie.'[8] Although he was talking about film's potential, and not the case where 'movie-makers' capital sets the fashion,'[9] Benjamin was still quite optimistic in 1936. Arnold Hauser, writing almost 20 years later, concurs with Benjamin ('apart from film, progressive art is almost a closed book for the uninitiated') but predicts that 'the cleft will sooner or later arise that even in this field separates the layman from the connoisseur'.[10] Given such categories as 'avant-garde' films, 'art' films, and the number of film journals, conferences, etc., the accuracy of this prediction seems self-evident.

So how does popular film view modern art? Like the other mass cultural forms: with hostility and suspicion. At the outset, let me emphasise that with the possible exception of one, the films I will be discussing are not 'about' art and artists. They are modern Gothic romances which center around a female protagonist and her ambivalent relationship with her husband, whom she suspects of being a murderer – Hitchcock's *Rebecca* (1940) and *Suspicion*

(1941), Tourneur's *Experiment Perilous* (1944), Godfrey's *The Two Mrs Carrolls* (WB, 1947) and Korda's *A Woman's Vengeance* (1948).

Initially I was attracted to and interested in these films for reasons and purposes different from the concerns addressed here. Yet I was struck by both the frequent hostile allusions to modern art and occasionally to high art in general, and the use of the presence of a realistic portrait as an occasion to valorise an illusionist over a modernist aesthetic.

Let me give a few examples. In most of these films, either the heroine or the hero-villain are wealthy and/or aristocratic, which explains the presence of portraits, first, as additional signifiers of wealth and class status. What is more interesting, however, is the way in which these portraits became a focus or occasion for championing an illusionist aesthetic.

The best-known example occurs in *Suspicion*, where the traditional portrait of Lina's father, General McLaidlaw, which hangs originally in Lina's father's house, is opposed to the abstract painting which appears in Lina's second home, decorated by her husband Johnny. Stephen Heath uses this example to begin his article, 'Narrative Space.' Of the sequence in *Suspicion* in which Lina is visited by the two police inspectors. Heath writes:

> the scene finds its centre in a painting: the massive portrait of Lina's
> father which bears with all its Oedipal weight on the whole action of the
> film... and before which she now positions herself to read the newspaper
> report of the friend's death and to gather strength enough to face the
> scrutiny of the law, the look relayed from portrait to police and to
> portrait again.[11]

The one exception to the purposeful symmetry and economy of the sequence is Benson's gaze left to the other painting the 'post-cubist Picasso-like painting' which Heath describes as 'useless' (isolated, without resonance over the film...), serving to demonstrate the rectitude of the portrait, the true painting at the centre of the scene, utterly in frame in the film's action.[12] The significance of Benson's fascination with the painting for Heath, then, is its 'interruption of the homogeneity of the narrative economy...'[13]

While I am basically in agreement with that analysis, several other things could be said about the sequence. First, although the 'post-cubist' painting is 'useless' from the point of view of narrative motivation, the fact that it does serve 'to

demonstrate the rectitude of the portrait, the true painting,' demonstrates its 'usefulness' from another point of view, and the fact that it does have 'resonance over the film' when it takes its place among a complex of thematic associations and oppositions: McLaidlaws/Aysgarths, old money/new money, realistic portraiture/post-cubism. Johnny, Lina's husband, is *déclassé* – the scion of a wealthy family, now totally without money - and the opening sequence of the film economically conveys Johnny's class position: Lina encounters him on a train attempting to ride in a first-class compartment with a third-class ticket. The film establishes an opposition between the old wealth and stability of Lina's family on the one hand, and the new wealth and recklessness of Johnny's on the other. 'Before the Fact', the Francis Iles novel upon which *Suspicion* is based, is more explicit:

> the Aysgarths in fact, at Elefield, were neither quite of the old order, nor
> of the new. The more the land of England is changing hands, the more do
> the former holders by right of birth look down on the new owners by
> right of purchase; and the more do the latter scoff at the former. For one
> who takes pleasure in despising his neighbor more than himself, the
> English countryside of this decade offers exceptional opportunities.[14]

This opposition, then, is also signified by the portrait of the General versus the 'post-cubist' art that Johnny prefers, suggesting that the latter is slightly suspicious, along with Johnny's character.

Second, Benson's fascination with the painting and the supposed humour of the sequence is based upon a contemporary 'truism': the incomprehensibility of modern or nonfigurative art to the layperson (in this case, a detective), and the widening gap between high art and mass culture.

A similar sequence occurs in *A Woman's Vengeance*. Based on the same mode of humour as the sequence above, workmen in the central character's house gawk at a Modigliani and tease the maid about the 'speaking likeness.' In this film, attitudes toward art are used for purposes of characterisation. A distinction is drawn between Henry's wife Emily, who, besides being a whining invalid, says that modern painting 'makes her sick,' and Janet, Henry's friend, who gets a volume of Proust for her birthday and admires Modigliani. However, since it is eventually revealed that Janet is a murderer, and Henry a philanderer, the association of modernism with these characters is hostile rather than sympathetic.

The short story upon which the film is based is Aldous Huxley's 'The Gioconda Smile', a title deemed 'too obtuse' by the studio when Huxley adapted the work for the screen.[15] In the story, not only are their attitudes toward art used to characterise the women, but they are seen by Henry in terms of art works as well, as the title indicates. Thus Janet, the intellectual snob, is described as a Roman matron with a mysterious 'Gioconda smile'. Doris, his second wife, with her round babyish face, resembles the pictures of Louise de Kerouaille ('Who's Louise de Kera - whatever it is?' she asks). The visage of the once beautiful Emily was now 'the face of a dead Christ by Morales'.

Huxley's objectification of women in art works apparently extended to his artistic criticism as well as his artistic creation. Huxley participated (along with Clement Greenberg and Francis Henry Taylor, director of the Metropolitan Museum, and others) in a 'Round Table' discussion of modern art sponsored by *Life* magazine in 1948. The painting 'Parnassus' by Nicholas Poussin was cited by Huxley:

> ...to illustrate an important esthetic criterion: that one of the
> characteristics of a great, as opposed to a lesser, work of art is that it
> imposes a unity on a greater diversity of elements. The Poussin picture,
> according to Huxley, contains a 'very subtle and elaborate system of
> formal relationships', which the artist has welded into a perfect whole.
> Mr. Huxley also pointed out that Poussin used the same face for all his
> female figures, showing that he was much more interested in the
> picture's formal than in its psychological content.[16]

Rebecca and *The Two Mrs Carrolls* actually involve characters who are artists. In *Rebecca*, we learn that the heroine's father was a traditional artist, and the heroine herself complains of her own work that she can never get the perspective right. One of the minor characters, upon discovering that the heroine sketches, remarks, 'Not this modern stuff I hope. You know, turn a lampshade upside down to represent the soul in torment. Ha!'. (This speech was not in Du Maurier's novel.)

In *The Two Mrs Carrolls*, the artist-husband's non-representational style is actually presented as a sign of his mental derangement. With some confusion of terms, the daughter in the film says of his portrait of her mother, 'It isn't a portrait. Father says it's representational'. (Actually, this man paints his various wives as 'The Angel of Death' before he kills them.) The temporary script and

master synopsis for the film were even more explicit. The former details Geoffrey's method of painting and theory of art as 'not strictly figurative' and 'interested in ideas'; 'but Geoffrey's art is limited by a certain morbidity, the result, if one looks for a Freudian interpretation, of seeing his parents killed in his childhood.' Geoffrey's paintings are described here as 'depicting human figures in dramatic and bizarre poses', and in the master synopsis as 'the product of a mind that must be verging on insanity.'[17] Although a rebellion against naturalism was a common response of portraitists to the rivalry of photography, 'mentally ill' was, as we shall see, one of the epithets most commonly applied to modern portraitists and artists in the 1940s.

The Two Mrs Carrolls evidences a suspicion not only of modern art but of art in general. As in *Experiment Perilous*, where the hero is a self-proclaimed 'artistic illiterate', the housekeeper in *The Two Mrs Carrolls* snaps, 'When you work for an artist, you can expect just about anything.' In fact, publicity for the film played off the stereotype of the effeminate artist and contrasted it with Humphrey Bogart's usual screen persona of the 'tough guy'. The Warner Brothers pressbook includes an article with the headline 'Smock and Beret Make Tough Guy Hit Ceiling', which describes producer Mark Hellinger's 'gag' allowing Bogart to think he was to wear a smock and beret and Bogart's subsequent refusal. In addition, the temporary script includes a brief sequence in which a group of people discuss Geoffrey's paintings with this description: 'The man is an art critic – the women are normal people.' Once again, this points to the widening gulf between high culture and its practitioners and critics on the one hand, and mass culture on the other. Benjamin's essay becomes relevant here as well, for in a continuation of the argument cited earlier he states:

> the progressive reaction is characterized by the direct, intimate fusion of
> visual and emotional enjoyment with the orientation of the expert. Such
> fusion is of great social significance. The greater the decrease in the
> social significance of an art form, the sharper the distinction between
> criticism and enjoyment by the public. The conventional is uncritically
> enjoyed, and the truly new is criticized with aversion.[18]

The question now arises: why the portrait as an occasion for such a hostile view of modern art? In part, because the portrait represents one of the dominant genres in the history of Western painting, with a marked increase in illusionist techniques which culminate in the illusionist aesthetic of Hollywood

film-making. But the history of portraiture develops and declines with a society which stresses the importance of the individual, usually the individual wealthy white man and the women and children associated with him. The portrait originates in Greece in 700 BC. With the development of commerce, urban society and the idea of a competitive economy, the notion of individualism becomes prominent in all fields of cultural life: thus we get the beginning of a subjective trend in poetry, the predominance of the lyric, the new claim of the poet to be recognised (as opposed to the collective work of the rhapsodes), the first signed works of visual art, and the public portrait, coins and miniatures.[19] In the Roman tradition, portrait sculpture was revived in the masks of ancestors. In the last years of the Republic, the patrician privilege of displaying portraits of ancestors in funeral processions had been extended to plebian families, but the cult of ancestral portraits remained essentially a feature of aristocratic funerals.[20]

Portraiture declines in the Middle Ages. 'The crucial thing is that in the range of commissions set to medieval art no need, no requirement of any kind, aroused or stimulated the capacity to interpret individual characteristics.'[21] In the late Middle Ages and early Renaissance, portraiture is revived in the form of the portraits of donors of religious paintings, but they are relegated to the corners of the panel, the portrait still subordinate to religious considerations.[22]

Even in religious paintings, we begin to see the shift towards interest in individuality. For example:

> ...the portraits of donors in the Ghent Altar as well as in Jan van Eyck's other religious pictures are dimensionally speaking, equivalent to the holy figures and are not inferior to them in significance, taking the picture as a whole. Man confronts his God with a newly awakened feeling of selfhood.'[23]

Or, 'Ghirlandaio's fresco cycles are so replete with portraits that they almost serve as family chronicles of the wealthy patricians who sponsored them.'[24]

Finally, with the re-emergence of commerce and urban life in the Renaissance, we see the reawakening of interest in the individual and the secularisation of the portrait:

> the portrait as we understand it comes into its own as a genre when the person portrayed occupies the center of the panel as the nobility and the gentleman come to occupy the center of public life. The portrait,

removed from the religious painting and the fresco, seen to be more than a painted medal or a derivative of sculpture, appears with the growing secularization of life and the development of late Renaissance courtoisie, and thereby comes to serve several functions.[25]

This secularisation, in addition to the movement of the person to the centre of the panel, and the interest in the individual revealed in such things as the development of the convention of the three-quarter angle,[26] includes the naturalisation of the symbolic or religious. For example, in Janson's interpretation of the famous 'Giovanni Arnolfini and His Bride', 'the symbolic is included as naturalistic detail':

> ...the shoes which the couple has taken off remind us that they are standing on 'holy ground'; even the little dog is an emblem of marital faith... The natural world as in the Merode Altarpiece, is made to contain the world of the spirit in such a way that the two actually become one.[27]

Gombrich includes a humorous anecdote from Leonardo's notebooks which basically illustrates the same point:

> it happened to me... that I made a religious painting which was bought by one who so loved it that he wanted to remove the sacred representation so as to be able to kiss it without suspicion. Finally his conscience prevailed over his sighs and lust, but he had to remove the picture from his house.[28]

Not only does this illustrate the increased secularisation and naturalisation of painting, but cites a precedent for the strength of the illusionism which causes a man to fall in love with a painting, as in *Experiment Perilous* or Preminger's *Laura*.

The revival of interest in realistic portraiture and the mastery of physiognomic expression takes its place along with the more frequently mentioned techniques of illusionist art: the rendering of space through perspective, and the suggestion of light and texture. The association of the portrait with illusionist art continues in the question of resemblance, and the debate between the champions of the 'fine' versus the 'like' portrait. This debate illustrates the tension between decorum, convention and flattery of the patron, on the one hand, and realism and the vision of the artist on the other. Along with the landscape and the still life, portraiture as a genre dominates the

Western tradition of painting until the middle of the nineteenth century. All this changes with the invention of photography, or rather, with the acceleration of industrialisation and the concomitant philosophies of positivism, empiricism, and the emphasis on scientific observation into which photography is born.

As with other realistic genres, the invention of photography made realistic portraiture somewhat superfluous. Ingres, for example, was described as 'the last great professional in a field soon to be monopolized by the camera.'[29] Remy Saisselin, the author of a book entitled 'Style, Truth and the Portrait', points out that 'the whole man of portraiture had to give way to passing glimpses of individuals,'[30] and 'the art of portraiture was to die as a significant genre with the society that had of it a model for man. Everything would change after 1848.'[31] Portraiture, as mentioned previously, turns to exaggeration, caricature, satire, abstraction. Implicit in Saisselin's last remark is a nostalgia for the type of art which is possible in a society which valorises the individual. This is more explicit at the end of his essay, in which he laments that the 'portrait today is hardly a believable genre,' quotes from the 'Notebooks' of Henri de Montherlant: 'I love those Renaissance portraits in which the principal person points with one hand to his breast as if to indicate that he, and none other, is important; and concludes that we no longer live in the type of society that makes the art of the portrait possible:

> our society is neither aristocratic nor monarchical, and power and
> privileges have taken to forms which are not susceptible to artistic
> glorification. Rather, since Daumier, we know them to be necessarily
> an object of satire.[32]

In its preface, this book, based upon an exhibition at the Cleveland Museum of Art in 1963, is even more explicit about the relationship between the 'lost art' of portraiture and mass culture, and the role of the preservers of high culture within a 'mass society.' The author, Sherman E Lee, bemoans:

> ...the waning interest in individual human beings and their external
> appearance as an indication of character. These considered en masse,
> have become above all units in large series or groups designated
> variously as majorities, pluralities, minorities, trends, consumers, etc – we
> know their designations all too well. Still, we fight for the preservation of
> the individual for his worth, his idiosyncracies, his peculiar place within

his particular circle. The emergence of the individual, as distinguished from the hero, as a worthy subject for art was the original contribution of European art after the 14th century, the 'waning of the Middle Ages.' It followed the rise of a cultural tone that recognized and was interested in man as an individual and as a representative of a creative class.[33]

The individual referred to was most likely an aristocrat or a member of the newly emerging merchant class, although Lee does not see him as such; his generic 'man' and unspecified 'we fight' posits a universal human condition. I cite this example because it seems to me the same sentiment represented in the valorisation of the portrait against modern art in the films.

The novel upon which this film is based is much more explicit about the juxtaposition of the portrait with both modern art and modern life. Since the novel has a contemporary setting, it is the Museum of Modern Art which contains the portrait: '"Purely representational", said an affected voice at his shoulder. He was alone with Allida'. Afterwards, the doctor goes home: 'He took in at a glance the sticky pink of the walls, the impersonalized banality of the "reproduced" furniture, the geometric neatness of the ranged medical magazines on the table, and the stiff folds of the coarse net curtains motionless in the air-conditioned steel-framed windows.'[34] Thus the 'purely representational' portrait is favorably contrasted with not only the modern works which we assume the owner of the 'affected voice' prefers, but with the 'impersonalized banality' of mass-produced furniture and decor. This passage succeeds, then, in linking modern art and mass culture, and expressing nostalgia for a pre-industrial, pre-mass cultural era and one of its representational forms, a realistic portrait. The film takes this one step further by placing its story in 1903.

The 'affected voice' which dismisses the portrait as 'purely representational' leads us to the main charges against modern art: its incomprehensibility, its appeal to a narrow elite, its ugliness, the claim that it looks like the work of children and/or the mentally deranged, the claim that its practitioners were insincere fakes attempting to deceive the public, and the claim that it was politically subversive. For example, S J Woolf, in an article entitled 'Is it Art or Is It Double Talk?' juxtaposes a painting by Dali with one 'by a patient in an insane asylum'; and portraits by Picasso and Modigliani with works of children aged seven and twelve (and of course, these comparisons, meant to be derisive, impugn the imaginations and creativity of children and those considered

Picasso, seen as a prime exponent of Modern Art as fakery.

mentally ill); and, in the ultimate defense of illusionistic art and vulgar biographical criticism, attributes Matisse's style to his 'defective vision.'[35] As one critical response to this article pointed out, Woolf's authority as an art critic was based upon the fact that he was an artist who 'painted a series of portraits of the leading American generals.'[36]

The chief proponent of the 'modern art as fakery' school was T H Robsjohn-Gibbing, whose *Mona Lisa's Mustache, A Dissection of Modern Art* was published in 1947. Robsjohn-Gibbing's main argument was that modern art is 'a revival of one of the oldest systems for getting power,' ie, magic and deliberate mystification.[37] Robsjohn-Gibbing was not above presenting his theories in fictionalised form as well. In 'Dilemma: the perils of making a cult of the modern,' a short story printed in *House Beautiful*, Harriet, the Midwestern heroine, is taken by her friend Elise (who 'looked even more bizarre than usual') to an opening at the Museum of New Reality. The logo for the exhibit, 'Ectoplastic Design,' is an enormous white foot cut out of plywood, with two circles of silver wire crossing it. Among the artists (all 'foreigners'), number one de Xifos, active in the 'Greek Adad Movement'; Mirsky, whose ceiling fan is presented as something from his 'neoplastic period'; the cynical and practical Kissitzsky, who exploits his trouble with US customs to increase the price of his work; and last, but not least, Karl Junger, who 'squeezes wet plaster between his hands while he's in a trance.' The people viewing the exhibit, with the exception of Harriet, of course, are pretentious, insufferable snobs, calling all those who disagree with them 'bourgeois Philistines.' And, as for Harriet, 'she had resisted the temptation to tell Elise that she thought modern art looked better in Bonwit Teller's window than it did in the Museum,' and the narrative ends with Harriet triumphantly throwing her program from the exhibit into the wastepaper basket.[38]

The charge of 'ugliness' was another which echoed throughout the decade. For example, Margaret Cresson argued that modernism is ugly and 'John Doe' is unimpressed:

> he goes to a fine, big art show. What does he find? Back yards and railroad sidings, dark and murky landscapes, prostitutes fixing their garters, bulbous-limbed nudes. He can see enough of those where he came from. He guesses that art isn't for him. He decides to go to the movies instead.[39]

Again the class nature of art appreciation is condescendingly proposed, with mass culture available to fill the gap. Often this critique of 'ugliness' on aesthetic grounds was a thinly disguised political attack. The 'Purpose of Art' in *Catholic World* begins:

> Medieval art was warm and pure, gay with color and with youth, deep of soul and popular. Today, art is often so frigid, unclean, stale, insipid, that in Goethe's words, it sickens the soul. Everybody had heard about the ejaculation made by some visitor to a modern exhibition of paintings: 'Oh, that my eyes could vomit!'

The article attacks not only 'modern art' in the name of the amorphous 'people' ('The people will not be satisfied with mere artistic form, nor interested in painters' experiments and delicate questions of light-effects. Their eyes are too normal, their palate is too natural, their taste is too unspoiled, for that') but a certain kind of 'realism' as well: 'but realism becomes unhealthy and perverse, if it regards as most real the things which are vile and common and ugly – the scum of life – and lives and works for them alone...'

> much is made of the democratic tendency of art and many believe that by means of it, art and true appreciation of art will again find a way to the heart of the people. To be sure, art is not to be reproached for devoting itself to the fourth estate, to the machinist, to the plowman, the proletarian, any more than fiction is to be reproached when it leaves the salon for the workshop and the peasant's hut... Yet everything depends upon the purpose of art in attempting to get down to the common people. If it aims to exploit misery, hunger and filth, as a novel means for the stimulation of dulled nerves, it scarcely deserves praise. If it aims to raise the prevalent discontent to a higher pitch, to stir up hate and jealously [sic], it acts criminally; it becomes a socialistic agitator, a dangerous anarchist.[40]

The attack on modern art as subversive at times was not even so thinly disguised as this. Against the optimistic claim of the *Saturday Review* writer that 'modern Art has ceased to be considered a conspiracy by a subversive minority', and that America had become a 'home of modernism' because of the ostracism of modern art by authoritarian regimes; there were attacks such as that by Hearst columnist Paul Mallon, who, in an open letter to his boss, requested that:

You, as a primary advocate of Americanism, should use all your resources in the press and magazine field to let the public get the facts. Today the public mind thinks of art in terms of medieval foreign masters. Our art is as good or better but it has not been similarly publicized...

Much modern art is psychologically Communistic. Picasso, who led this school, was a Communist. He gave eminence to the imaginative school of art in which the observer or buyer must imagine how well the artist conceived the painting no matter how poorly he executed it or presented it. This is precisely the same process of the Communist political doctrine which requires the observer to imagine the nonexistent beauties of a way of life which reality would disclose as far from sublime. It has blood on its hands.[41]

Note the negative connotation placed on the utopian strivings of the imagination, both in art and politics.

This attitude is, unfortunately, alive and well today In Denver, Colorado, a group called the Denver Businessmen's Briefing on February 3, 1981, published a two-page ad in the *Rocky Mountain News* telling readers how they could 'evaluate the ACLU and others... using the Communist/Socialist Conspiracy Checklist'. This forty-seven point checklist of 'declared goals of the Communist Party' included such statements as plans to 'control art critics and directors of art museums' and plans to 'promote ugliness, repulsive and meaningless art'.[42]

In the Forties, these kinds of overt political attacks were not limited to the rantings of the Hearst press. Francis Henry Taylor, director of the Metropolitan Museum, damns Picasso and his successors as he praises them:

that this message is more often than not a message of propaganda for some popular and current ideology is of course one of the fundamental dangers inherent in the modern movement. But Picasso, even when he is most socially destructive, is free, from the charge of producing something meaningless or utterly private in its concept.[43]

Taylor lays the blame not at the feet of modern artists, but with the decline of traditional and spiritual values, and he supports his position with a reactionary and racist quote from Toynbee:

the prevailing tendency to abandon our artistic traditions is not the result of technical incompetence; it is the deliberate abandonment of a

style which is losing its appeal to a rising generation because this generation is ceasing to cultivate its aesthetic sensibilities on traditional Western lines. We have willfully cast out of our souls the great masters who have been the familiar spirits of our forefathers; and while we have been wrapped in self-complacent admiration of the spiritual vacuum that we have created, a Tropical African spirit in music and dancing and statuary has made an unholy alliance with a pseudo-Byzantine spirit in painting and bas-reliefs, and has entered in to dwell in a house which it found swept and garnished... Our abandonment of our traditional artistic technique is manifestly the consequence of some kind of spiritual breakdown in our Western Civilization; and the cause of this breakdown evidently cannot be found in a phenomenon which is one of its results.[44]

Similarly, Peyton Boswell Jr. argued in *American Art Today*, 'because of our Anglo-Saxon heritage American art is a literal three-dimensional art. There is little room in its pattern for such aesthetic detours as cubism or nonobjective painting'.[45]

Writers such as this had to do some fancy footwork in order to explain the ostracism of modernism in the Stalinist USSR and in Nazi Germany, and to distinguish their positions from those of the official positions of regimes they decried. George Biddle, in 'The Victory and Defeat of Modernism' (1943), concludes by asking 'is the distinction I made between the social role of art in a democratic state and in the totalitarian states of Europe - Russia, Germany, Italy - a somewhat legalistic one?' A good question, but Biddle worms out of it by concluding that the difference lies simply in the question of censorship. Similarly, Taylor asserts that 'no intelligent person would seek to deny the innate and inalienable right of the artist to do and think as he pleases,' yet at the same time states, 'but as a citizen the time has come for him to choose whether he is for civilization or whether he is against it, whether he believes in the freedom of individual conscience or whether he is ready to accept whatever propaganda is fed to him with a spoon'. He then returns to his original assertion: 'Only by complete freedom of creation can the integrity of art be kept alive.'[46] Thus Taylor could conclude:

but that, on the other hand, is no reason why the public should be dragooned to admire and to applaud what they cannot understand. If the public must respect the artist's freedom of creation, then in the same way the latter must acknowledge the public's freedom of acceptance or rejection. Any other concept is academic and totalitarian.[47]

That the modern art establishment itself was on the defensive can be revealed in the nature of some of the exhibits at the Museum of Modern Art which sought to legitimise modern art by the appeal to tradition. For example, in 1940, a new exhibit contrasted twenty-eight pieces by masters of the Italian Renaissance with twenty-nine modern pieces on similar subjects. Against accusations that this was a sensational stunt:

> the museum says that both groups belong to the same stream of
> European art. Looking from one to the other, it believes, the spectator
> will see by contrast what the differences are and why, and what
> fundamental qualities the artists have in common.[48]

Later in the decade, to celebrate its twentieth anniversary, the Museum opened a show, entitled 'Timeless Aspects of Modern Art', which juxtaposed historical examples with modern, not on the basis of any lineal descent or influence, but simply on the basis of resemblance For example, a Panamanian deer's head mask used in Indian ceremonials, was placed next to Picasso's sketch of a horse in the bombing of Guernica 'to show how similar devices were used to create frightening effects'; while 'the way line can create an effect of mystery' is illustrated in an Argentinian Indian disk and a ghost's face on an envelope by Paul Klee in 1937. 'To show how an impression of spiritual solemnity is often achieved by simplification and by enlargement of head and eyes', the museum hangs an ivory Madonna by ninth century Christian Copts in Syria or Egypt with a 1932 painting of Christ by Rouault. The 'continuing use of elongation and attenuation for emotional effect' is shown in an Etruscan warrior of about 600 BC and Lehmbruch's youth of 1913, while a Micronesian mask and a 1915 head by Modigliani illustrate that elongation and simplification in modern art have age-old precedent.' The explanation of the museum clearly indicates the legitimising intention of the exhibit:

> there is no intention of proving that these affinities enlarge or detract
> from the quality of modern art. We want only to show that some things
> which look weird and unprecedented have been done by artists since the
> very beginning of civilization. We do not pretend that the motives for
> their production are the same. But because the objects resemble each
> other in some aspects we hope to prove that modern artists are not just
> tricksters trying to invent bewildering new means of expression in order
> to be different or perverse.[49]

René d'Harnoncourt, who arranged the exhibit, skirts the issue of the

ahistorical nature of it:

> Modern art is that art which is an expression of our time and is firmly anchored in our day. Like all art, it has three aspects: that which belongs to yesterday, that which is timeless, that which is specifically of its own time. The exhibition is intended to show the timeless aspects.[50]

As for the other aspects, that:

> which has so much connection with today that this aspect overwhelms the others - such as Picasso's double images, which are the consequence not only of the art of the past but much more of psychology and the camera and new space-time concepts... we will show this kind of connection in a later exhibition in the series.

Another example of the defensiveness of the modern art establishment is the name change on February 17, 1948 (the anniversary of the Armory show), of the Institute of Contemporary Art. The explanatory statement indicated that:

> Modern art failed to speak clearly... there emerged a general cult of bewilderment. Once the gap between artist and public had widened sufficiently, it became an attractive playground for double talk, opportunism, and chicanery at the public expense... 'Modern Art', denoting simply the art of our times, came to signify for millions something unintelligible, even meaningless. Today, however, 'modern art'... has become both dated and academic.

Lest this pronouncement be interpreted as 'an invitation to reaction', the museum stated:

> we are unalterably opposed to extremism of the die-hard conservative kind... Our endorsement will take the form of exhibition, publication, and where possible, the effective integration of art with commerce and industry.[52]

These attacks on modern art and knuckling under by the chief exhibitioners were obviously not the only voices heard throughout the decade. Clement Greenberg, writing in *The Nation*, noted 'the spreading recognition in this country of the fact that its most significant art is tending to become more and more exclusively abstract - and has begun to provoke a determined counter-reaction.' He lists a series of events, among them the name change of the

Boston museum, and somewhat pessimistically points to the division between mass culture and high art audiences:

> as for the public - which public? The millions who, as the institute says, find 'modern art' something unintelligible and even meaningless? Those same millions also prefer Norman Rockwell to Courbet, and neither the Institute of Contemporary Art nor any other institution will in our day and age ever persuade them to comprehend the standards that make Courbet the one to be preferred.[53]

The artist Stuart Davis wrote a less condescending reply to George Biddle. Davis points out that Biddle's arguments 'go far beyond any mere quibble about styles in painting.'[54] He disputes the notion that modern art is 'escapist' and 'Ivory Tower' - it 'has had repercussions in all parts of the civilized world on aesthetic perception and industrial design.' As for the participation of the masses:

> Modern Art does speak a common language to thousands who have had the opportunity to cultivate it. It will become part of the common art language of the masses as opportunity for participation in authentic art experience is made available to them. But that language cannot be formulated in terms of their relative illiteracy in art and the prejudices resulting from it... To assume incapacity on the part of the masses for the fullest cultural growth is incompatible with belief in the democratic principle.[55]

Davis also takes on the question of censorship. Although examples of outright suppression or destruction of art in the United States are infrequent, there have been a number of them, most notably the destruction of Diego Rivera's mural in the Rockefeller Center in 1933. However much more common is the form of indirect censorship of agencies of sponsorship and distribution:

> in whose policies, the artist has little voice. These policies, which both reflect and create public opinion, react directly on the economic status of the artist and on his aesthetic orientation. Overt suppression is only the cruder form of censorship; the preferred instruments of coercion are propaganda and economic attrition.[56]

What type of propaganda? Davis traces the way in which isolationist thought is connected with the tendency of Americans to view 'abstraction' with suspicion:

Business approves of art, yes, but an art of the status quo to soothe the public mind and keep it on the beam. An art of the glorified familiar and spiritual nostalgia in reverse. And by all means a one-hundred-percent American art purged of the dangerous thoughts of foreign isms, an isolationist art singing the American Way of Life.[57]

Sentiment for an isolationist culture has been rallied round the slogan of 'The American Scene.' Through institutional and individual propaganda, a school of illustrative painting has been created and patronised and has attained an almost official status.[58] This is what exercises a censorship in our channels of art communication:

> it is not that the American artist is prevented from painting any way he chooses, but that he faces a public preconditioned to look with suspicion on anything beyond the literal, the sentimental, or the academic ... The American Scene philosophy parallels political isolationalism in its desire to preserve the status quo of the American Way of Life.

He continues:

> for many years past such men as Thomas Craven, Peyton Boswell, Jr, editor of *Art Digest*, Forbes Watson, and many others have been propagating their versions of the American Scene idea. Through books, magazines, newspapers, and lectures they reach a vast audience which is told that Modern Art is un-American and devoid of content. The Modern artist is outlawed and deprived of cultural citizenship, and the idea of democracy in culture goes down the drain. The relations between art and politics are devious, and often obscure, but they exist. The American Scene ideology has in it germs which the fascist-minded among us may find it profitable to cultivate.[59]

In conclusion, although many of the attacks on modern art pander to the lowest common denominator, anti-intellectualism, xenophobia and red-baiting, they still point to the very real class nature of artistic taste, the gap between high and mass culture. The nostalgia for a pre-industrial past and its representational forms (portraiture, illusionism) is a reaction against the economic, social and technological change which is represented in and by both modernism and mass culture.

Can we learn anything from the attacks on modernism in the Forties? We seem

to be entering into an era where both financial and ideological assaults on the arts in general, and, as the quote cited earlier from the Denver paper seems to indicate, on modernism in particular, are being renewed with vigour. It is clear from the past and the present that such attacks are political, although they often disguise themselves in 'purely aesthetic' argumentation, and must be met with a political response. If this is so, then those of us who wish to live in an atmosphere which allows for artistic freedom and experimentation must not dismiss such critiques as mere Philistinism, retreating into elitism and snobbery. It is up to us to connect the struggle for experimentation in art to other forms of economic, political and cultural democracy.

NOTES

1 Linda Nochlin, *Realism*, Baltimore, Penguin, 1973, pp 240-241.

2 This was noted by Arnold Hauser, when, after describing the special properties of the cinematic medium, he lamented that 'directors and cameramen are concentrating their attention, under the pressure of a second, already less film-minded generation, on the clear, smooth and exciting narration of a story and believe they can learn more from the masters of the *pièce bien faite* than from the masters of the silent film.' Hauser, *The Social History of Art*, New York, Vintage, 1951, IV, p252.

3 This and the quotes which follow are from Oliver Larkin, 'Domesticating Modern Art', *The Saturday Review of Literature*, 15 July 1939, p 8.

4 Ralph M. Pearson, 'A Modernist Explains Modern Art', *New York Times Magazine*, 1 September 1946, p 39.

5 Saul Helfgott, 'People Iss Nuts Youst Lak Monkeys Iss', *Senior Scholastic*, 20 October 1948, p 22.

6 George Biddle, 'The Victory and Defeat of Modernism', *Harper's*, June 1943, p 34.

7 *ibid*, p 36.

8 Walter Benjamin, 'The Work of Art in the Age of Mechanical Reproduction', *Illuminations*, London, Jonathan Cape, 1970, p 234.

9 *ibid*, p 36.

10 Arnold Hauser, p 251.

11 Stephen Heath, 'Narrative Space', *Screen*, Vol 17 No 3 Autumn 1976, p 68.

12 *ibid*, pp 69,70.

13 *ibid*, p 71.

14 Francis Iles, *Before the Fact*, London: Victor Gollancz, Ltd., 1932,
 p 265.

15 *Time*, 9 February 1948, pp 93-94.

16 Russell W. Davenport and Winthrop Sargeant, 'A Life Round Table on
 Modern Art', *Life*, 11 October 1948, p 78.

17 Thomas Job, temporary script, UA collection, University of Wisconsin
 Centre for Theater Research.

18 Walter Benjamin, *op cit.*

19 Arnold Hauser, *The Social History of Art*, I *op cit* p 87.

20 Friedlander, *Landscape, Portrait, Still-Life: Their Origin and
 Development* New York: Philosophical Library, 1963, p 234.

22 Remy G. Saisselin, *Style, Truth and the Portrait*, New York: Harry N.
 Abrams, Inc., 1963, p 2.

23 Friedlander, *op cit* p 238.

24 H W Janson, *The History of Art*, Englewood Cliffs, New Jersey:
 Prentice-Hall, Inc. and New York: Harry N. Abrams, Inc., p 246.

25 Among these functions Saisselin includes an historical record, an
 instrument of glorification, the remembrance of loved ones, tokens of
 friendship and the gratification of vanity, Saisselin, *op cit*, p 2.

26 According to Janson, 'Not until the Master of Flemalle – the first
 artist since antiquity to have real command of a close-range view of
 the human face from a 3/4 angle, did the portrait play a major role in
 Northern painting.' Janson, *op cit*, p 291. (Friedlander also links the
 development of the three-quarter profile with illusion, p 236.)

27 *ibid*, p 292.

28 E. H. Gombrich, *Art and Illusion: A Study in the Psychology of Pictorial
 Representation*, Princeton, New Jersey: Princeton University Press,
 1960, p 95.

29 Janson, *op cit*, p 474.

30 Saisselin, *op cit*, p 23.

31 Saisselin, *op cit*, p 22.

32 Saisselin, *op cit*, p 24.

33 Saisselin, preface by Sherman E. Lee, dated May 11, 1963.

34 Margaret Carpenter, *Experiment Perilous*, Boston: Little, Brown and
 Co., 1943, pp 71-72.

35 S J Woolf, 'Is It Art or Is It Double Talk?' *New York Times Magazine*, 14
 April 1946, pp 22-23, 59.

36 Letter from Gregory Mason, in 'I Say It's Art' – 'I Say It's Double Talk!',
 New York Times Magazine, 28 April 1946, pp 53-54.

37 'The Modern Art Racket', *Newsweek*, 27 October 1947, p 99,
 somewhat sarcastically reviews the book. For example, 'No
 worshipper of history, he considered the Victorian age 'an exciting
 world, stripped of the darkness, of superstition and ignorance'

whose 'middle classes needed no supernatural dressings to replace the precise knowledge by which science explained its beauty and wonder'.

38 T H Robsjohn-Gibings, 'Dilemma: the perils of making a cult of the modern', *House Beautiful*, December 1946, pp 216-217.

39 Quoted in 'Beautiful or Beastly?', *Newsweek*, 14 August 1944, p 92.

40 From Rt Rev Paul Wilhelm von Keppler, *More Joy*, tr Rev Joseph McSorley, St. Louis, B Herder; excerpted as 'Purpose of Art' in *Catholic World*, May 1947, p 172.

41 Quoted in 'Paintbrush and Sickle', *Time*, 25 February 1946, p 40.

42 Cited in Stephen Gascoyne, 'ACLU vs. Moon Mullins', *Westword*, 1981.

43 Francis Henry Taylor, 'Modern Art and the Dignity of Man', *Atlantic Monthly*, December 1948, p 33.

44 *ibid*, p 36.

45 Cited in Stuart Davis, 'What About Modern Art and Democracy?' *Harper's*, December 1943, p 21.

46 Taylor, *op cit*, p 36.

47 *ibid*, p 36.

48 Anita Brenner, 'Can Both Be Art?' *New York Times Magazine*, 28 January 1940, p 4.

49 Aline B. Louchheim, 'Modern Art? Not So Modern', *The New York Times Magazine*, 21 November 1948. p 50.

50 *ibid*, p 51.

51 *ibid*.

52 Cited in 'Modern Into Contemporary', *Newsweek*, 1 March 1948, p 73.

53 Clement Greenberg, *The Nation*, 6 March 1948, p 285.

54 Stuart Davis, *Harper's, op cit* p 16.

55 *ibid*, p 17.

56 *ibid*, p 17.

57 *ibid*, p 20.

58 *ibid*, p 21.

59 *ibid*, p 21.

10
Critical Contradictions
Media Representations of *The Dinner Party*

Marie Gillespie and Sylvia Hines

The Diner Party is a massive triangular table laid with 39 places, each of which includes a runner, cutlery, a goblet, and a plate. Intended as a reinterpretation of 'the Last Supper from the point of view of those who had done the cooking throughout history'[1], it uses the traditional crafts of ceramics, china painting and embroidery practised in recent times particularly by women. Each setting is a symbolic representation of a woman of achievement in the history of Western Civilisation. Thirty-seven of the plates use vulvate imagery which changes from flat ceramic painting to sculpted three-dimensional plates to represent the most contemporary women. Only one of the women represented is black. The floor in the middle of the table is constructed from hand-crafted tiles, with the names of a further 999 women radiating from the place names.

In recent years *The Dinner Party* has been widely used as an example of feminist art practice in the discourses of both the popular media and art criticism. Its production company, the Through the Flower Corporation, has also consistently promoted it as feminist art.

In claiming this status for itself, *The Dinner Party* potentially challenges certain culturally dominant myths on which the institution of art is founded. Firstly, that art has its source in the creative imagination (not skill) of the embattled genius and – in modern times – is produced in struggle, isolation and solitude: over 400 women and men contributed their voluntary labour to this piece of 'art'. The proper content of art is also held to be apolitical, even if formally challenging: *The Dinner Party* has a clear political intent. Art's address is to the individuated subject, its meaning unproblematically available to those with the necessary niceties of perception, sensibility and education: *The Dinner Party*

makes its address to a potentially politicised grouping rather than to the atomised individual.

It has also generated a substantial body of commentary and critical analysis, some adulatory and some profoundly critical – the latter coming particularly from the women's movement.[2] The aim of this chapter, however, is not to examine the reviewers' value judgements about its worth as feminist art, but to examine a number of media representations of the piece and to consider how they construct and articulate the relationship between the discourses of feminism and art. Finally, we hope to illustrate how the analysis of media representations can offer valuable insights into the nature of both art and feminism, as well as opening up a new critical space which has wide implications for the study of art. We will look at a documentary about the making of *The Dinner Party* (*Right Out of History*)[3]; the brochure that

The Dinner Party (complete work).

accompanied its exhibition at the Donmar Warehouse in London in 1985;[4] a short item in a Channel Four news broadcast;[5] and the press reviews of the London exhibition.

Right Out of History is part of a particular tradition of feminist documentary film-making closely associated with the consciousness-raising groups of the women's movement. It is a tradition characterised by the use of a 'realist' aesthetic, a close identification of the film-makers with their subjects, a privileging of women's experience and an address to a female audience. Many such films, with a clear political intent, have grown out of – and been extensively used within – the Women's movement.[6] Yet *Right Out of History* is also an art documentary, which has a very different tradition and usage. Melding two very different styles in this way creates a tension between the collective, artisanal, participatory modes of production privileged within feminism and the individualism of the solitary artist.

The film can be divided into three parts. First is an expository sequence in which Judy Chicago relates the overall rationale of the project and in which the narrative enigma is set. The second section, structured around a series of mini-dinner parties involving women on the project, depicts the production process and is contained within the narrow space of the art studio. The final part deals with the finished work of art, the opening of the exhibition and the responses of some of the guests.

The status of *The Dinner Party* as 'art' is established in the film primarily through the construction of an individual auteur: Judy Chicago. Indeed its story is completely enclosed in hers, the only one of the many men and women working on the project who have a biography within the film. The expository sequence firmly establishes her primacy. Opening with a shot of her skipping, only half visible through an open doorway, the narrative enigma is set. The spectator's activity becomes a quest to know more about her and her project. Before we meet any other characters, she outlines her aims and the film cuts immediately to shots of the production process well underway. This compression of time and omission of the process of recruiting volunteers and funding the project, constructs it as springing unproblematically from Chicago's will and vision. However, constructing Chicago in this way as the film's 'star' – a familiar technique within the art documentary – sits uneasily in the feminist documentary format, and the film thus attempts to articulate a vision of Chicago as a star, auteur and feminist. She is frequently seen discussing

feminist politics with other women and even challenges theirs for what she claims is a lack of theoretical rigour.

The film presents Chicago's aim as being to reclaim the female crafts of embroidery, needlework and ceramics. Not only does she claim this for herself, but a relatively large amount of screen time is given to sequences of her visiting china-painting exhibitions and talking to a number of craftswomen. This aim, however, proves unassimilable with the presentation of her as artist and auteur. For whilst the project's intention may well have been to elevate craft to the status of art, the film actually structures a strong opposition between the two; and a distinct hierarchy of value and status attaches itself to the various competences and skills – both intellectual and practical – of the other women.

Chicago, for instance, is often critical of the artistic aspirations of her co-workers, and suggests at one point that some of them are in a state of 'total fantasy' about themselves as 'artists'. Shots of her working typically represent her engaged in fine art detail rather than the heavy construction work or the less satisfyingly 'skillful' areas of work defined as craft. When shown with other characters the context is more often one of conflict than harmony: indeed, in the central narrative segment the harmony of the project is frequently punctured by disruptions and heated arguments about the hierarchical and inequitable division of labour. Depending on the ideological position of the spectator this may be read as either part of the struggle of the artist in realising her vision, or as contradictory and disturbing to the feminist ethos of the project. These conflicts are dispelled as the group prepares for the opening of the exhibition and the film moves towards its narrative closure.

In this final section, which foregrounds the finished work of art, the stylistic qualities of the art documentary are dominant. John Roberts points out that this genre on television has actually been seen as beset with a 'transmission problem'[7]: a sense that 'Art itself on television, is a best... a tease, an introduction not a substitute for the real thing'.[8] The aura of *The Dinner Party* – its uniqueness and unreproducability – largely comes from the combination of its physical immensity with its fine detail. Most visitors report that it is experience of this size and its nearness which they find particularly moving: even a number of profoundly critical pieces speak of this aspect positively and with appreciation. While the film attempts to convey this by lingering pans around the table, bolstered by a musical soundtrack which evokes a sense of

pomp and pageantry, it can only offer us a representation: *The Dinner Party* as experience remains necessarily distant and inaccessible.

This need not be considered a failing. As Roberts suggests, this very distance from the bewitching aura can open up a productive space for critical analysis, moving us away from liberal discussion of the work of art as emotional experience and creating the possibility for analysis of it as commodity: the product of intensive labour. The extended and highly intensive labour that The Dinner Party necessitated is represented in the film through numerous montage sequences, interviews with the women workers about what they are doing, and through the frequent arguments about the rigid allocation of tasks.

Although these conflicts are suppressed in the final narrative section, they still open the way for a reading of the relations of production on the project as hierarchical, exploitative and alienating. This problematises any overall

(Detail from) *The Dinner Party* – the place settings symbolically represent women of achievement.

validation of the project as 'feminist', whilst still, in the very representation of this labour process, challenging a bourgeois definition of art as a spontaneous overflow of powerful creativity. The tensions produced in *Right Out of History* through the combination of elements of the generic traditions of the feminist documentary and the art documentary thus serve fundamentally to destabilise its presentation of *The Dinner Party* as 'feminist art'.

The remaining texts that we consider relate to the London exhibition of *The Dinner Party* in 1985. The brochure accompanying the show was produced by the feminist company which financed the exhibition in Edinburgh and then London, and is part of the general promotion of the piece. Its function is to be informative and to give the visitor a memento to take home – a memento which then operates as a sign for particular social groupings, giving its owner 'cultured' or feminist credentials. It firmly situates the piece within fine art, rather than a craft tradition, and the major part of it is a reproduction of the 39 plates.

In contrast to the documentary film where there is always a tension between the feminist and the art discourses, this is smoothed over in the brochure. Chicago is again presented as auteur, but the guiding principle is now not will and intent but spiritual, prophetic vision. The equilateral triangle on the cover symbolises, we are told, 'an equalized world'[9] and the catalogue reproduces the banners that flanked the entrance to the exhibition, each of which carries an embroidered phrase:

And she gathered all before her
And she made for them a sign to see
And lo they saw a vision
From this day forth
Like to like in all things
And then all that divided them merged
And then everywhere was Eden once again

The tension has been resolved by suppressing the political edge of feminism: we are now in a world which is at once utopian and essentialist, affirming 'the feminine principle and spirit within each human being'[10] and leaving no space for analysis for social and political realities and categories of difference. Thus the project is constructed as an almost religious, cult enterprise, and the 'she' who made for them a sign to see can be read not only as the Goddess but as

Chicago herself. Certainly the project's claimed feminism has become totally subsumed in a universalising, semi-religious conception of art.

Occasionally, art makes news. It is usually the 'priceless' painting that has been stolen, or the higher-than-ever-prices raised at the latest auction. Yet it is also news when art ceases to be art – when it transgresses the boundaries of what is acceptable to common-sense and good taste. Public opinion is thus mobilised around the 'excesses' of the avant-garde: the acquisition of Carl Andre's 'Bricks' by the Tate in 1976, for example, or the exhibition of Mary Kelly's 'Post-Partum Document' at the ICA in the same year. In this instance the privileged voice in art's discussion ceases to be that of the 'critic' – so important in most documentaries on art – and becomes that of the 'common-man', who voices populist, common-sense objection to the excesses of the liberal establishments which have funded or otherwise supported such 'nonsense'.

"Nothing particularly coy about the nature of female symbolism"– *ITN 7pm News*, Channel Four, 1 March 1985.

ITN News covered the opening of the exhibition in just such a way in an item on the Channel Four 7pm news programme, framing the discourses of Chicago and the appreciative audience (two female, one male) within a sceptical male discourse. Introduced by the news presenter as 'bound to cause controversy' the (male) reporter then gave a description of it in which each term was presented with an ironic qualifier: 'The Dinner Party is, if nothing else, a big piece'; the 39 place settings are 'apparently meant to represent' women of achievement; 'there's nothing particularly coy about the female nature of the symbolism'. And whilst Chicago is still represented as the sole author, it is not her creative vision, but something she has 'dreamt up'. The discourse of 'art' here, then, is a traditional one: The Dinner Party is 'feminism', an 'other' sufficiently threatening not only to need to be contained, but also to be ridiculed. The item closes with statements from the three people who have seen the exhibition, cut together without interjection from the reporter, and with two men who happen to be passing by outside. The first, conveniently wearing a cloth cap, in response to a prompt which we do not hear, describes it as a 'con-job'; the second, at the wheel of his lorry, 'thought it was a new restaurant, for a dinner like, y'know'. The idea of the con-job is interesting: it is presented as a comment on The Dinner Party itself, when of course, never having seen it, it can only be a comment on the unlikeness of the venue.

The Dinner Party was reviewed in The Observer, Art Monthly and in a number of radical magazines – Spare Rib, Feminist Art News and Artrage. There were also two lengthy, adulatory pieces in City Limits. The radical press were the most critical reviewers, convincingly and extensively critiquing the representational politics of the piece. The establishment response was, in fact, more favourable; indeed, the presentation of the project as the work of a feminist author fell very well into the dominant approach of bourgeois art criticism. Jane Lott in The Observer described Chicago as 'an artist strong-minded enough to do without husband, family, conventional support structures, because they would have got in the way of her concentration on her work' and went on to quote her as saying 'I often wish I were a lesbian: it would make things easier'.[11] The review thus accepts a statement of feminist intent as sufficient for the definition of feminist art, ignoring political questions about whether the iconography or production practice of the piece can be considered feminist; in favour of a biographical construction of Chicago as feminist author.

Margaret Gartlake in Art Monthly is one of the few reviewers to consider the project's ostensible aim to elevate female crafts to the status of art.[12] She

suggests that the whole 'razamatazz' surrounding the piece is needed precisely to sustain this idea, one which is fundamentally flawed in its attempt to take crafts from one particular historical conjuncture and transpose them into another: the forms of china-painting and embroidery, 'lack social or symbolic functions today'.[13] This is an important point, and one which brings out the actual ahistoricism of this supposedly historical project. It is because of this failure that, although she finds the work impressive in terms of 'high-art' technique, she feels that 'its place is within the history of feminism rather than that of art.[14]

Media representations can, thus, serve as complex systems of interrogation not only of a particular work but also of the critical paradigms into which it is received. In foregrounding *The Dinner Party* as 'feminist art' for example, the representations we have looked at have problematised both feminist art practice and that of the mainstream art world: their analysis reveals a range of responses that can inform debates on the place and function of feminism in relation to art practice and more broadly to culture and society in general. It may also provoke a critical engagement with the relationship between the art work and the spectator: an area well developed in film theory but less so in art theory and which is crucial in moving feminist debate away from notions of 'essential' femininity.

Ultimately, studying media representations of 'feminist art' may deliver more insights into hidden assumptions and values of the mainstream art world and its critical reviewing systems than reveal any 'truths' about feminist art practice, which is as diverse and dynamic as the (establishment) art world it seeks to challenge.

NOTES

1 Judy Chicago, as quoted in the (untitled, unattributed) brochure
 accompanying the exhibition of *The Dinner Party* in London 1 March
 – 26 May 1985 (produced by Diehard Productions/Through the Flower
 Corporation, place of publication and date unspecified) p 2.
2 See for example Karin Woodley 'The Inner Sanctum' in *Artrage*
 p 9-10 1985.
3 *Right Out of History: The Making of Judy Chicago's* Dinner Party
 (Johanna Demetrakas, USA, 1980).
4 London brochure, *op. cit.*

5 ITN News, Channel Four, 7pm, 1 March 1985.

6 For further information on this style of documentary (and some feminist criticisms of its aesthetic) see Charlotte Brunsden (ed) *Films for Women* (London, BFI, 1986), Part One.

7 John Roberts 'Postmodernism, Television and the Visual Arts', *Screen* Vol 28 No 2 Spring 1987, reprinted in this volume.

8 Nigel Finch cited in Roberts, *ibid.*

9 London brochure, *op. cit.* p 3.

10 *Ibid.*

11 Jane Lott, 'Women put in their plate', *The Observer*, 10 March 1985.

12 Margaret Gartlake, 'Judy Chicago's *Dinner Party*', *Art Monthly*, no 85, April 1985, pp 17–18.

13 *Ibid*, p 18.

14 *Ibid.*

11

Nobody's Here But Me
Cindy Sherman's Photography and the
Negotiation of a Feminine Space

Lone Bertelsen

Subjectivity does not only produce itself through the psychogenetic
stages of psychoanalysis or the 'mathemes' of the Unconscious, but also
in large-scale social machines of language and the mass-media – which
can not be described as human.

Félix Guattari[1]

Cindy Sherman has performed in front of her own camera since the late
Seventies and has produced a wide variety of stylised still images – mostly of
women – dealing with the issue of female subjectivity. In 1994 she
collaborated with Mark Stokes in the production of his documentary *Nobody's
here but me* – a production as slick, complex and visually impressive as
Sherman's images themselves.

Sherman's photographs cite, imitate and combine elements from a variety of
sources. Her early works comment on the relationship between popular culture
and the mass media – Hollywood B-movies and film noir, advertising, fashion
and femininity – and draw on the photographic styles used in these. A later
series, partly informed by horror movies and fairy tales, present images which
are more disturbing and abject. These have a more fluid quality and are, as
Rosalind Krauss identifies, often horizontal in composition.[2] Some of the works
(such as *Untitled #175*, 1987) seem to appropriate the techniques of abstract
expressionism. In these, Sherman literally changes our perspective, forcing us
away from the phallic and vertical, in which sublimation is inscribed, towards a
de-sublimatory horizontal field.[3] The subjects of these abject photographs are
constructed from mucous-like fluids, blood, mould and vomit; half eaten and
rotting food; masks of old people; baby dolls; and finally, images of dispersed
body parts shattered, or barely visible, hidden beneath the ground.

Another series parodies 'historical portraits'. In these, Sherman points her camera towards 'high art' and its idealisation and fetishisation of the (female) portrait. Sherman's portraits can be seen as a critique of the supposedly pure form of the historical portrait. As Laura Cottingham has identified, she presents herself in the 'style of David, Goya, Titian, Ingres, Holbein and others'.[4] However, her portraits differ by having huge (fake) noses, dark circles under their eyes, fake breasts and other protheses strapped onto their torsos.[5]

Finally, her recent work, on what Rosalind Krauss has called the 'Sex pictures', is partly inspired by the 1930s surrealist Hans Bellmer's series of photographs 'La puppée' – which show a victimised (seemingly raped) female doll.[6] While Sherman's own body no longer appears in this series, the images are very provocative and confrontational. They show dismembered life size dolls[7] in graphic and sexually suggestive positions. However, the photographs are such an exaggeration of Bellmer's 'originals' that they appear ironic, and even darkly humorous.

1 CRITIQUE, SUBJECTIVITY AND PRODUCTION

Since Sherman has made few statements about herself and her photography she has left discussion of her work relatively open. This has resulted in the production of a substantial and varied body of writing about her photographic images. Although Stokes operates outside the written genre of art criticism, his documentary extends elements of this discourse.

Nadine Lemmon, a significant critic of Sherman's, has argued that Sherman's photographs (and it seems poststructuralist thought and postmodern practises in general) cannot challenge and 'deconstruct oppressive "ways of seeing"'[8], or of representing women, but end up simply affirming these. She claims that Sherman's images can have no critical force. Quoting Mira Schor, Lemmon asserts that Sherman's photographs, or more precisely, her 'negative representations', are:

> ...disturbingly close to the way men have traditionally experienced or
> fantasized women... Her images are successful partly because they do
> not threaten phallocracy, they reiterate and confirm it.[9]

Lemmon suggests that even though Sherman's images depict a multiplicity of

identities, her images do not avoid fixing woman in an identity produced by a masculine desire. What further appears to be at stake for Lemmon is that the contemporary concern with theory – combined with a rejection of the notion of the unified, reasoning, subject – serves 'to foreclose dialectical reasoning and critical questioning.'[10] Not surprisingly, many considerations of Sherman's photography have been informed by both traditions of psychoanalytic and post-structuralist considerations of postmodernity. While aspects of some of these can be understood, at the very least, as somewhat problematic for feminism, I cannot agree with Lemmon when she appears to suggest that (cute) 'wordplays have come to replace the critical'[11] in contemporary cultural production; and, similarly, that Sherman's double mimesis has no critical potential. In short, Lemmon argues that the 'Sherman Phenomenon is an alarming symbol of our current cultural and critical situation.'[12]

Despite the force of such criticism, a careful study of Sherman's images, and the analyses advanced in *Nobody's here but me*, enable us to identify Lemmon's failure to recognise the possibility that a photographic (mimetic) aesthetic might destabilise the centred humanist (male) subject – a subject which itself relies on the devaluation of its opposite for maintaining its central, stable, reasoning position. This is not to say that a number of postmodern readings of Sherman's photographs do not ignore the critical aspects of her photography – they do – it is rather to suggest that Sherman's photographs, often described as postmodern themselves, do in fact have a critical force. The critical aspect of Sherman's work has been recognised, in different ways, by writers ranging from Judith Williamson to Rosalind Krauss. *Nobody's here but me* is an extension of that more positive discourse about Sherman's photography, identifying the critical potential(s) of her images through both spoken statements and the subtler, complementary discourse of its visual style.

II RE-REPRESENTING CINDY SHERMAN AND HER PHOTOGRAPHS

Nobody's here but me emphasises the manner in which Sherman refuses to impose any ultimate truth value onto her images of woman. She leaves the interpretation of her own work very open-ended. On a number of occasions in the film she comes close to declaring that she does not really know what her photographs are about. As she states at one point:

I definitely incorporate a lot of ambiguity and ambivalence in the work...it is hard to describe the way I work because I work so intuitively...I often don't know what I am going after until after it is shot or after I have done several shots...and sometimes I don't know about what I have done until like I read what somebody has written, so it is hard for me to really analyse the work...

The documentary attempts to escape imposing any fixed value onto Sherman's images and departs from constructing (the personality of) the artist as the primary source of creative expression. It neither presents a single, authoritative account of Sherman's photographs nor does it attempt to portray the artist herself at the moment of artistic creation or inspiration. While Sherman remains a principal focus for the documentary, the film comprises a rich visual juxtaposition of various visual representations of women: extracts from contemporary and 1950s feature films; sequences from Super-8 home movies; photographic snapshots; and images and impressions of urban life and the cultural politics that have influenced Sherman's still images. The film also includes images of Sherman dressing up as the subject for her own photography, preparing her studio, and on-screen commentaries by feminist writer Judith Williamson, friend and artist Robert Longo, and actor/performers Eric Bogosian and Jamie Lee Curtis.

Longo provides us with a useful insight into the context of Sherman's work with his comment that, as a consequence of Reaganism and Thatcherism, there was a return to traditional values in the mid to late 1980s which was symptomatised in the art world by a return to painting. Longo calls these paintings 'expressionistic garbage', done by men, and points to the fact that these artworks got the financial and public support. He further suggests that Sherman's more violent pictures came out of that period as 'she really wanted to pound the fuck out of somebody' because a female artist and photographer like herself was not getting the same support as the male painters. However, Longo is also quick to point out that, on the other hand, Sherman's own photographs have a 'pictorial quality... in the nature of traditional art history'. The documentary reinforces Longo's account of the critical aspect of Sherman's photography by disclosing how Sherman sees her later 'Sex pictures' as partly a reaction towards the conservatism of the NEA (the national endowment of the arts). They withdrew funding from a number of 'controversial art projects' around 1990. Curtis suggests that Sherman was poking 'fun at the NEA' in that

she was making 'pornography out of plastic'[13]. Williamson, one of the first feminist writers to engage with Sherman's photographs, also emphasises the value in her work. In the film, she states that while she does not necessarily like 'all the scenarios which are portrayed in the images', she does like to get 'the opportunity to think about them and to see the process by which images of women are produced'.

In amongst all this, almost as part of it, Sherman's photographs are re-presented. Her still images most often fill the TV screen. They emerge as part of a series of moving shots of New York, Central Park, night life, a 1950s movie or the film *Halloween* (starring Curtis). The photographs are also shown juxtaposed between advertisements on the television, shots of the street, the place where her photographs were taken, urban life in general; or Sherman feeding her parrot, walking the street, shopping for props, visiting a video shop or setting up in her studio. On the other hand, sometimes Sherman's photographs do not fill the entire TV screen. They are sometimes re-presented hanging in galleries or in museums; or reproduced in the pages of books, on the cover of the journal *Screen*, or as illustrations of articles about Sherman's work (by Laura Mulvey and Judith Williamson for example). The photographs are also presented circled on a proof sheet together with many other unpublished images and finally shown as slides.

The display of Sherman's images is accompanied by various sounds. The words and the music from a crime scene in a B-movie or horror film at times serve to make Sherman's more disturbing stills less distressing. At other times we hear the noise from a helicopter or the seductive male voice accompanying a 1950s advertisement. We also hear sounds from television programs and music ranging from a relaxed trumpet piece to a 'grunge' rock track. During one sequence, Bogosian reads extracts from the Grimm Brothers' fairy tale 'Fitcher's bird' that Sherman was asked to illustrate for *Vanity Fair* . The tale is about an evil wizard who steals children – in this case little girls, and dismembers their bodies. However, the heroine of the story – the youngest of three sisters (the two oldest are cut up by Fitcher) assembles all the body parts, burns down Fitcher's house, with him in it, and brings the children back to life. Immediately before and during the voice-over narration, the film shows images of Sherman putting an anatomical doll together. The suggestion is that Sherman fills the same role as the youngest sister in the Grimms' tale and brings things to life from dismembered parts.

Nobody's here but me exemplifies an approach which was advocated by Walter Benjamin. Benjamin called for the producer of aesthetic works to think about and reflect on her or his 'position in the production process'[14] and argued that once this occurs 'the mind which believes only in its own magic strength *will* disappear'.[15] While Stokes' film places a great deal of importance on the artist herself, it succeeds in reflecting on Sherman's position in the process of production, through the inter-discursive play and juxtaposition mentioned above, and focuses on the 'speaking positions' of a woman photographer in contemporary America. The film shows Sherman placing herself, as a model, within 'the representational crisis'[16] she is documenting. Priscilla Pitts argues that Sherman's photographs 'actively focus on how notions of selfhood are constructed through the visual order, particularly in the case of women'[17] and contends that 'Sherman's gender is in every way crucial to her project.'[18] It is this that is the aspect of her photography which is made most prominent in Stokes' documentary. Although Sherman states that 'as a person' she is not 'overtly political' or a 'heavy duty feminist', she also stresses that political and feminist concerns come out in her photographs.

III COPIES OF COPIES OF...

In one sequence in the film, Sherman is shown flicking through a magazine, with the television on. She tells us that she grew up in America in the 1950s, as one of the first generations who spent large portions of their childhood watching television, and comments that 'I would say my inspiration comes from a lot of the media related influences around me...'. She goes on to state that her motivation for the *Untitled Film Stills* comes out of her frustration with the stereotypical role models from her childhood, arguing that:

> any woman from that period was some kind of... role model not really in
> any kind of positive way that inspired me but that probably frustrated me
> ultimately in terms of what was expected of me as a young girl turning
> into a woman...Hollywood actresses were part of that just because they
> were on the television set.

The female figures she portrays in her early work resemble female actors from various Hollywood films, yet, as Laura Cottingham points out, The *Untitled Film Stills* do not refer to any film in particular.[19] Sherman concurs, stating that,

I don't really think in terms of a full narrative... What I am trying to do in that series - what I was trying to do – was to make people make up stories about the character.

Sherman adds that while many of the women in the film stills look 'almost expressionless' upon closer scrutiny we realise that 'they have either just experienced something or are about to experience something'. The images do not in themselves provide a full narrative. Sherman states that it is 'sort of left up in the air what is going to happen'. This is perhaps appropriate since, as Barthes has written: 'the photograph itself is in no way animated (I do not believe in "lifelike" photographs), but it animates me: this is what creates every adventure'.[20] The photographs themselves invite the viewer to enter the image, and to construct a story about what is happening. Stokes' documentary constantly plays at this itself, setting up various scenarios by showing fragments from a number of visual genres featuring women.

Krauss argues that in the *Film Stills* of women reflected in the mirror, the viewer is almost included in the photograph. (This inclusion is particularly obvious in *Untitled Film Still #2*, 1977 and *#81*, 1978). There is a certain depth to these mirror photographs and 'continuity established by the focal length of the lens creates an unimpeachable sense that her look at herself in the mirror reaches past her reflection to include the viewer as well'.[21] In a sense this makes the viewer self-conscious and uncomfortable. There is no space for a distant, neutrally observing spectator. In contrast to the popular images that inspired the *Untitled Film Stills*, we can not passively consume Sherman's photographs. We realise that even though her *Untitled Film Stills* are formed by the signifiers of mass and popular culture they also resist these signifiers. By miming, quoting and combining from various cultural texts, which are often phallocentric, Sherman's mimesis, like a number of feminists texts (such as Irigaray's for example[22]), comments on and intervenes in these discourses and produces new meaning; her photo-images change what they appropriate.

As mentioned earlier, many of Sherman's images are re-presented by Stokes as framed by the television set itself. Stokes in a sense turns Sherman's photographs into television, and runs the risk of perhaps exploiting the artist and her work for the sake of making 'TV Art' (a term Philip Hayward uses in the introduction to this volume). However, what happens when Sherman's photographs are re-represented by the medium that she has turned into art[23] is that the subversive aspects of her photographs sometimes become even more

obvious. As an example, in filmed shots of two of the mirror photographs (*Untitled Film Still #14*, 1978 and *#56*, 1980) Sherman's look at herself in the mirror is extended to further include the viewer by clever movement of the film camera. As mentioned, Sherman's photographs transform various visual representations while she is appropriating them. Likewise reproduction by television changes Sherman's still photographs. Yet this change does not necessarily contradict or exploit the photographs themselves but can in fact further 'mobilise' their critical force and productive potential.

By showing such a variety of stereotyped filmed shots of women, Stokes' documentary supports Krauss' argument that Sherman's photographs are not addressing 'real life' women but stereotyped film stills, which are themselves already a reproduction. Krauss rightly refers to Sherman's photographs as copies of copies, as simulacra. But Sherman's copies are, in a sense, such 'bad' copies that we can not recognise an original film on which they could be based. We might therefore comprehend that the 'original' or 'ideal' – the (supposedly) *signified* – does not exist. However, although Sherman's photographs work on the level of the signifier, her images are not simply a celebration of 'the free flow of the signifier' where anything goes. Rather, the whole process of representation (and the artist herself) cannot be seen as separate from that which is represented. As Krauss emphasises:

> that Sherman is both subject and object of these images is important to their conceptual coherence. For the play of stereotype in her work is a revelation of the artist herself as stereotypical. It functions as a refusal to understand the artist as the source of originality, a fount of subjective response, a condition of critical distance from a world which it confronts but of which it is not a part.[24]

IV MULTIPLICITY AND DIFFERENCE

'*I* am not 'I', I *am* not, I am not *one*. As for *woman*, try and find out...'

Luce Irrigaray[25]

In *Nobody's here but me* Sherman says that her images should not be understood as self-portraiture nor as the manifestation of her own unconscious desires. She never sees *herself* in her photographs. Barthes, in his essay on

photography wrote:

> once I feel myself observed by the lens, everything changes: I constitute myself in the process of 'posing', I instantaneously make another body for myself, I transform myself in advance into an image. This transformation is an active one: **I feel that the Photograph creates my body or mortifies it, according to its caprice.** (my emphasis)[26]

The same physical material – Sherman's own body – until very recently recurs in all the photographs. Yet, the evidence of Sherman's body in each photograph reveals the immense possibility of a multiplicity of possible feminine differences. Sherman never appears the same. We find no normative referent to the 'real woman' in her art. The figure in Sherman's still images can not be pinned down. She changes from still to still. The 'subject' as centre is absent in her work. I suggest that Sherman is a maker of difference. Her photographs exemplify the multiple possibilities of a female (bodily) becoming. As Rosi Braidotti, following Deleuze might put it: this is the creation of the self as a nomadic subject.[27]

Nobody's here but me re-presents us with a large number of Sherman's photographs over a very short period of time. As a result it is made obvious that Sherman's photographic image (mostly of women) changes from still to still. The photographs, as the title *Nobody's here but me* itself suggests, can be perceived as an example of the 'recurrence of difference in repetition'. The documentary title draws our attention to the fact that only Sherman is here yet we are presented with a rich variety of 'Shermans' recurring in different images. It follows that Sherman's photographs work against setting up an ideal of the female self. The photographs do not represent the subject as a stable point of reference and reject the notion that there is an essential or original femininity or authentic self which can be uncovered, represented or created. There is no feminine absolute signified. As the documentary illustrates, Sherman can only rearrange the relations between the existing, often misogynist, fetishised signifiers to set up a new aesthetic horizon which makes possible women's multiple possible differences, becomings or recurrences. The multiple cannot simply be discovered but must be produced. As Deleuze and Guattari assert: 'In truth it is not enough to say 'long live the multiple', the multiple... must be made'.[28]

Irigaray, amongst others, argues that women's multiplicity of differences has

been negated by mass culture's (often phallocentric), objectifying, representations and constructions of women in terms of a masculine imagination, fear and morphology.[29] Yet Sherman through miming, in a style not dissimilar to Irigaray, interrupts, and is able to produce a space for difference in, what she appropriates. This is the central focus of the documentary, which largely portrays Sherman as a woman negotiating a culture which initially offers her little space. Thus her fear of, and means of coping with, the New York street is dealt with at length, even in the way she is framed by the movie camera tentatively looking out from her doorway. The documentary also dwells upon her love of horror films, her anger at the NEA, the male domination of the art world, and so on. It could be contended, in fact, that the way in which Sherman negotiates this lack of cultural space becomes the core issue of the documentary. It could also be seen to be the core issue of her work.

V IMAGINATION AND WONDER

Sherman stresses at the very start of *Nobody's here but me* that from the beginning of her photographic career she was never that interested in photography itself nor interested in capturing the world as we see it. Sherman points out that her interests lie more in the area of capturing what we imagine and can not see through the camera. She says that she is trying to show 'what you may perhaps never see' in order to capture 'what is in somebody's imagination'. This is an important point because according to Irigaray, our, primarily, visual framework for formulating the self is especially important to the manner in which women have been symbolised, objectified and stereotyped in very negative terms. Irigaray writes 'imagine that woman imagines and the object loses its fixed, obsessional character'.[30] This possible female imagination is precisely what Sherman's photographs make the viewer aware of through their manipulation of stereotypes. As she says, she is interested in capturing what is not simply visual nor representable.

In order to emphasise the importance of Sherman's creation of feminine 'imaginings' it is useful to refer to Irigaray's considerations of the cultural space allowed for a feminine expression of both wonder and anxiety. Irigaray has argued that in our Oedipal, visual economy we need to replace envy and lack with wonder. In her early writings Irigaray draws our attention towards

recognising the dominance of the look (vision) and of separation in Freud's theory and she argues that his theory is to a large extent symptomatic of our whole culture. Irigaray attempts to create a space for touch, nearness and a recognition of the other. In a later reading of Descartes, Irigaray reconceptualises Descartes' notion of wonder and suggests that wonder must signify (sexual) difference and be faithful 'to becoming... without letting go the support of bodily inscription'.[31]

Freud (and later psychoanalytic theory) has argued that the first passion is not based on wonder but on drives which lead to (penis) envy in the case of the female and fear (of castration) in the case of the male – and thus the 'Oedipus complex... is the keystone of his system'.[32] Irigaray asserts that, within a psychoanalytic discourse based on castration and envy, it is never easy for woman to come to terms with her lack and therefore it is virtually impossible for women to sublimate their excessive libidinal drives into other areas of life, such as artistic production. (Indeed, it is questionable if they have any at all – since Freud argues that the libido is always masculine.) As Irigaray asserts, 'everything he has told us about becoming a woman explains why 'femininity', even successfully achieved, cannot sublimate'.[33]

A large number of the various facial expressions of the woman in Sherman's *Untitled Film Stills* series and early colour photographs are of wonder rather than of envy (see *Untitled Film Still, # 21*, 1978 for instance). This replacement creates a space which allows woman her own imagination, one that is not constituted through envy, separation and lack, but rather through wonder itself. Such photographs resist the sublimation of 'masculine castration anxiety' onto women. The photographs thereby motivate the production of desires and imaginations appropriate to women themselves and further make possible their subsequent sublimation. As mentioned previously, if we scrutinise Sherman's *Untitled* photographs collectively, as Stokes' film does, we can see that Sherman's photographic images present the female self as a 'nomadic subject'. However, it is not satisfactory simply to celebrate difference and multiplicity because, even as a 'nomadic subject', woman can still serve a masculine desire and end. The notion of wonder is therefore crucial. The expression of wonder in these photographs is a recognition of the different spaces occupied by the 'subject in wonder'. Wonder recognises rather than negates the desire and alterity of the other. Furthermore, without a recognition of difference (both within the self and between self and other), wonder would simply not exist. It

now becomes obvious how the emergence of the expression of wonder on the faces of the female figures in Sherman's photographs – which themselves derive from stereotypical images of women – have a powerful effect. The subtle appearances of wonder in Sherman's appropriations opens up a space for participation.

VI DEATH AS HORIZON

The Sherman image we are first presented with in *Nobody's here but me* (*Untitled #153*, 1985) occurs on a number of occasions. It shows a moist, almost plastic-like figure of a dead woman lying on the ground. The recurrence of the photograph supports Sherman's own ideas about the connection between her work and death, which are also the last ideas presented in the documentary.

Throughout *Nobody's here but me* we glimpse many fragments from various horror films. Towards the end of the film Sherman says that they are her favourite movies. She further discusses how living in Manhattan and reading the paper makes you think about death every day. She informs us that when a student, who was writing a thesis on her photographs, suggested that a lot of her work was about death, Sherman thought that the student 'was totally off the wall' (although she also says that she was producing some of the more disturbing images at that time). However, now Sherman thinks that perhaps the student was right. She says that horror makes 'you prepare to deal with potential violence and potential death' and 'I... try to come to terms with that in the work somehow'.

According to Irigaray, men have projected their own desires and their own fears about death onto women and have, through this projection, attempted to control the most uncontrollable and unrepresentable – which is death. Man has constructed woman as representative of his own fears. Because the representation of woman repeatedly has come to serve the male 'libido' and the male 'death drive', women have been cut off from experiencing their own fears about death. The '*death drives can be worked out only by man*'.[34] Woman comes to function as place 'for the sublimation and, if possible, mastery of the work of death'.[36] In arguing this, Irigaray is connecting the Freudian understanding of the castration complex with his theory of the death drives.

I have already discussed how a replacement of envy with wonder allows for a female imagination to be conceived of. However, a symbolisation of their own specific fears would further enable women to come to terms with this darker side of life. Irigaray writes on numerous occasions that woman in our culture is cut of from her beginning and end. By experiencing their own horror, abjection and potential death women would be able to pose death as horizon and end of life and be able to 'sublimate' their own fears about death onto a horizon. This would allow women to come to terms with their own fears and horrors so as to live life.

In the aesthetic/photographic production of difference we can not simply create positive images of women, as the abject can not be avoided. It too has been denied to women and needs to be imagined and represented.[37] In a sense Sherman's photographs recover the abject for the feminine rather than making the feminine the abject for the masculine. Sherman's photographs begin to construct the possibility of a feminine 'death drive'. Her abject images work against the representation of woman as fetish. They also challenge the distinction between the inside and the outside of the body. The photographs have become fluid, slimy and mucous-like,[38] in short – disgusting. These grotesque horizontal images de-sublimate[39] in order to disrupt the sublimation of a masculine abjection and fear onto woman.

The representation of woman's death has often been in the hands of the voyeur. By making death the final issue in the documentary, *Nobody's here but me* acknowledges that, by giving woman access to her own end, Sherman's images take that power away. Furthermore, by opening the film with Sherman's statement of her concern to capture what we imagine and cannot see – ie what is in somebody's imagination – the documentary asserts that Sherman's images are not uncritical and they do not fix woman in a male desire.

Throughout *Nobody's here but me* Stokes remains a shadowy authorial presence. In all but one instance Stokes' gender (and gender position) remains submerged. This moment is a troublesome one however, one when his discourse slips. Although Stokes remains invisible throughout the film, his voice intrudes on to the soundtrack when he interrupts Robert Longo to ask a question. This is the only time his voice is heard. Unfortunately perhaps, his engagement with Longo, rather than with any of the female interviewees, can be read as an identification between two males involved in Sherman's advocacy – a 'tuned-in' communication between two subjects similarly positioned with regard to

Sherman's discourse(s). Although Longo makes some interesting points about her work, he also is the only commentator to discuss aspects of her personal life and he takes on an almost paternalistic attitude to Sherman herself. The film does not simply pass over these aspects, Stokes' intrusion at this point serves to emphasise the authority of the masculine voice and masculine advocacy of Sherman's work. The irony is that the (otherwise) carefully constructed documentary – and Sherman's photographs themselves – do not need any such intervention to make their point. As I have argued, the documentary succeeds in foregrounding the critical force of Sherman's images and avoids using them simply as illustrations to support a biography and/or critical thesis. The film's success resides in its presentation of Sherman's images as agents of discursive production which intervene in representational traditions and standard subject-object relations. Presented in this manner, Sherman's images can be understood to demonstrate how the subject is addressed and can be altered, even changed within, and by, mimetic artistic production. This makes it explicit that Sherman's photographs do not reinforce stereotypical representations but are in fact productive of new subjective possibilities for women.

NOTES

1 Félix Guattari, *Chaosmosis; An ethico-aesthetic paradigm* (trans Paul Bains and Julian Pefanis), Sydney, Power Publications, 1995, p 9.

2 For a discussion of the importance of the horizontal composition in some of Sherman's photographs see Rosalind Krauss's text to *Cindy Sherman* 1975-93, New York, Rizzoli, 1993.

3 See Krauss *ibid* for a discussion of the operation of de-sublimation in Sherman's photographs.

4 Laura Cottingham, 'Cindy Sherman' *Contemporanea* May 1990, vol 3, no 5, p 93.

5 For an interesting discussion of how the 'horizontal axis' imposed by the fake body parts desublimates 'the facade of the vertical' see Rosalind Krauss, 1993, *op cit*, pp173-174.

6 See Krauss, *ibid* for further discussion.

7 In the documentary Sherman informs us that she obtained these dolls from an educational medical supplies centre.

8 Nadine Lemmon, 'The Sherman Phenomenon: A Foreclosure of Dialectical Reasoning' *Discourse* Winter 1993-94, vol 16 no 2, p 104.

9 Mira Schor quoted in Lemmon *ibid*, pp 104–105.

10 *ibid*, p 100. Lemmon is not explicitly arguing that we need to maintain the humanist conception of the subject but it is implied in her call for dialectical reasoning.

11 *ibid*, p 113.

12 *ibid*, p 115.

13 Sherman further informs us that she wanted to address the issues of sexuality and consequently AIDS in these photographs.

14 Walter Benjamin 'The Author as Producer' in Victor Burgin, ed., *Thinking Photography*, London, Macmillan Education, 1982, p 29.

15 *ibid*, p 31.

16 Cathy N. Davidson, 'Photographs of the dead: Sherman, Daguerre, Hawthorn' *South Atlantic Quarterly* Fall, 1990 vol 89 no 4, Fall 1990, p 675.

17 Priscilla Pitts, 'Cindy Sherman and Others' in *Cindy Sherman* (catalogue), Auckland, National Art Gallery New Zealand, 1989.

18 *ibid*.

19 Laura Cottingham, *op cit*, p 93.

20 Roland Barthes, *Camera Lucida* (Trans Richard Howard), London, Fontana 1984, p 20.

21 Rosalind Krauss 1993, *op cit*, p 56.

22 See particularly Luce Irigaray *This Sex which is Not One*, (trans Catherine Porter with Carolyn Burke), New York, Cornell University Press, 1985(a).

23 NB This is not to suggest that television *cannot* be art.

24 Rosalind Krauss, 'A Note on Photography and the Simulacral', *October* 1978, n31, p 59.

25 Luce Irigaray, 1985 (a) *op cit* p 120.

26 Roland Barthes, *op cit* pp 10–11.

27 Rosi Braidotti, *Nomadic Subjects: Embodiment and Sexual Difference in Contemporary Feminist Theory*, New York, Columbia University Press, 1994.

28 Giles Deleuze and Felix Guattari, *A Thousand Plateaux* (trans Brian Massumi) Minneapolis: University of Minnestota Press, 1987, p 6.

29 See Luce Irigaray, *Speculum of The Other Woman* (trans. Gillian C. Gill), Ithaca: Cornell University Press, 1985(b) and Irigaray 1985(a) *op cit*.

30 Luce Irigaray, 1985(b) *op cit*, p 133.

31 Luce Irigaray, *An Ethics of Sexual Difference* (trans Carolyn Burke and Gillian C Gill), London, The Athlone Press, 1993, p 82.

32 Luce Irigaray, 'Luce Irigaray'(interview) in Elaine Hoffman Baruch and Lucienne J. Serrano, eds, *Woman analyze Woman: In England, France and The United States*, New York, New York University Press, 1988, p 163.

33 Irigaray, 1985 (b) *op cit,* p 123.

34 *ibid,* p 53.

35 *ibid,* pp 54–55.

36 Margaret Whitford, 'Irigaray's Body Symbolic' in *Hypatia* Fall 1991
 vol 6, no 3, p 105.

37 *ibid.*

38 Margaret Whitford (*ibid*) argues that Irigaray's abject image of the
 'mucous' resists the Oedipal economy which links the 'pleasure
 principle' as well as the 'death drives' to the castration complex. The
 mucous can be interpreted as transgressive of fixed form; it is neither
 solid nor fluid, and it can not be seen as an object separate from the
 body. It blurs the distinctions between inside and outside and thus
 deconstructs dichotomies. The mucous is more accessible to touch
 than to sight as it can not be seen in Lacan's flat mirror. Whitford
 suggests that Irigaray's symbolisation of the mucous can connect
 women to their end and liberate them from the position of place for
 men's representation of their own abjection and fear.

39 Rosalind Krauss, 1993, *op cit,* p193.

12
Venus Resurrected
Sirens and the Art of Norman Lindsay

Clarice M. Butkus & Philip Hayward

John Duigan's film *Sirens* (1994) offers a fictionalised account of incidents from the career of Australian artist Norman Lindsay. Its principal narrative thread involves a young English curate visiting Lindsay in order to persuade the artist to withdraw his controversial drawing 'The Crucified Venus' from an exhibition of Australian art due to tour overseas. The main body of the film takes place in the grounds of Lindsay's (real-life) home and studio Springwood, which the curate and his wife visit for several days while en route to the curate's first parish. The duration of their stay coincides with Lindsay's painting of the canvas 'The Sirens', and their departure immediately follows Lindsay's completion of the work. Within this slender narrative frame, the film addresses issues of moral propriety; sensual and sexual repression; and the nature of the female nude as a (fitting) object of artistic representation. This chapter analyses the manner in which the film explores these themes and provides a representation of the artist and his oeuvre.

I LINDSAY'S CAREER

For much of his career, the painter, illustrator and novelist Norman Lindsay (1879-1969) was Australia's most notorious artist. Several of his paintings were the cause of major public scandals and one of his novels, *Redheap* (1930), was banned by the Australian minister for Trade and Customs on the grounds of its indecency and obscenity (with the ban remaining in force until the late 1950s). Lindsay's notoriety derived from the combination of his unbridled heterosexual eroticism (most often expressed through representations of the unclad female form) and his continuing critique of Christian moral piety and

conservatism. Much of his early work, particularly that executed in the period 1910–40, ran directly counter to the extreme (public) conservatism of the times. This period has often been characterised in terms of its 'wowserism' – an Australian term referring to censoriousness and prohibition. Indeed, the critic John Hetherington has argued that 'wowserism has probably never been more active in Australia than it was at that time'.[1] One of Lindsay's chief critics was the Anglican Church of Australia, an organisation then, as now, one of the most culturally conservative and anglophilic of Australia's social institutions.

The choice of (episodes from) Lindsay's life as the subject of a major Australian feature film – eventually funded as an Anglo-Australian co-production – afforded its film maker the opportunity to explore a rich vein of Australian cultural history. Despite the avowedly popularist aspect and marketing of the film, discussed in greater detail below, the script and narrative of *Sirens* demonstrate considerable research into Lindsay's art, writings and career. Indeed, far from being a superficial narrative 'loosely inspired by' the artist's life, the film is steeped in *Lindsayana*. It is 'built' from themes and fragments of Lindsay's own life, art and writing. In terms of its biographical address, *Sirens* draws on a number of published sources (most notably his daughter Jane Lindsay's book *Portrait of Pa* [1973]); aspects of Lindsay's novels (most particularly *A Curate in Bohemia* [1913] and *Miracles by Arrangement* [1932]); and the manner in which these novels relate to and reflect his work as an artist.

Lindsay began studying drawing and painting in Melbourne in the late 1890s and lived and worked in the Heidelberg area in 1897. He married Katie Parkinson in 1900 before moving to Sydney in 1901 to work for *The Bulletin* magazine, a publication renowned for its bold and uncompromising editorial policies. In 1902 Lindsay met Rose Soady, who was then 16, who became first his model, then his mistress (and later, in 1920, his second wife). His first brush with scandal occurred in 1904, when he exhibited a pen and ink drawing entitled 'Pollice Verso'. This showed Greek and Roman figures turning their thumbs down to a figure on the cross. Somewhat surprisingly perhaps, the National Gallery of Victoria purchased the drawing in 1907 for one hundred and fifty guineas, then a record price for pen and ink work. After intense pressure from the Anglican establishment, who denounced the drawing as 'blasphemous', the gallery's trustees removed it from exhibition and put it into storage.

In the period 1906-9, Lindsay worked on the (self-initiated) project of illustrating Casanova's *Memoirs*, producing over a hundred illustrations. In 1909 he travelled to England by sea. During a stop-over in Naples he visited Pompeii and began illustrating another book he had read on his journey, Petronius's *Satyricon*. While he reportedly found Britain stuffy and conservative, he managed to secure a publisher for his illustrated *Satyricon*, with Ralph Straus printing a limited edition of 265 copies. He found the social milieu of Paris more to his liking but experienced a sense of culture-shock at the preoccupations of its art world. Unlike the Paris he had imagined, and the French painters he admired, he found himself in a city where Van Gogh and Cezanne were enjoying considerable popularity. Their Modernism ran directly counter to his affinities with artists such as Rubens, Bocklin or Bouguereau and to the standards of pictorial realism he cherished. Judging from the work he produced upon his return to Australia, the only effect this encounter with Modernism had on Lindsay was to reaffirm his conviction in his existing Neo-Classicist style of painting and drawing.[2]

He returned to Sydney in 1911. In the following year Soady purchased a house at Faulconbridge in the Blue Mountains, using money saved from her modelling career. Lindsay soon took up residence at the property, known as 'Springwood'. The rural re-location was not without its problems however. Lindsay found it difficult to recruit local models, in what was then predominantly a conservative country area, and difficult and/or costly to entice them up from Sydney. To ameliorate this, he took a large number of photos of models, developed these himself and drew from the photographs.[3] As well as organising Lindsay's re-location, and thereby facilitating arguably the most fertile period of his career, Soady also posed for the artist's next notable *success-de-scandal*, the pen and ink drawing 'The Crucified Venus'. This picture showed a female figure being nailed to a crucifix by a monk, watched by a crowd of clerics and others. It was exhibited at a Society of Artists exhibition in Sydney to a (predictably) controversial response. Reaction was even more marked in Melbourne, where it was exhibited in 1913. The picture was denounced by the art critic of the *Age* newspaper and removed from exhibition after two days. It was only reinstated when Julian Ashton, president of the Society of Artists, threatened to withdraw all entries by artists from New South Wales. In 1923 several of Lindsay's drawings were exhibited at a Society of Artists exhibition in London, to controversial response and, in 1924, eleven of his works were hung at Artists Week in Adelaide, to similar reactions.[4]

Throughout his career as an artist Lindsay wrote a series of essays, articles and novels. *Sirens* draws on themes from several of these. The most obvious parallels to *Sirens'* narrative are the novels *A Curate in Bohemia* (1913) and *Miracles by Arrangement* (1932). *A Curate...*, Lindsay's first novel, was based on his experiences as a student. It paints a picture of bohemian life in Melbourne as experienced by a young, newly-ordained curate visiting the city en-route to his first (country) parish. The plot involves various outrageous episodes including several meetings with an agreeable and 'liberated' young woman who works as an artist's model and occasional dancer. This characterisation and narrative has clear affinities with *Sirens*. With commendable prescience, the critic John Hetherington recognised the dramatic qualities of the novel in 1961, commending *A Curate...* to film makers by arguing that:

> ...much of its action is trivial to be sure, but the whole novel is an
> effective period piece and its value is not likely to diminish with time,
> and might even tend to grow. Although it was conceived and written in
> an era when the cinematograph machine was still hardly more than an
> experimental curiosity, it would make a hilarious film.[5]

Despite the similarities between the plot of *A Curate...* and the film, aspects of *Sirens* are also suggested by other elements of Lindsay's work. One particular painting which – in combination with the theme of *A Curate...* – evokes *Sirens'* scenario, is his work 'Springwood Fantasy' (1953). This, and many other sketches and paintings, used the beautiful grounds of Springwood as its setting. The oil painting features the poet David Campbell and his wife, who visited Springwood on several occasions, amidst the gardens and a circle of sensuous, semi-clad models. (One of the 'fantasy' elements here of course being that Springwood supported such a 'colony' of women[6].)

In terms of *Sirens* representing a blend of themes from Lindsay's work, one of the other major influences can be seen to be that of the scenario and narrative of *Miracles by Arrangement* (1932). This is set in the countryside at the outer fringes of Sydney, and its plot concerns the Greshams, a middle aged couple in a stilted relationship, who toy with the idea of taking lovers before settling for stability. The novel is the most autobiographical of all Lindsay's work and contains much which seems to specifically allude to characters and issues in his life. It includes scenes reminiscent of *Sirens* where Gresham meets representatives of the new spirited generation whose values rock his complacency. John Hetherington has described the book as being imbued with

a 'riotous, musky, mildly Rabelaisian spirit'[7], a characterisation which equally well applies to Duigan's film.

II LINDSAY, MODELS AND NUDES

From the earliest stage of his career Lindsay chose fleshy, statuesque models as the subjects for his paintings. This did not simply represent a personal predilection, a subjective ideal of female allure, but rather a more complex association of the body with the symbolic. For Lindsay the ample female body represented an essential biological femininity. Lindsay summed up this view in a comment to the writer Rubery Bennett, declaring that:

> I am not interested in portraying womanhood narrow hipped and flat chested like a fashion magazine. I am only interested in portraying the woman who is the mother of the human race.[8]

The majority of his work shows a concern for the *expressive* body over passive flesh. The women depicted in his paintings were essentially figures of an idealised mythic past rather than contemporary social beings. He specifically acknowledged this aspect in a letter to his sister Mary in 1953, where he stated his preference for 'unaffected' female models in the following terms:

> I would have no use for a highly intellectual cultured lady as a model. It would put me out, having to pay the polite deference her class and culture would expect... *(arguing that such a model)* would kill all movement in a picture, which demands rhythm, gesture, action, expression.[9]

Lindsay's assessment of 'intellectual' and/or 'cultured' women as unsuitable for his purposes reflects his perception of there being innate binary oppositions – intellect v sensuality, education v instinct, self-consciousness v spontaneity (etc.). Within these binary oppositions, Lindsay believed that his (educated, intellectual, self-conscious) artistry *required* its (female) 'other' in order to produce his work. Unlike many of his contemporaries, he acknowledged the importance of the model's creative input to the work of art (and the necessity of the artist nurturing this), commenting that:

> I have always kept a sympathetic bridge with my models. They mean so much to a painter. Artists are fools who don't make a model feel that. It

is very rare that one gets the sort of model that one can paint direct from, and not have to add the qualities they lack.[10]

The 'sympathetic bridges' that Lindsay acknowledged were ones that he sustained over considerable periods of time, working repeatedly with individual models. One of the models with whom he established a particularly creative rapport was his wife-to-be Rose (who modelled significantly less for him after their marriage in 1920). It is no accident that Rose was the model for the tortured female figure in 'The Crucified Venus', the process of modelling for which must have been a complex and intense experience.[11]

Rita Lee, a young woman of Spanish and Chinese parentage, was the model for a number of striking paintings and sketches produced by Lindsay in the 1930s and 1940s. The quality of the work Lindsay completed with/of her lends support to his own assessment of the contribution of a model to the creative process. Lee, for her part, has described working with Lindsay as 'like making a film with some wonderful film director'.[12] Despite this characterisation, Lindsay's own comments on Lee's most outstanding attributes reveal a rather different artistic pre-occupation. Lindsay describes her as:

> the perfect model for the metier of oil painting... She had the loveliest breasts I had ever painted from, and they drove me to despair. No crude combination of colours extracted from the earth can hope to capture the pearly shimmer of light on the youthful female breast.[13]

Despite contemporary rumour, much subsequent speculation and the extreme, even morbid, sense of sexual longing evident in the above quotation; Lindsay constantly refuted allegations that he was sexually involved with (any of) the models who provided him with the uninhibited poses represented in his art. As he wrote to his sister Mary in 1953:

> I have never put an amorous hand on a model. To do that would have destroyed the unuttered pact between artist and model. It is a Narcissus urge which makes a girl ardent to have her feminine charm affirmed by a male observer. If the male responds only to its sex-allure, the self-esteem of a Narcissus fantasy is hurt and offended. And the artist who squanders desire on her body has debilitated the urge to replicate its desirability in paint.[14]

This statement conveniently elides the 'amorous hands' which he layed on his

wife-to-be Rose, who continued as his model for a number of years despite his assault on her 'self-esteem'. Lindsay addressed this issue, in a markedly different way, in his 1938 novel *The Age Of Consent*. This concerns an artist working on the South Coast of New South Wales, on a break from the city, who meets a gauche young country girl who first becomes his model, and then his lover. There is a clear parallel with Lindsay's career as an artist, and an obvious connection between the book's title and the age of Rose Soady at the time of their first meeting. Set in a more stable period of Lindsay's life however, *Sirens* does not address this theme and the (fictional) Lindsay is represented as wholly 'professional', even remote, in his dealings with his models. This particular distance reflects the extent to which the film displaces Lindsay from the centre of the narrative. Barbara Cramer has commented that the fictional Lindsay 'does little more than stand by with an air of omniscience and detached amusement, paternally surveying his seraglio'[15]. We might take this further. The real, the represented and the awareness of representation blur. There is a sense in which Sam Neill can be seen to play Lindsay as the bemused observer of the fictionalisation of the (real) Lindsay's life and estate through motifs derived from Lindsay's art – a situation likely to produce 'an air of omniscience and detached amusement' for its fictionalised protagonist.

III SIRENS – A SPRINGWOOD FANTASY

Sirens is set in and around Lindsay's actual house Springwood, in the lower Blue Mountains. The plot concerns an English cleric and his wife Estella (played by Hugh Grant and Tara Fitzgerald respectively) visiting Lindsay (Sam Neill) and his wife Rose (Pamela Rabe). Also resident at Springwood are three models, Sheela (Elle Macpherson), Pru (Kate Fischer), Giddy (Portia De Rossi); and a (supposedly) blind male groom (Mark Gerber). From the outset of the film it is clear that the young couple have entered a world foreign to their own. Duigan constructs the Springwood estate and its inhabitants as the embodiment of a particular set of bohemian values which stand in stark contrast to those represented by the minister and his wife. The young curate perseveres in vain to convince Lindsay of the dangerously profane nature of his work throughout the film and remains seemingly unaffected by his encounter with the small community. Estella however experiences a profound sexual awakening as a result of her stay.

There are three key elements to Duigan's depiction of Springwood. These concern the body, the environment and the mythic. Bodies, and specifically – though not exclusively – female bodies, are significant presences and 'markers' of the Springwood estate and its surrounds. Of particular prominence, both within and with regard to the marketing of *Sirens*, is the presence of Australian 'supermodel' Elle Macpherson (often known by her media nickname 'The Body'), making her screen acting debut. Along with the casting of the two established actors, Neill and Grant, Macpherson's presence was a major factor in the film's promotion, packaging and – presumably – box office and video rental appeal. More specifically, much of the film's pre-release hype centred not only around the anticipation of witnessing 'The Body' in various states of undress but also around the 20 lbs Macpherson had gained in order to approximate the Rubinesque quality of Lindsay's own models. Macpherson's physical re-modelling for the role reflects Lindsay's association of fleshliness, fertility and sexuality (as discussed in the previous section). The curvaceousness which characterises all the models in *Sirens*, including Rose, is accompanied by an overt sensuality on the part of these women. By contrast, Estella, the diminutive curate's wife, is depicted as the embodiment of reserve and repressed sexuality. However, as the film's conclusion reveals, even the physically slight are not beyond sexual redemption...

In her book *Portrait of Pa* (1973), Lindsay's eldest daughter Jane described Springwood's grounds in detail and commented that:

> Pa's aim had obviously been a European Romantic period type landscape
> of waterfalls and walks seen so often in his works. The romantic's dream
> of nymphs and satyrs, gods and goddesses, forest pools and leafy glades
> did not quite translate to the stark reality of the Australian Bush.[16]

Sirens avoids these difficulties however by representing Springwood in a magic, idyllic (mid- summer) setting, free from the cold of a mountain winter or the frequent droughts and bushfires which afflicted the property in the 1920s[17]. Springwood, and the lush natural environs surrounding Lindsay's home, are depicted as a (second) Garden of Eden. Lindsay's notion of the 'woman who is the mother of the human race' is of particular relevance to a second set of associations Duigan constructs. Macpherson's character Sheela (whose name even denotes, in Australian usage, a woman) performs the role of a latter-day (fallen) Eve. She regularly appears with an apple in hand and, in other scenes, snakes slither around, disturbing coffee cups and model ships. Duigan even

goes so far as to include a (clearly discernible) headline 'Snake Runs Amok in Kindergarten' on the front page of one of the newspapers perused by Estella.

The Edenic landscape of the film is also represented – and 'customised' – with an abundance of Australian flora and fauna. The natural inhabitants of the estate comprise a range of Australian icons, such as koalas, wombats and wallabies (which Lindsay's own cartoon work helped to establish as icons in the first place). The film also refers to the dangers of sharks, water snakes and red-back spiders. These references serve the dual purpose of emphasising the Australianness of the place and the potentially threatening nature (both literally and metaphorically) of the environment – the dark aspect of its (fallen) Eden. The discomfort that such surroundings pose for the curate and his wife is emphasised in the film with their depiction as variously startled, fearful, winded and even ill. This contrasts with the natural affinity that the 'sirens' and groom have for their physical surroundings, surroundings they inhabit as much as *spirits of place* than as human subjects. Appropriately for sirens, both Sheela and Pru have a particular affinity with water and are often shown bathing naked in a mountain pool. Devlin, too, is shown lying in the landscape in naked splendour. The sensuality of the figures is linked with the lushness and fertility of a specifically Australian land, as if that very sensuality somehow resided in the soil itself (an issue which will be elaborated on below). Clearly, such associations cohere with Lindsay's own aesthetic interests in 'earthiness' and the notion of a figure who is 'mother of the human race'.

The third significant facet of Duigan's vision of Springwood is its association with the mythic. The most obvious reference is that explicitly acknowledged in the film's title, the sirens themselves, the nymphs of classical mythology who lured mariners to their deaths through the destructive power of their songs.[18] The sirens of Duigan's film represent a more contemporary version of the myth however, that of dangerous, alluring women who operate beyond the bounds of conventional moral behaviour. Pru, Giddy and particularly Macpherson's Sheela are consistently provocative in the film. They exercise a considerable influence on Estella and Anthony's relationship, unnerving the couple and bringing repressed tensions and feelings to the surface. The sirenic qualities of the models are most obviously emphasised in two of the pool sequences. One of these, mixing mythological references, is clearly based on John Waterhouse's well known painting 'Hylas and the Nymphs', which shows a group of alluring, naked young women attempt to entice Hylas, a young male, into joining them

in their watery realm. In Duigan's version, Devlin comes to the pool to drink but declines the women's invitation to swim with them.

Contrary to the traditional inflection of the myth, it is Estella, rather than her husband, who is most drawn to the sirens throughout the film. Sheela and Pru's open sexuality, and their constant attempts to shock her, gradually loosen the binds suppressing Estella's libido. By the end of the film she has become uninhibited enough to engage in an intense erotic encounter with Devlin. This is only a step along the way to her sexual 'awakening' however. Following her night of passion with Devlin she is afflicted with a desire to escape Springwood and its (very real) seductions. Problems with the local rail services prevent that escape however, and she is forced to stay another night. A crucial dream sequence then ensues.

In her dream she awakens in the night and makes her way to the sirens' pool. Once there, Estella slowly descends into the water and then floats atop it, in a scene inspired by another seminal Pre-Raphaelite painting, Millais' 'Ophelia'. For a moment Duigan draws upon the resonances associated with Millais' painting (and, of course, Shakespeare's *Hamlet*), that of Ophelia as an iconic victim of patriarchy, and then powerfully subverts these associations. Estella's watery reverie is disturbed by the intrusion of the film's three sirens. Initially only their hands are visible, as they emerge from the water and move towards Estella threatening to pull her under. Estella's heavy breathing, the hands which glide in a careful dance across her flesh and the slow motion image sequence which accompanies her final utterance of 'I want to wake up now', combine to produce a spectacle of female eroticism which hovers at the brink of immersive ecstasy. Almost overwhelmed, she (and we) awake with a start. We have indeed witnessed a death at the hands of the sirens, but is Estella's sexual repression, not the woman herself, which has perished.

It is curious that a film whose promotion rested so patently on the exploitation of the female body, and of Macpherson in particular, delivers a more complex layering of sexual associations. The force of the dream sequence is not so much its intense eroticism – which plays on stereotypical male fantasies of lesbian sexuality as much as it does a genuinely 'alternative' female erotica – but rather its narrative significance. It is not Estella's encounter with the masculine 'other', in the form of the virile groom, which 'liberates' her but rather a powerful dream of sensual affiliation (as opposed to congress) which, through its affirmation of a feminine principle, completes this progress.

Estella's transformation is emphasised in the film's concluding sequences. The first of these, in a neat narrative resolution, binds her into the process which takes place during the duration of her stay at Springwood (and which gives the film its name), Lindsay's execution of 'The Sirens'. In one of the earliest Springwood scenes in the film, Giddy describes the myth of the sirens to Estella and Anthony, shows them the props and costumes intended to be used in the painting and invites them to model. Anthony politely declines the offer. Throughout the film, sequences showing Lindsay sketching and painting his naked models recur. On the final day of the curate's visit Lindsay shows Anthony the completed painting. To Anthony's outrage, the artist has included a naked representation of Estella, as a fifth siren, alongside Sheela, Pru, Giddy and Rose. In fury he summons Estella to examine the canvas. Her response astonishes him. Her only comment, eloquent in what it leaves unspoken, is that 'it's a good likeness'. Anthony's indignation is instantly deflated as he is suddenly isolated from the circle of complicity of which Estella is now a part.

There are more surprises to come for Anthony however. In a scene utterly out of character for the Estella we are presented with in the opening scenes of the film, she takes an active role in attempting to sexually arouse her husband in a crowded railway carriage as they leave the mountains. She has not simply acquiesced to her representation as a siren, she has actually *become* one and assumed the uninhibited licentiousness of the models she came to identify with during her stay. Of course this is all too neat. By ending in this manner the film heavily underscores a discourse of sexual freedom (or rather freedom perceived as the encouragement and licence to actively participate in sexual activity) which conflates Lindsay's own bawdy sensibility and visions of ideal womanhood with a (quaintly dated) 1960's aesthetic of 'sexual liberation'.

In his discussion of Manet's painting 'Olympia' – and the scandal which followed its exhibition in 1865 – T J Clarke takes great pains to write the clear disclaimer that:

> a nude... is a picture for men to look at, in which Woman is constructed
> as an object of somebody else's desire. Nothing I go on to say about
> *Olympia* is meant to suggest that Manet's painting escapes that wider
> determination, or even escaped it once upon a time... It was meant as a
> nude and finally taken as one.[19]

At this point we sound a similar note. *Sirens* primarily operates as filmic erotica

(and is thereby amenable to consumption as such). The representations it offers *may* subvert notions of sexual restraint or propriety but they offer no radical alternatives. They may indeed be read as reinforcive of the patriarchal inscription of heterosexuality and the commodification of the female body (to such an extent that this point hardly needs making). In setting themselves against moral prudery and 'wowserism' both *Sirens* and Lindsay hit soft targets (since, as always, the Devil has the best tunes). In this regard it is salutary to note that in 1967 *Playboy* magazine, then a crusading journal of sexual liberation – as conceived within the orthodox parameters of male desire – published a piece which identified Lindsay as a notable pioneer of its crusade.

The December 1967 issue of *Playboy* included four pictorial features. Three of these were photo spreads: 'Bunnies of Hollywood', 'The Wicked Dreams of Elke Sommer' and 'Playmate of the Month'. The fourth was a ten page feature entitled 'Art Nouveau Erotica'[20]. This included reproductions of work by Norman Lindsay, Gustav Klimdt, Aubrey Beardsley, Franz von Bayros and Frank Christophe. A brief editorial introduction defined its category of 'art nouveau erotica' and singled out Lindsay for particular praise:

> like the turned-on art of today's hippies, art nouveau began as a reaction
> to the up-tight moral and aesthetic values of 'square society'. Lindsay's
> rococo creations – drawn during the Twenties in Australia, where the
> antisexual vestiges of Victorianism outlived its influence in Europe – are
> among the most outstanding and erotic examples of this hothouse
> genre.[21]

In 1994 *Playboy* reviewed *Sirens*. Knowingly or not (and probably not) the reviewer echoed themes from the magazine's earlier discussion of the 'hothouse genre' of 'art nouveau erotica' and lauded the film as: 'One of the most erotic movies of the year... [a] witty saga of sexual inhibitions unbuttoned.'[22]

The analysis we have been developing does not attempt to elevate – or even 'redeem' – *Sirens* as any kind of radical, critical or deconstructive text. Far from it. *Sirens* can be seen to be marked by a nostalgia for a pre-Feminist era where art – and society and culture as well – could present the female form as an object of the (male) gaze without problem. Our discussions have rather centred on the intersections of other discourses across the film's primary level of operation as a piece of light, art-tinged erotica. These other discourses are

those that are enabled by the film's primary level and have been presented to a wide audience through the film's success. It is the particularity of these textual details that most interests us and is taken by us as an index of the film's originality. In this manner, *Sirens* resembles Lindsay's career as a figure painter. While much of his work operates within a particular – and particularly predictable – oeuvre, occasional works such as 'The Crucified Venus' stand out and merit attention for their complexity. In a similar manner, the individual scenes in *Sirens* we have identified and discussed offer complex crystallisations of issues of representation, erotics and the gaze as re-represented from Lindsay's work through Duigan's film. Ultimately however, *Sirens* operates within a genre that might be termed 'arthouse erotica' and has to be understood as such.

IV SIRENS – PROMOTION AND RECEPTION

Despite the misgivings of many of the surviving members of Lindsay's family, the National Trust of Australia, owners and managers of Springwood, actively aided the production of *Sirens* by closing the house and grounds for the duration of the film shoot. In return, the organisation was prominently associated with the release of the film. The film's launch was covered extensively by the Australian media. A series of press articles focused on Macpherson in her screen debut and the film attracted considerable attention from TV and radio. In a move which neatly conflated Macpherson's presence in the film with the actual Springwood house – and its history – the grounds of Springwood were the subject of a special episode of the popular TV gardening magazine series *Burke's Backyard.* In a programme which went to air in May 1994, Don Burke was given a tour of the gardens by Macpherson, in role as herself, as (if) an expert on the gardens and their history. The film was accompanied by an exhibition at Sydney's Powerhouse Museum entitled 'Sirens – A Brush with Life', which had its own high profile launch. This exhibition was itself accompanied by the premiere of 'Norman's Siren', a performance piece by Jan Pinkerton inspired by Lindsay's work and particularly, 'his affinity with the female form... and his relationship with his siren sculptures'[23]. The piece was later staged in the gardens of Springwood itself, where many of the sculptures are situated.

The film, its promotion (and the National Trust's association with it) 'fed-back'

to the Springwood property itself. Amanda Trevillion, manager of Springwood, reported an increase in visitors of 100 per week in the year following the film's release. Many of these visitors signalled their interest in the property by inquiring as to whether the film was actually shot there[25] – exploring the property subsequent to their experience of it on film. The international release of *Sirens*, and the considerable publicity accruing to it by virtue of Macpherson's role (and disrobing), also impacted on both the Springwood estate and Lindsay's position in the international art market. Despite exposure in publications such as *Playboy* (as discussed in Section III above), Lindsay never attained a significant reputation as an artist in the USA prior to the 1990s. *Sirens* improved this situation in two principal ways. Firstly Lindsay became a tourist attraction, part of an Australian heritage of which few American tourists had previously been aware. Trevillion reported a 'great surge of interest' from the USA after the film's release, with numerous requests for information, books and prints and, later, a stream of American tourists who cited the film as the reason for visiting the house[26]. Immediately after the release of the film Leonard Joel, the main dealer in Lindsay's work, also noted a rise in interest in the artist's work and an increase in the volume of his paintings becoming available for sale.

Lindsay, or rather, his family, the National Trust and art dealers, were the beneficiaries of *Sirens*' success. Macpherson was another winner. The generally positive response to her acting debut, and the evident bankability of her (physical) presence, allowed her to make the transition from being a model with aspirations to act to being an in-demand actress. This, and associated publicity, was of course, also beneficial to her public profile and modelling career. Her next screen role was as star of her own exercise video – *Elle Macpherson: The body workout* (1995) – currently one of the best-selling examples of its genre. The video explicitly refers back to *Sirens* and explains how her role in the film *necessitated* the exercise regime she enacts. As she states to camera in the video's introductory sequence:

> Karen Voight developed this circuit training workout for me after I
> made the film *Sirens*. You see I'd put on 20lbs for the role and I wanted
> to lose the weight but still stay strong without being stuck at the gym
> the whole time.

Following *Sirens*, Macpherson performed a number of cameo roles in Hollywood films and, at time of writing, (as if to confirm her upward cultural

mobility) is about to appear in Franco Zeffirelli's version of *Jane Eyre*. Indeed, the association between Elle and the art world of *Sirens* has become so pronounced that a feature in the high circulation Australian publication *Women's Weekly* framed a discussion of her Australianness – as an overseas-based professional – within a description of the inner-sanctum of her New York home. This detailed the manner in which:

> a large Ned Kelly painting, one of a series by the late Sidney Nolan,
> hangs over the fireplace; a huge Aboriginal dot painting by Rover Thomas
> fills one wall; and a canvas by Jean-Michel Basquiat... fills the wall over
> a giant four-seater couch.[27]

With delectable symmetry, the article also announced the latest addition to her art collection, a Lindsay nude bought for her by her then lover, British art dealer Tim Jeffries, since, as Macpherson explainned, 'he thought it looked like me [in *Sirens*]'.[28]

This emphasis on art, and the image of a contemporary, cosmopolitan Australia Macpherson is taken to represent, is markedly different from the predominant image of Australia popularised in the 1980s, ie the witty Ockerism of Mick ('Crocodile') Dundee. The context established for Macpherson, with a flat filled with works by Nolan (newly popular in the USA since his early 1990s New York show); Thomas (one of the many Aboriginal artists feted in Manhattan over the last five years); and quintessential New York graffiti artist and Warhol-protege Basquiat; establishes her as a 'cultured' woman. This image is in stark contrast to the early 1990s TV commercial which featured Paul Hogan – in role as Crocodile Dundee – in an art gallery. Like the bishop and curate at the beginning of *Sirens*, he is confounded by a work of Modernism. For him however it is not the subject of the painting that is disturbing but rather its abstract style. Like the cowboy protagonist who reels back before a blank canvas in Glen Baxter's ironic cartoon 'It was Tom's first Brush with Modernism'[29], Hogan-Dundee (representing the old Australia) is shocked by an abstract painting. In confusion he looks to a fellow gallery visitor for some kind of explanation. The man exclaims, with evident irritation, 'it's Jackson Pollock's' – a sentiment with which Hogan-Dundee heartily agrees, thinking that his companion is using rhyming slang.

Although Lindsay would have heartily concurred with this sentiment, it represents an old image, an old joke. The representation of Australia and

Australianness in *Sirens* is informed by a more contemporary sensibility. During the early 1990s, the republican movement grew in popularity in Australia, largely due to the support given by then Labor prime minister Paul Keating[30]. This republicanism sought to define Australia in opposition to (specifically) Englishness, Anglicanism and monarchy. The battles between Lindsay and his curate adversary in *Sirens* are therefore symbolic of the 'bigger (political) picture'; and the bodies of the models are the symbolic terrain on which the battles take place (an aspect which illustrates the infinite uses – and abuses – which patriarchal culture makes of the female form). While the film's theme of female association and erotic empowerment is a notably original inflection of its genre, *Sirens* ultimately enshrines the female as a model for masculine discourse and thereby returns, with admirable fidelity, to Lindsay's own work. In this sense, if nothing else, *Sirens* provides a notable representation of Lindsay's ideas and oeuvre.

NOTES

1 John Hertherington, *Norman Lindsay*, Melbourne, Oxford University Press, 1991, p 8.

2 See Deborah Edwards, *Stampede of the Lower Gods: Classical Mythology in Australian Art 1890s-1930s*, Sydney: Art Gallery of New South Wales (1989) for a discussion of Lindsay and Australian Neo-Classicist painting.

3 This practice was hardly new however, artists such as Delacroix, Riesner and Durieu had used photographs in this manner as early as the 1850s. Delacroix's famous work 'Odalisque' (1857) was, for instance, painted directly from a posed photograph. (See, Scharf, *Art and Photography*, Harmonsworth (UK), Penguin, 1979 pp120-125 and pp130-134 for further discussion.)

4 We should also note that Lindsay's Billy Bluegum cartoons, and accompanying verses, published in magazines such as *The Bulletin* and *The Lone Hand* from the early 1900s onwards, satirised various aspects of Australian cultural life using koalas to represent and parody social attitudes. One of these, entitled 'The Sad Fate of Gamboge Bluegum' (originally published in 1912) satirised the controversy over his nude paintings – one of the elements at the heart of *Sirens* itself – by recounting the social outcry among koalas at Gamoge Blugum ('the artist bear') painting an (unclothed) koala model. Social outrage forces Gamoge to dress his koala model and the verse ends with the couplet 'For Society says no bear should dare/ To paint a bear entirely bare'.

5 John Hetherington *op cit,* p 37.

6 In fact, models were only infrequent visitors to Springwood and there is no evidence that more than one – aside from female members on Lindsay's own family – were ever resident together at the house.

7 John Hetherington, *op cit,* p 35.

9 Cited in Lin Bloomfield, *Norman Lindsay – Impulse to Draw,* Sydney and London, Bay Books, 1984, p130.

10 *ibid,* p132.

11 As T J Clarke has emphasised:

> A nude could hardly be said to do its work as a painting at all if it did not find a way to address the spectator and give him access to the body on display. He had to be offered a place outside the picture, and a way in; and be assured somehow that this way was the right one. (T J Clarke, *The Painting of Modern Life,* London, Thames and Hudson, 1984, p 132.)

In these terms, the pictorial 'problem' with 'The Crucified Venus' is that the viewer is placed in the position of viewing a body which is simultaneously voluptuous and tortured. The (male) viewer is thereby invited to take a sadistic pleasure in looking at a body, as *his* look is mediated, and colludes with, the looks (and implicit compliance) of the spectators in witnessing the spectacle of the tortured woman. This is uncomfortable enough as a public 'art' image but is rendered more complex by the positing of a female agonised body in a place and position more usually occupied by Christ. (It should be noted however that Rose Lindsay ignores such issues in her biography *Model Wife: My Life with Norman Lindsay,* Sydney, Ure Smith, 1967 – which mostly deals with details of domestic and social life.)

12 Bloomfield, 1984 *op cit,* p150.

13 *ibid,* p 152.

14 *ibid,* p 134.

15 Barbara Cramer, *Sirens* (review), *Sight and Sound,* August 1994, p 54.

16 Jane Lindsay, *Portrait of Pa,* Sydney, Angus and Roberston, 1973 p 26.

17 See Jane Lindsay, *ibid,* pp 88-94 for further discussion.

18 For further discussion of the myth of the Sirens see Hayward, P 'Rhapsodies of Difference', *Mediamatic* v4 n1/2 Fall 1989, pp 13-22.

19 Tim Clarke *op cit,* p 130.

20 *Playboy,* December 1967 pp 129-139.

21 *ibid,* p130.

22 Review by Bruce Williamson, quoted in Village Roadshow promotional leaflet, April 1994.

23 Promotional handbill for 'Norman's Siren' (1996)

24 Conversation with Philip Hayward at Springwood, 12 April 1996.

25 *ibid.*

26 *ibid.*

27 Jo Wiles, 'One Elle of a life!', *Women's Weekly* December 1995,
 pp 4-7.

28 *ibid.*

29 Featured on the cover of the first edition of Philip Hayward (ed)
 Picture This, London, Arts Council/John Libbey, 1989.

30 Although it received a major set-back with the election of a Liberal
 Party government in 1986.

13
Gardens of Speculation
Landscape in *The Draughtsman's Contract*

Simon Watney

The financial and critical success of Peter Greenaway's film, *The Draughtsman's Contract*, has been accompanied by a general tendency to categorise and analyse it as a thriller. Thus, for example, Tony Rayns has noted how, 'like any good English Mystery thriller, *The Draughtsman's Contract* trades in deceptive appearances, secret motives and cold-blooded murders'.[1] In a similar vein Helen MacKintosh describes it as a 'riddle about conspiracy and murder'.[2] Undoubtedly the film encourages such an initial reading since, as Angela Carter has neatly observed, its 'plot is a combination of two characteristically British genres, the country house mystery and the comedy of manners. Agatha Christie articulated in terms of William Congreve'.[3] However, to leave off commentary at that point would be rather like qualifying *The Pilgrim's Progress* as a travelogue, or *Kiss Me Deadly* 'simply' as film noir. For, like them, *The Draughtsman's Contract* is fundamentally and essentially an allegory. And more than that, it is a film *about* allegory.

Set in a period which still conceived its world in allegorical terms, prior to the encroachments of rationalist or positivist thought, it is a film which encourages modern audiences to reflect on the profound changes in the history of European representation over the last three centuries, and their consequences for how we think ourselves and the world we share. Greenaway himself has described it as a 'figures-in-a-landscape movie... an opportunity for me to animate and celebrate the paintings of the seventeenth century and to re-invent an elaborate conversational language of conceit, pun, illusion and word-play that is, for better or worse, absent from contemporary speech'.[4] He explains elsewhere that he chose to set his film in the England of the 1690s:

because of the new Protestantism of the English throne: because this was the moment when English painting was becoming indigenous: because the Whig landowners were about to start their massive building and property activity. Because these were the last years before the formal garden broke open under the impact of landscape gardening.[5]

All these things 'made it a pivotal point for the games I wanted to play'. In this chapter I want to consider some aspects of these 'games', and to trace their complex interplay within the film's use of landscape imagery. The actual plot, as such, will not concern me, except in its bearing on the central metaphor between the practices of draughtsmanship and of film-making, a metaphor concerning vision or, to add an important double-meaning, speculation.

Uninterested in what he regards as 'an English filmic obsession' with the 'chimera' of realism, Greenaway flaunts the conventions of 'period reconstruction' film-making. He deliberately introjects into his Restoration *mise-en-scène* a number of carefully chosen modernist themes in order precisely to problematise that seeming universality of 'human' experience which is assumed and constructed within the tradition of British 'historical' films. The authenticity of set, costume and dialogue to which the film ostensibly aspires is constantly undercut by the introduction of elements which undermine the very notion of authenticity itself. For this reason the film's greatest weakness lies in those occasional attempts to map out an allegory of contemporary Britain. Raymond Williams has characterised Restoration society in terms of the ways in which it 'reduced men and women to physical, bargainable carriers of estates and incomes'.[6] But the cynicism of Restoration Comedy concerning the relation of marriage to property, is quite unlike the contemporary optimism of feminist consciousness and analysis. In *The Draughtsman's Contract*, the women are revealed, ultimately, to have the upper hand. They finally 'play the game' more successfully than the men. But the game itself is not questioned. As an allegorical comparison then between the consolidation of two newly emergent ruling classes in late Seventeenth and late Twentieth century Britain the film is, I think, slight. But, as I have suggested, any such reading would depend on a relatively superficial reading of the film's literal plot, as a thriller. Its range of intertextual reference is not so much with other films as with other modes of representation, with theories of representation itself.

It is thus no accident, as Greenaway is the first to point out 'that the central

figure, the draughtsman, has in 1694 an optical device to help him fix his landscape on paper, a device which in principle, is little different from that used by the cameraman in 1982 to fix the landscape of *The Draughtsman's Contract* on the film'. This analogy is reinforced as he describes how 'the camera retains, like the draughtsman in the film, a steady, uncommitted, observant, critical eye...' Thus, he concludes, 'all events are open to interpretation and re-interpretation'.[7] This is the very nature of allegory – to demand further elucidation and commentary, beyond any closure of literal narrative devices. For allegory invariably proceeds from a radical distrust in 'mere' appearances. It conceives the world not as a stable set of coherent discrete objects, but rather as an endless network of resemblances and associations, in which signification is the primary order of things. Thus medieval and renaissance thought evaluated, in a simple example, the nut as

The camera retains, like the draughtsman in the film, a steady, uncommitted observant, critical eye.

an outward sign of its hidden kernel, permitting a host of analogies to be made between the body and soul, matter and spirit, object and significance. The world is scanned as a series of signs revealing the Divine Intention behind all things or, where such hermeneutic interpretation failed, the Satanic. The natural, or non-human world was thus perceived in a profoundly ambiguous manner. Most plants and animals can be folded into the symbolic structure of Christian thought but what we think of as nature was regarded on the whole as a semiotic void, a meaningless domain, unthinkable, a vast absence against which the formal garden was pitted by analogy with Eden, a nature made meaningful by pattern and design.

Hence we may understand the elaborate geometrical Gardens of Love or Garden of Vanity, or Youth, as they appear in Renaissance culture, surrounded by high and sturdy walls within which their contents can alone possess meaning and Value. It was the business of the gardener then to confer upon inchoate nature the signs of cultural and spiritual significance which they did not otherwise possess. By the Seventeenth century this process had inevitably also incorporated the rhetoric of Antiquity, with all its complex values and meanings. However, by the time of the period in which *The Draughtsman's Contract* is 'set', the old allegorical culture which had sought to establish a system of resemblances between all things was already giving way to a new paradigm of though which, on the contrary, was beginning to think its world in terms of differences rather than those systematic similarities which had previously served to 'prove' the essential semiotic coherence and order or the Christian universe. The signs of Divine presence were no longer required to actually resemble the deity, as in the example of the nutshell's relation to its kernel, or rind to its inner fruit

For, as Michel Foucault has analysed in depth, this was the period in which we can trace the origins and emergence of the concept of Natural History, itself the precursor of modern biological and evolutionary theory.[8] Indeed, it is worth noting that when Sir Joshua Reynolds came to decorate the entrance hall of The Royal Academy a century later with all allegorical figure of Theory, he depicted her seated on clouds clutching a scroll inscribed with a single word Nature. In the Restoration period this alignment of Theory, in the form of the newly established Royal Society, and Nature, in the form of elaborate formal gardens, resulted in a wholly innovative attention to the natural world. Taxonomy was beginning to replace symbolism as the primary level of

attention to plants and animals alike. The symbolic plants of the old allegorical garden were too soon to be categorised and classified in ways which released them from their overwhelming obligation to analogically 'resemble' their Creator, and in this space between symbolism and science emerged the emblematic formal garden which plays so central a role in *The Draughtsman's Contract*, a garden in which the literary and artistic, the visual and verbal were united in the common rhetoric of statuary, obelisks, fountains, and so on.

At the same time analogies between landscape and the human mind were commonplace in Seventeenth century thought, as witnessed in the poetry of Andrew Marvell and many others. The Restoration garden operated as an extended field for mental play, constructing and permitting a fixed narrative of literary associations, generally with religious and Classical reference points. The long-term business of 'establishing' such a garden was, of course, inseparable from the assumption of long-term residence and ownership:

> by the Eighteenth century, nearly half of the cultivated land was owned
> by some five thousand families. As a central form of this predominance,
> four hundred families in a population of some seven or eight million
> people, owned nearly a quarter of the cultivated land.[9]

The private, enclosed, contemplative gardens of the pre-Civil War period were thus giving way to more elaborate forms of signifying relations to property and the 'countryside' as a whole. Beneath this lay the continuing if residual force of the older idea of the garden as a sign of Natural Order, legitimating social change well into our own times.

The Restoration garden therefore mediated a number of contemporary issues concerning the control of land, the idea of the Nation, the 'rights' of its new Caroline owners, and theories concerning the correspondence between garden design and moral philosophy. Thus a mid-century writer could observe how:

> when Speculation and practice, Art and Nature, are matched, they
> are pregnant and fruitful, but the one alone, wanting a mere helper, what
> fruits can it bring forth: Experience (as a philosopher said) is the Root
> of Art.[10]

The position of the viewing figure in the landscape is thus crucial, since the garden was expressly designed as an emblematic equivalent to his or her social standing. The emblematic garden, with its statues and inscriptions, its symbolic

plants and its allegorical geometry of vistas and flower-beds, offered itself as a confirmation of the 'right' to possession, a narrative of many-levelled connotations to be explored and deciphered at one's leisure. It was thus regarded as a proposition in its own right, and as a model for social relations as a whole. Writing his stage directions to *The State of Innocence* in the next century, Dryden required a Garden of Eden in the style of an ordinary Restoration garden as best representing what he regarded as 'an ordered and rational innocence'.[11]

The late Seventeenth century figure, standing in his or her garden, could thus scrutinise it from a number of related perspectives. There was no question of valuing nature as an end in itself. Always there was a chain of significations involved, leading the spectator from oblique references to the gardens of Antiquity to the Garden of Eden, referring directly to specific classical myths and equally directly to the emergent science of horticulture. Hence the significance of the pomegranate which the draughtsman presents to his employer, which we are clearly intended to relate to the celebrated image

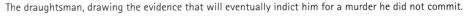

The draughtsman, drawing the evidence that will eventually indict him for a murder he did not commit.

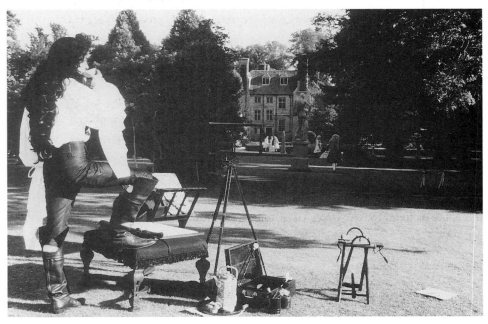

painted by the Dutch artist Danckert of the royal gardener, a certain Mr Rose, presenting King Charles with the first pineapple brought to fruition in England. In this context the entire formal plot of the film serves to reconstruct for us, in equivalent contemporary terms, this experience of 'reading' a garden. For the analogy of the whodunnit which Greenaway employs brilliantly encapsulates that work of detective, interrogative vision which was the everyday experience of the owner of a Restoration garden, paralleled in our times in the explorative gaze of the Private Eye or the forensic scientist.

Only from this perspective can we understand why Greenaway has introduced into his film a draughtsman whose drawings so engagingly flaunt all the conventions of Seventeenth century draughtsmanship. Mr Neville has been employed to produce a series of twelve topographical drawings of that property which stands at the heart of the film. He approaches his task in a spirit which is literally unthinkable before the Nineteenth century, in other words, the spirit of Naturalism which could value the appearance of the natural world directly as a self sufficient end in itself. His attitude in the film is criticised as being 'strictly material', and much is made of the fact that he only represents what he actually sees at one time and from one position. This is in flagrant contravention of the fact that such topographical drawings as were indeed frequently produced in this period were invariably constructed from a bird's-eye view, with emblematic figures of ownership and property paraded decoratively in the foreground.

The unfussy architectural drawings which he produces take on a formal narrative life of their own in the film as it becomes apparent that he is unwittingly reproducing in them a number of artefacts – shirts, a ladder, and so on – which will subsequently be used as evidence to indict him for a murder which he has not committed. He's being framed. There is thus an accumulative sense in which we also come to scrutinise these drawings with increasing interest as it becomes apparent to us what is actually going on.

We look at a couple of landscapes, and then begin to search actively for signs. This is the pictorial conceit which constitutes the central thrust of the film, and what is more, it is completely independent of the actual plot which is a mere pretext to encourage this process of cumulatively active looking on our part as the audience. It is a device which Greenaway uses to brilliant effect in order to temporarily rid us of that very sense of the Picturesque which, a generation or so later, was to lead to the wholesale destruction of most of the emblematic

gardens which were established in the Restoration period.

For the landscaped gardens of the eighteenth century would strip away all the elaborate parterres and emblematic devices of this kind of garden, introjecting into the seemingly 'natural' look of the rolling landscape those values of power and privilege which had previously been openly signified in the formal enclosed garden. We may detect this process 'on the horizon of history' in the strange person of the Genius of the Place figure, which haunts the film. By this notion of the Genius of the Place, the Eighteenth century writer (and gardener) Pope had referred to what Capability Brown was to regard as a site's 'capabilities', its supposedly intrinsic capacity for transformation under his 'capable' control. Pope's genuis loci was envisaged as a form of nature god to whom a given site is sacred, and by whom it might ultimately be reclaimed. This provided a rather playful justification for the wholesale demolition of the formal garden, as undertaken by Brown and others, for a rural gentry which no longer spoke

Power and privilege – introjecting into the seemingly natural look of the landscape.

Greek, and wished to signify its ascendency in the more abstract terms of the generalised Eighteenth century English landscape garden, purged of all direct symbolic or emblematic material, an idealised space which drew its appearance ultimately from the work of such painters as Poussin and Claude Lorraine, as allegory vanished from European art under the twin pressures of 'scientific' topography, and Romanticism. It is this immense amount of labour which is invested behind the appearance of the garden and the countryside as a whole which is also felt as cumulative force throughout the film. There is always somebody at work on the landscape, just as the landscape itself is always at work, producing meanings and chains of association which ironically legitimate the social hierarchy of the land.

Peter Greenaway has argued that the film 'is essentially about a draughtsman drawing a landscape, and the facets of the drawing and the landscape are compared on another level of representation, the film'. He wanted 'those three ideas to be present in the whole structure of the movie, so that one is aware that we are making comparisons all the time between the real landscape, Mr Neville's image of it and, ultimately, us as viewers seeing those ideas represented in film'.[12] It is this concern with representation as such which marks the film's position within the tradition of British independent cinema. But at the same time the emphasis on the disinterestedness of the overall look of the film (including its highly problematic presentation of sexual violence) places it clearly within the discursive framework of modernism. Greenaway has stated tellingly that he 'was interested in the ways that either the drawings reflected or did not reflect what was in front of me. The question of whether the draughtsman draws what he sees or what he knows'.[13]

This distinction between 'seeing' and 'knowing' is as much a commonplace of modernist aesthetics as the garden/mind analogy was of the Restoration period, and both are to he found frequently in the dialogue as well as the look of the film. Braque's celebrated claim that he painted what he knew rather than what he saw has reverberated down the century as a rallying-cry for anti-naturalists of all persuasions, in film as well as painting. The problem with this formulation however remains in its implicit reinforcement of the idea that there is such a thing in the first place as 'seeing' which can meaningfully be separated from the entire process of visual cognition. This assumption is itself a tenacious legacy from positivist thought, and needs to be questioned extremely hard. It is certainly an assumption which is entirely alien to Seventeenth

century thought, which was unable to distinguish in this fashion between material objects and our mental perceptions of them, a distinction which, as I have argued, is a basic defining tenet of positivism. Peter Greenaway's healthy distrust of reflection theories of cinematic and, by extension, photographic meaning, remains one of the most encouraging resources in contemporary British cinema. Nonetheless, it seems strange to me that this semiotic distrust is couched in terms which owe more to Cezanne than to Saussure.

NOTES

1 Tony Rayns on *The Draughtsman's Contract* in the BFI Press Dossier, London, BFI Production, 1982.

2 Helen MacKintosh on *The Draughtsman's Contract* in *City Limits*, No. 70, 4–10 February 1983.

3 Angela Carter on *The Draughtsman's Contract* on the Channel Four programme *Visions* (December 1982).

4 Peter Greenaway in programme notes for the 1982 London Film Festival screening of *The Draughtsman's Contract*.

5 *ibid.*

6 Raymond Williams, *The Country and the City*, London *Paladin*, 1975, p 69.

7 Peter Greenaway, *op cit.*

8 See Michel Foucault, *The Order of Things: An Archeology of the Human Sciences*, London, Tavistock, 1970.

9 Raymond Williams, *op cit*, p 78.

10 Ralph Austen, 'The Spiritual Use of an Orchard', appendix to *A Treatise of Fruit Trees*, London, 1653.s

11 John Dryden, 'The State of Innocence', Act 2 Scene 2.

12 Peter Greenaway, cited in Robert Brown, 'Greenaway's Contract', *Sight and Sound*, vol 51 no 1, Winter 1981-2, p 35.

13 *ibid*, p 38.

Index